Loving Orphaned Space

MRILL INGRAM

Loving Orphaned Space

The Art and Science of Belonging to Earth

TEMPLE UNIVERSITY PRESS
Philadelphia • *Rome* • *Tokyo*

TEMPLE UNIVERSITY PRESS
Philadelphia, Pennsylvania 19122
tupress.temple.edu

Library of Congress Cataloging-in-Publication Data

Names: Ingram, Mrill, author.
Title: Loving orphaned space : the art and science of belonging to earth /
 Mrill Ingram.
Description: Philadelphia : Temple University Press, 2022. | Includes
 bibliographical references and index. | Summary: "Loving Orphaned Space
 uses a geographer's tools to challenge and engage with single-function,
 socially and ecologically isolated space, and explores how artists help
 expose the costs of these disconnected spaces and build new
 relationships with our environments"— Provided by publisher.
Identifiers: LCCN 2021040408 (print) | LCCN 2021040409 (ebook) | ISBN
 9781439921944 (cloth) | ISBN 9781439921951 (paperback) | ISBN
 9781439921968 (pdf)
Subjects: LCSH: Urban geography—Social aspects. | Urban renewal—Social
 aspects. | Environmental psychology. | Environmentalism in art. | Place
 (Philosophy) in art.
Classification: LCC GF125 .I54 2022 (print) | LCC GF125 (ebook) | DDC
 307.76—dc23/eng/20211213
LC record available at https://lccn.loc.gov/2021040408
LC ebook record available at https://lccn.loc.gov/2021040409

∞ The paper used in this publication meets the requirements of
the American National Standard for Information Sciences—Permanence
of Paper for Printed Library Materials, ANSI Z39.48-1992

Printed in the United States of America

9 8 7 6 5 4 3 2 1

For Jackie

Contents

Acknowledgments

In keeping with a book about Earth and orphaned space, my gratitude begins with a tiny slip of lakeshore near my house for which I am enormously grateful. It's a steep, vegetation-choked stretch of shoreline that remarkably—in a neighborhood that has gone full throttle through several real estate booms—sits quietly and undeveloped as either a park or a property. I have spent much time there, pushing through the honeysuckle to see spring ephemeral flowers, taking photos of ice forming and deforming, picking up trash, and thinking back on what this landscape might have looked like for the people who created the earth mounds on top of the hill overlooking the lake. At certain times of the year, I have a lot of human company as birders come to see the long-distance travelers, especially warblers, that flow into the trees in the spring. After so many years of clambering around or just sitting, a piece of my heart is in that place. Having it in my life makes me feel lucky.

I have that same feeling toward many people. I dedicate this book to Jackie Brookner, whose loss I feel every day. I am deeply grateful for the inspiration and generosity of Jackie as well as Lillian Ball and Frances Whitehead. All three artists generously shared their visions

and the nitty-gritty of how they went about realizing them. They each took precious time to introduce me to their work and their collaborators. The core of this book rests on the work of these three very badass women.

I am also thankful for their wonderful collaborators, including Nicole Crutchfield, Cali Anicha, Rachel Asleson, Loretta Cantieri, Dwight Mickelson, and others on the Fargo Project. I thank M. Jenea Sanchez, another artist, for sharing her inspiring work in the U.S.-Mexico borderlands with grace and flexibility. I also want to thank Paul Schwab for the time he spent talking to me about *Slow Cleanup*. I am grateful to Dea Converse for taking the time to walk and talk about the secrets of regulating underground petroleum storage tanks. My thanks go to John Steines for letting me follow him around (trying to keep up), to Lou Host-Jablonski for hosting many beautiful conversations, and to Matthew Miller for his commitment to saving an orphaned space in Madison, Wisconsin.

I was incredibly fortunate to join an international team of geographers in 2010 providing me with an opportunity to research environmental art-science collaborations. I am deeply indebted to Sallie Marston, Deborah Dixon, JP Jones, Hattie Hawkins, Keith Woodward, Elizabeth Straughan, and Linda Vigdor.

The insights of the reviewers of this manuscript—including members of the Temple University Press editorial board, editor-in-chief Aaron Javsicas, and two outside reviewers—greatly improved this book. I give them my thanks.

It is not an overstatement to say I might not have written this book without the love and wisdom of my friends and artists Kristin Thielking and Lisa Beth Robinson, whose own art-science collaboration as well as excitement about my ideas helped keep a guttering flame alive when I was seriously distracted. I'm indebted to them and other members of the Catching a Wave Collaborative—Shona Paterson, Hester Whyte, and Martin Le Tissier—for giving me opportunities to share my ideas with others, especially students. To so many creative and hardworking people in my life, especially Vera Wong, Erik Ness, Kimi Eisele, and Carole Trone, I owe thanks for many things, including helping me remember that tenacity is at the top of the list

for creative production. Thanks go to Ellen and Anita for giving me a place to stay during fieldwork and, especially, sharing their dogs. And many thanks to "Las Cebollas" for opening my eyes to the diversity of aspiring agriculturalists and the importance of access to land. I am also indebted to my colleagues at *Ecological Restoration* and *The Progressive* magazine, which provided me places to publish related work on the contributions of art to environmental work.

To my mother, Helen Ingram, who is also, wonderfully, a coauthor on several projects, my gratitude has no boundaries. I am indebted to her for reading all the drafts, the lengthy phone calls, and all the times she told me, "This is good." Also, it has been wicked fun. To my father, Jeff Ingram, I am forever grateful for his belief in my ideas, his steadfast interest and support, and especially his example of long-time activism, authorship, and dedication to loving Earth.

To Ken I owe the most—for supporting my ability to keep chasing ideas, turning them over with me when I managed to catch one, listening to me practice presentations, and otherwise sticking with me through thick and thin. I thank Emlyn and Isaiah for their deep, beautiful hearts. I also thank them for reading my work and for their examples of commitment to a creative life.

This book has been a decade in the making, and many times along the way, I have hesitated, wondering about the usefulness of one more book, another collection of written words, when action is so clearly critical. As I worked on completing this project, a series of astounding ruptures to life as usual made it difficult to stay focused—a pandemic, global uprisings for racial justice and Indigenous rights, mobs storming capitol buildings, huge fires, and floods. One morning I watched a video of a large chunk of Norway's coast, liquified by melting permafrost, separate and sink into the ocean, carrying houses and a road with it. There is no hiding for anyone, it seems, from this moment of tremendous human reckoning. How will we look back at this time? I am both terrified and tremendously hopeful of what might emerge.

My persistence with this project is rooted in a conviction that collaborative work on local environmental projects attends to crosscutting issues like rights to the city, racial justice, climate change, biodi-

versity, public health, and socially relevant research, as well as loneliness, grief, and individual feelings of helplessness. There's good work to be done and being done. I see it everywhere. I offer this book in the spirit of all the other tenacious efforts of ordinary people solving problems and loving Earth.

Loving Orphaned Space

1

Touring Orphaned Space

Because everything was alive, responsive in its own way,
capable of being hurt in its own way, capable of punishment
in its own way, Zhaanat's thinking was built on treating
everything around her with great care.

—LOUISE ERDRICH, *The Night Watchman*

John and I decided we'd chance making it across the marsh with somewhat dry feet. We'd been zigzagging our way through a scrubby woods, bypassing people's encampments—empty now in the colder weather—and walking over low hills; bulldozed piles of soft, soggy dirt. We ducked under low, spreading branches of magnificent oaks and struggled through thickets of buckthorn. In some places brambles made it impossible to pass. We were now facing a wetland choked with reed canary grass, and though we could see ice over much of it, we weren't sure how much had thawed and how much water we'd encounter if the ice didn't hold us.

It didn't hold. The marsh wasn't deep, but we went in over our ankles. By the time we made it across the boggy space to the vast, crumbling parking lot where we'd left a car, our boots were coated in mud, our feet swimming in wet grit. It was a bonding experience. Now we each knew what the other was made of. We were not afraid of some mud, brambles, or chance encounters with people without anywhere else to be—all of which are possible to meet in spaces behind buildings, between highways, alongside stormwater-entrenched creeks.

Because that's where both of us wanted to be. At least, that's what I was thinking when I followed John across that marsh.

Why I wanted to be there is the purpose of this book. Passing by empty lots, I watch plastic bags assembled, flapping at me, and wonder what they are trying to say. I take note of the small broadleaf plantain and yellow cone-headed pineapple weed pushing up through the packed earth of a street terrace and wonder what story they are telling. My attention on these overlooked and disconnected spaces is, for me, part of a long-term exploration of environmental networks—the relationships connecting people and other beings—and the stories we use to narrate those relationships into existence and maintain them over time.[1]

In many such spaces, our stories are just too simple. I think about the small patch of land between sidewalk and road that I cross every day as I leave my house. I'd spent some time there, for a while, shunning grass and trying to coax along a variety of plants—not weeding too much but kicking back at any one plant that decided to make the place its own. I was in there, palavering with the daylilies, coaxing them to move over, not sure who or what else for—but please, just share, for Chrissake—and noting the path through them made by the neighbors on their way to the bus stop, its own kind of lily control. Maybe I should stop worrying about the lilies, I wondered. What else might happen in this space if I let it? Or what if I brought in some other things with their own ideas?

Lurking under this conversation were "the rules" from the city. You can't grow too high, you know, or you might block visibility for traffic. No fencing or staking that might trip up folks making their way home in the dark. The space has a job to do: separating the road and the sidewalk, a temporary holding space for snow and maybe trash bins—and no idiosyncrasies should interfere with those primary functions.

But despite that, under the radar, I was holding raves, inviting in the riffraff—that is, until the precarity of it all came to the fore. In a day, the fruits of all my negotiations were buried deep in chunks of asphalt and concrete as the city rebuilt the road. Months later, city workers pulled off the concrete then laid topsoil and spread grass seed. I believe it included three varieties of Kentucky bluegrass, 25

percent creeping red or Chewings fescue, and a couple improved varieties of a turf-type perennial—maybe ryegrass. Which is all well and good, but really, I was looking for a different conversation. And anyway, those intrepid lilies (*Hemerocallis fulva*, for those who care) came roaring back. So I brought over some other things—a yarrow, a sedum or two—and we were at it again. I'd wondered what might happen if I could cut a small notch in the concrete sidewalk to let in a bit more rain runoff. And how tall is that redbud seedling going to get before the city cuts it down?

Across the street it's a different story. The neighbor mows, removing anything that isn't grass, and those chosen grass varieties are performing. They get nicely raked. They are having their own conversation, though it's not enough to pull me across the street to join.

For me, spaces like these, put to work in a city, beckon. In part, the draw is related to what Karan Barad means when she writes, "the void is not nothing but a desiring orientation toward being/becoming, flush with yearning and innumerable imaginings of what could be/ might yet have been."[2]

I'm interested in the yearning, which I feel and act on, as well as the energy expended and the politics of keeping certain spaces so policed and "empty." Those politics involve an active process—an "orphaning," as I've come to call it—that disconnects and disappears space by minimizing ecological, social, and other relationships. I want to catalog the forces at work and the resources spent on creating and maintaining orphaned space and expose what this purposeful disciplining of space costs us. Voids, marginalia, empty spaces must be created and maintained . . . a process often unquestioned. But as Barad explains, "The question of absence is as political as that of presence. When has absence ever been an absolute givenness? Is it not always a question of what is seen, acknowledged, and counted as present, and for whom?"[3] The void has long been a "crafty colonialist apparatus," Barad reminds us, conveniently couched in categories like "uncivilized" or "virgin" to justify all kinds of appropriation. We can add "vacant" and "infrastructure" and "open" to that list.

Our culture normalizes land as a commodity, something anonymous, and bought and sold with infinite possible futures. There is too little attention to the past and too narrow an imagination for the

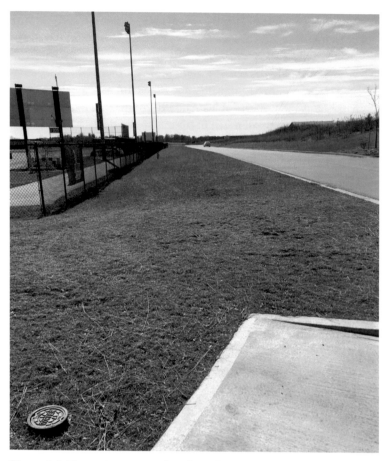

Figure 1.1 The maintenance of orphaned space is always active and continuous, implemented through the severing and minimization of ecological, social, and other relationships. (Photo by the author.)

future. We struggle even to fully embrace the complex natural ecologies at play in space, let alone the role of history. To maintain this anonymity, we actively orphan.

I came to the word "orphaned" after a long search for language to capture the widespread processes of disconnection and disciplining of space that I saw everywhere, often in the service of infrastructure.

Although often used to refer to someone who has lost their parents, this flexible word also refers to "a thing abandoned, forgotten, destitute, and separated from others of its kind," according to the *Oxford English Dictionary.* The condition of being orphaned can refer not only to humans who have lost parents but also to animals who have lost caretakers, to umbrellas that have lost owners, to cars for which manufacturers no longer make parts, and, I suggest, to territory held in isolation and stasis or with diminished connectivity. Some might worry the term anthropomorphizes, and perhaps that is not, generously speaking, outside my intent. The opportunity we have in taking a hard look at the diversity and ubiquity of these spaces around us is similar to the exploration by Balayannis and Garnett of chemicals as kin.[4] The chemicals we create, they point out, are dangerous but also sustaining. Polarized approaches to categorizing them as either beneficial or dangerous mean we make too little of their material politics. The authors refuse dualistic notions of human-made chemicals in favor of more complex processes of negotiation with chemicals as *both* enabling and harmful.

For me, orphaning similarly refuses categorization as either good or bad and insists we embrace orphaned space as a product of our own activities. Orphaned spaces do important work, but with uneven and often harmful geographies. This embrace is not necessarily a parental one, but it does suggest familial relations and a two-way relationship of caring with the potential for feelings of transcendence, for love. The term "orphaned" involves acknowledgment, responsibility, and leaning into the idea of belonging—that how we relate to orphaned space matters because we belong to each other. We abandon at our peril. The multitude of orphaned spaces—and they represent a tremendous amount of acreage, as I will explain—is being routinely produced and maintained at a significant cost. Such spaces deserve focus not only because they represent a large area and cost to maintain but also because of lost opportunities.

Marc Augé uses the term "non-place" to refer to spaces defined only by the passing through of individuals, lacking history or meaning and in which we spend an ever-increasing portion of our lives. Perhaps most familiarly, we recognize empty space as the result of ne-

glect, a failure of planning creating vacant lots, "marginalia," and "terrain vague."[5] Deindustrialization, redlining, population shifts, and the 2008 financial meltdown are some of the drivers commonly used to explain "empty" spaces in our towns and cities. Looking across the U.S. Midwest, where I live, cities like Saginaw, Michigan, have half the population today than they had 60 years ago. Cleveland lost nearly two-thirds of its population between 1950 and 2010. Detroit, in recent years, had over 90,000 vacant lots. And in a post-COVID-19 world, that trend has only increased as people struggle economically or take advantage of remote work to seek greater social distance outside concentrated urban areas.

There are so many of these vacant spaces that in many towns, their presence has become impossible to ignore and is the focus of emerging conversations around "urban greening" and "place making," for example.[6] Detroit has a new city blueprint focused on vacant land transformation, Buffalo is studying distributed green infrastructure to filter stormwater, Milwaukee is funding pocket parks, and Atlanta is investing in a 22-mile urban trail system—the Belt-Line—established on the site of a derelict railroad.

But there's much more to be said about orphaned space. While land managers embrace green planning, the uneven geographies of species diversity and pollution reveal how spaces are orphaned along lines of race and privilege. Such space is an environmental justice frontier—an opportunity for all of us to redefine ourselves as fairly treated citizens of a heterogeneous, diverse, connected world. I'm interested in the range of the impetuses of orphaning, the energy, practices, and reigning ideology keeping them cut off from living connections as well as from meaning and memory. Conversations about vacant land extend well beyond urban planning.

The land under our feet has a history. All of it. Consider the expropriation of land from tribal nations. The 1862 Morrill Act, for example, transferred almost 80,000 parcels equaling over 10 million acres of Indigenous lands across the country to fund the endowments of some 52 land-grant universities. It was a violence-backed transfer that still produces wealth for those institutions today. Or think about Ruth Wilson Gilmore's writing on mass incarceration and "forgotten places." She conceptualizes a single, though spatially

discontinuous, abandoned region consisting of places where prisoners come from (urban neighborhoods of color) and where prisons are built (former agricultural lands). She exposes the interconnectivity of these urban and rural places in her analysis of how the state, facing crises of legitimacy and finance, invested in mass incarceration to deal with "surplus" populations and land.[7]

Building awareness of how such forces shape land use, and the work of searching out more specific narratives relevant to any orphaned space, are key exercises in "resisting the void." There's often nothing unintentional about orphaning. Such spaces have purpose. They are managed to disappear—streamlined as a piece of our maintenance infrastructure or dedicated to a single function, like street terraces and rights-of-way. Other kinds of orphans exist as the apparent accidental appropriation of space by pollution such that it becomes single function by being toxic to any kinds of association. When the boundaries maintaining the orphan are breached, who ventures in and why? What new relationships emerge? For sure, nature abhors a vacuum, but coexistence is nothing to take for granted. How do decisions get made? Who cares?

The area around the marsh John and I visited has changed dramatically since our walk. An Amazon distribution center was proposed for one of the crumbling properties, including a surface parking lot to handle 700 cars. A city-adopted neighborhood plan had this space designated for "mixed housing," some of which would welcome lower-income folks to be near the green open space (which, as a designated wetland, at this point can't be built on by law). People contributing to the plan envisioned walking paths, pollinator sanctuaries, urban gardens, and installations that would filter runoff from the nearby streets, thus cleaning the water entering the wetland. But it turned out that even while the city formally recognized the plan, rezoning from "light industrial" was never pursued. A lawyer for Amazon slipped in an almost-missed request for a permit to build parking: acres of impervious asphalt adjacent to the wetland and a lot more through traffic in John's neighborhood as drivers for Amazon rush to deliver goods. Neighbors got wind of the plans at the last minute and showed up at a city meeting, which created delays, but ultimately, the assistant city attorney said the proposed uses

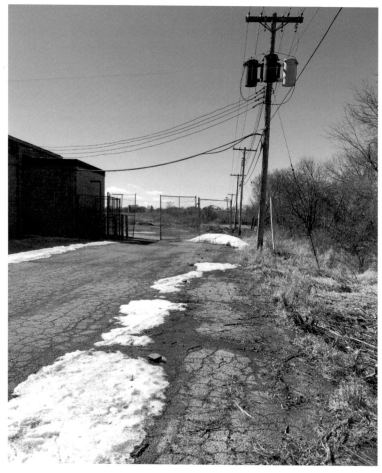

Figure 1.2 Orphaned space exhibits a kind of tension—places in waiting for fates decided elsewhere. (Photo by the author.)

of that parcel were all "permitted." No matter the years-long neighborhood planning process and city-approved neighborhood plan. Constitutional protections for property owners remain sacrosanct, and no city wants to face a lawsuit on those grounds.[8] Our city, like so many, relies on "growth" defined by development and increasing

rents. And a job with Amazon looks pretty good to a lot of people living nearby.

That neighborhood plan reflected a wealth of other ideas. John was excited about expanding ecological connectivity and designing mixed-generational housing and commercial spaces to feature a nearby stream and a small pond. We also talked about different ways to commemorate the history of the place—the tribes who've lived here, the farm that was here for generations. Other ideas included wildlife habitat and earth and water installations that clean stormwater. People in this neighborhood have less green space per capita than in surrounding neighborhoods, and the idea of creating welcoming outdoor spaces that would serve them close to home was compelling.

In even the most desolate orphaned spaces, more activity is going on than might be apparent at first. Things have a way of poking up and dropping in. It's not easy to predict—orphans are vacuums for new relationships, pulling in people with nowhere else to go, trash, sedimented layers of dust, bee poop, pollen, car exhaust, mercury, plastic detritus, and so on. All this stuff starts to matter, to build connections. This is why orphaning is often a very active process, denying relationships that want to happen.

Multiple forces bring orphaned spaces into focus. They are always part of a larger story, produced by specific patterns of urbanization and catalyzed into our awareness by climate change, pandemics, financial crises, and overwhelmed infrastructure. Orphaned spaces become visible as they fill with people who can't afford a place to live, developers looking for new spaces to build, or urban managers trying to solve infrastructure challenges regarding flooding, urban heat islands, food insecurity, and public health. All this is an opportunity to rethink our personal relationships to a vast quantity of public land that falls in a shadow area between private property and open-access space. Green infrastructure and "nature-based" solutions are recent developments in ways to think about and expand the uses for such space. But while approaches like these can be a positive addition to urban planning, they are not enough and, in fact, can be damaging. Green infrastructure projects can be driven by "outside-in" planning, with a community of experts making decisions about how

space is managed with only superficial input from residents nearby. And the links between green space development and gentrification are damning.[9]

This book is about the orphaning of space and also the work of people who resist orphaning processes. They gain access to orphaned space in different ways, a combination of following the rules and bending them. Connections are built and new relationships emerge from their work, which I describe as a kind of radical caring. It's work that builds on itself as "empty" spaces become charged with new connections and characters in a shared narrative.

The emergence of a network—an assemblage of new characters and relationships that can manifest once active orphaning is halted, even partially—is a particular story, always driven by history, as well as a collection of different agents and relationships that flow in once the seal is broken. Nothing can be taken for granted about who and what will come and be welcomed. Influences from near and far, from long ago and recent times, must be considered and treated with care. I feel just this sentiment in Louise Erdrich's novel *The Night Watchman*, in which she describes how the character Zhaanat, a keeper of knowledge, navigates her world: "Because everything was alive, responsive in its own way, capable of being hurt in its own way, capable of punishment in its own way, Zhaanat's thinking was built on treating everything around her with great care."[10]

This sense of care feels important right now, in a world full of surprises and uncertainty and under pressure from the relentless human drive to build and grow. What opportunities might lie right around us? Who is taking the time to slow down and listen? What do they hear?

John is a nurse, though he retired in 2019. He's also an artist, and in that way, he is like others I have followed into orphaned space. Compelled by widely ranging visions and ambitions, trained to observe what others don't, and encouraged to pursue knowledge across disciplines that might help realize a vision, artists are well equipped to question accepted uses of space and take advantage of unexpected events or ruptures in accepted ways of doing things. In many urban places, managers struggle with a convergence of aging and overwhelmed infrastructures, growing or shrinking numbers of residents,

and unpredictable "shocks" from extreme weather or other events pro-voked by climate change. Cracks have appeared. Bridges crumble, sewers overflow, treeless streets bake and melt. Suddenly, taken-for-granted infrastructures, like Heidegger's tools, become visible as they fail.[11] As local administrations scramble to cope, they have opened up opportunities for newcomers, including artists, to enter and exper-iment in once-disciplined spaces.

As editor of *Ecological Restoration* journal in 2007, I read an ar-ticle in the *New York Times* describing an exhibit, curated by artist Lil-lian Ball, that showcased restoration work creatively engaging with people in communities afflicted by polluted land and water. I had prided myself on publishing a cross section of articles by scientists and practitioners but had not before considered the role of artists in the work of restoring degraded land. I was particularly compelled by how the artists relied on ecological science but equally centered his-tory, meaning, and cultural legacy—elements all too often missing in ecological restoration projects. I reached out to Lillian and invited her to publish a piece in the journal, which was the beginning of an enormous expansion in my thinking about how we relate to the world around us.[12]

As I learned more about the legacies of environmental art and became more familiar with ongoing projects, though, I struggled to describe the breadth of many projects.[13] I failed frequently with read-ers and audience members who seemed to see such work as urban planning with good visuals. Eventually I realized it was not only the spaces that were overlooked and undervalued; it was also the labor of connecting them; building caring relationships. Understanding this led me to one of the most compelling artists to bring orphaned space into focus: Mierle Laderman Ukeles.

Ukeles's work, encapsulated as "Maintenance Art," was all about undervalued labor. In *Washing/Tracks/Maintenance: Outside*, 1973, Ukeles scrubbed the steps and floors of the Wadsworth Atheneum in Hartford, Connecticut, in four-hour shifts. Visitors, forced to step around her work, were confronted with her kneeling figure, jeans damp, arms furiously scrubbing. She put on display the labor of clean-ing and maintenance—so critical to everyday functioning at the mu-seum and so typically hidden and denigrated.

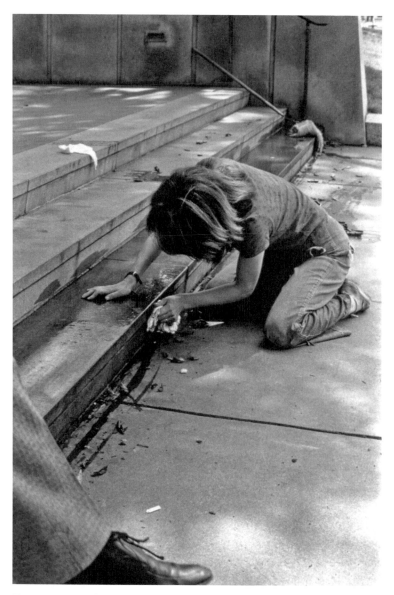

Figure 1.3 Mierle Laderman Ukeles, *Washing/Tracks/Maintenance: Outside*, 1973. Part of *Maintenance Art* performance series, 1973–1974. Performance at Wadsworth Atheneum, Hartford, CT. © Mierle Laderman Ukeles.
(Courtesy the artist and Ronald Feldman Gallery, New York.)

In her *Manifesto for Maintenance Art 1969!*, a four-page proposal that would frame her work for decades, she wrote[14]:

I am an artist. I am a woman. I am a wife. I am
a mother (random order).

I do a hell of a lot of washing, cleaning, cooking,
renewing, supporting, preserving, etc. Also,
(up to now separately) I "do" Art.

Now, I will simply do these maintenance everyday things
and flush them up to consciousness, exhibit them, as Art.

Ukeles rejected the experience of being seen as a serious artist one day and ignored the next as a mother pushing a baby carriage down the street.

Maintenance is a drag; it takes all the fucking time (lit.)
The mind boggles and chafes at the boredom. The
culture confers lousy status on maintenance jobs=
minimum wages, housewives=no pay.

Ukeles described a societal distinction between "Development," the labor of "pure individual creation," and that of "Maintenance," or "keeping the dust off the pure individual creation"—and then rejected it. She proposed that "the exhibition of Maintenance Art, 'CARE,' would zero in on pure maintenance, exhibit it as contemporary art, and yield, by utter opposition, clarity of issues."

Ukeles's challenge to this separation of the labor of caretaking from that of art making formed the backbone of her work for decades, frequently in collaboration with the New York Sanitation Department. In *Touch Sanitation*, 1979–1980, she spent a year shaking hands with 8,500 city sanitation employees, saying to each one, "Thank you for keeping New York City alive." As part of this work, she was also an advocate, exhibiting the labor of maintenance and calling attention to degraded and degrading working conditions for maintenance workers.

Ukeles's interventions were not those of a benevolent artist shining a light on the invisible worker, though. She aimed to expose us, the audience, to how much we depend on this work, yet shun those who do it. As she wrote in her manifesto, her work sought to engage a "flushing up into consciousness" the care work required to keep us going. *Social Mirror* (1983), consisting of mirror-clad garbage trucks, made the labor of maintenance hypervisible, the flashy trucks confronting viewers with their role as producers of waste, and demanding they reflect on the task of managing it.[15]

Her work reminds me of a passage in Wendell Berry's *Hidden Wound*, a book he wrote as he struggled to come to terms with the racist culture in which he grew up. As part of his navigation of the impacts of racism on his own soul, "as complex and deep in my flesh as blood and nerves," Berry zeroed in on the price of a white people's drive to shun and denigrate the labor of its own maintenance: "The notion that one is too good to do what it is necessary for *somebody* to do is always weakening. The unwillingness, or the inability, to dirty one's hands in one's own service is a serious flaw of character. But in a society, that sense of superiority can cut off a whole race from its most necessary experience."[16]

I first read that quote decades ago, and it comes into my mind often. What does Berry mean by "necessary"? I eventually came to see a connection between this idea of the psychic cost of shunning the "necessary experience" of caring for oneself and the feminism of environmental artists, like Ukeles, whose work gestures to the undervalued work of caretaking.[17] In an article for *Art Forum* in 1992, Ukeles extended her thinking about the labor of maintenance to land, describing New York City municipal landfills as abstract symbols of the overall "City as Authority" in tension with local people's needs for autonomy and places where they feel comfortable. "In this vacuum between the City's landfills and local places' distressed Faces, I see a rich, awesome Zone, highly charged and vibrating, awaiting the entry of Art," she wrote. Ukeles described plans to use the landfills to reflect on gendered images of Earth, including Earth as "Virgin," forever fresh and a source of reverent delight, and as "Whore," offering endless access and then "an endless sinkhole for receiving the remains, the unwanted and the despised."[18]

Her brilliant insight challenging the distinction between labor revered as a source of transcendence and that which is denigrated as maintenance work helped me conceptualize orphaning. It takes effort to sense what is systematically hidden, to reconceptualize the spaces we walk through every day and that so easily almost disappear even as we look at them. These often grungy, workaday spaces seem so necessary as they are—might we care for them as they care for us? Precisely because they are doing our maintenance work—might we embrace them in meaningful ways? What might those efforts look like?

A glance at an aerial photo of human development most anywhere on Earth reveals ubiquitous scrap pieces of land. Some are just tiny bits between a building and sidewalk; others are multiacre lots hidden behind warehouses or long strips between streets and waterways or along border fences. These parcels of land are so common most of us don't even notice them. Infrastructures like transportation and water drainage create strangely shaped spaces dedicated to specific, ancillary functions: street terraces, drainage channels, and highway rights-of-way, for example. There are also leftover odds and ends of space with no apparent function, like the bits of biscuit dough after cutting. These spaces are often fenced, creating conditions so ubiquitous and impactful that we now have a new subdiscipline of "fence ecology." Earth's rapidly spreading global network of fences likely exceeds the length of roads by an order of magnitude, creating an ecologically distinct and ubiquitous linear feature.[19]

Although orphaning is far from a solely urban phenomenon, the process is most apparent in cities. Two-thirds of all humans live in cities. Urbanization has been the great economic engine of the last fifty years. And while the amount and character of orphaned space varies enormously between Detroit and Lagos, or between Buenos Aires and Manhattan, "vacant" land and open space represent a remarkably significant percentage of urban land everywhere. And it's increasing. Cities around the world are stretching out, consuming land at a rate that exceeds population growth. In cities around the world, urban land consumption outpaces population.[20] Even with slowing population growth, development continues to unfurl—and, along with it, the routine orphaning of space. Furthermore, as cli-

mate change forces new migration patterns, new housing and commercial development will expand to accommodate these changes. A 2016 survey of U.S. cities concluded that over 17 percent of urban land is "vacant" (defined as undeveloped, remnant, underutilized, abandoned, or damaged) and that "most vacant parcels are small, odd shaped, and disconnected." But orphaned spaces are much more than vacant. The *Atlas of Urban Expansion* analyzed the density of 200 cities around the world with populations of over 100,000. The project revealed that urban "open space" includes parks and golf courses, rights-of-way, community gardens, campus greens, and brownfields, as well as abandoned lots. Across the 14 U.S. cities studied, urbanized open space (any "open-space pixel" less than 200 hectares and within 100 meters of built-up pixels) ranged from a low end of 21 and 22 percent in New York and Los Angeles, respectively, to 43 and 51 percent in St. Paul and Raleigh, respectively.[21] On closer inspection via Google Maps, St. Paul's "urbanized open space" includes golf courses, greenways along drainages and boulevards, campuses, and parks but also brownfields and litter-strewn, remaindered land fragments between developments and roadways.

Houston, a town infamous for its sprawl, flaunts 36 percent open space, according to the *Atlas*. The city's relaxed zoning and extensive hardscape are legendary. It suffered severe flooding after Hurricane Harvey in 2017 and continues to flood during even ordinary rains, in part because of the extent of hard surfaces and the lack of integrated stormwater management. Houston covers twice the area of New York City and has only a quarter of the population, which has doubled to 3.8 million since 1980 and continues to grow, adding 386 new square miles of impervious surface in the last 20 years.[22] Most of the flooding across Harris County during Hurricane Harvey occurred outside officially designated floodplains and disproportionately impacted neighborhoods of Black and Hispanic people. Reasons for this include uneven, and minimal, municipal investment in stormwater management across the city.[23] Houston's development, heralded as "free market," is, of course, not at all free. The city's development is subsidized by cheaply manufactured housing, taxpayer-subsidized tax credits, mortgage interest deductions, gas subsidies,

Urban Extent

The Urban Extent of Minneapolis-St. Paul in 2014 was 251,256 hectares, increasing at an average annual rate of 1.4% since 2000. The urban extent in 2000 was 206,520 hectares, increasing at an average annual rate of 2.9% since 1990, when its urban extent was 155,588 hectares.

1990 2000 **2014**

Urban Extent
☑ Urban Built-up
☑ Suburban Built-up
☑ Rural Built-up
☑ Urbanized Open Space

Exurban Area
☐ Exurban Built-Up Area
☐ Exurban Open Space

Rural Open Space
☑ Rural Open Space

Figure 1.4 The *Atlas of Urban Expansion* project mapped the extent of urban "open space" in 200 cities, revealing that vacant plots, parks, golf courses, rights-of-way, campus greens, brownfields, and other ubiquitous unbuilt space represent some 22 to almost 50 percent of urban extent. Here, in Minneapolis/St. Paul, the purple color represents built-up areas, the yellow shows urbanized open space, and the green represents larger unbuilt "rural" areas larger than 200 hectares. (Map from Shlomo Angel, Alejandro M. Blei, Daniel L. Civco, and Jason Parent. *Atlas of Urban Expansion.* Cambridge, MA: Lincoln Institute of Land Policy, 2012.)

flood insurance, and highway construction money—not to mention emergency relief, including homeowner buyouts.

The extent of Houston in 2014, according to the *Atlas of Urban Expansion*, was 423,148 hectares, or 1,045,621 acres, with some 375,000 acres of open urban space, but it ranked 81 out of 100 cities in the Trust for Public Land's "ParkScore" ratio of people to green space. If you visit some of Houston's "open space," you'll find vacant lots and parks but more often drainage areas for parking lots, greenways alongside channelized and cement-lined drainage ditches, and rights-of-way alongside highways.

The Harris County Flood Control District, where Houston is located, is charged with maintaining more than 2,500 miles of drainage channels, natural bayous, and large stormwater detention basins within the city limits as part of its attempts to manage water. A district report reveals that's equivalent to 18,000 acres dedicated to water storage and capture and subjected to "mowing, selective clearing, hazardous tree removal, herbicide application, tree pruning, and removing sediment and foreign materials that build up." The maintenance and opportunity costs are huge. Over a fourth of the city's revenue is from water and sewage fees, and its public works division, at over $2 billion, is the largest line item in the city's budget.[24]

What kind of land ethic upholds such routine generation of isolated and single-use space? Orphans are a type of waste, casualties of a rush to develop with little incentive to be sensitive to a broad valuing of land: for place, history, or local participation and control in what happens and where. Orphaning suggests low regard for ecological connectivity, local control, and non-consumption-oriented activities.

Chicago is a much more densely occupied city than Houston but still harbors 27 percent urbanized open space overall, and while this varies widely depending on proximity to the city center, even close in there are small open lots, areas with trees, and, of course, street terraces with grass and rights-of-way alongside train tracks.

How should we think about these fractured geographies? Orphaned spaces are maintained to have anemic social and ecological networks. Of course, closer inspection can reveal a lot going on—life flourishing in the cracks. As many intrepid urban explorers have doc-

Figure 1.5 Chicago Wilderness, a coalition of some 300 organizations, developed a "Green Infrastructure Vision" of 1.8 million interconnected acres of remnant woodlands, savannas, prairies, wetlands, lakes, and stream corridors. (Reprinted by permission of Chicago Wilderness.)

umented, the variety of life that can develop and thrive in edgy urban lands is remarkable. Large open spaces and parks in U.S. cities are home to muskrats, squirrels, foxes, coyotes, deer, rabbits, prairie dogs, and even elk and mountain lions, not to mention people. Cities in India even harbor jaguar habitat. Small urban "marginalia" support bees, flowers, hawks, and much more. As geographies of industry and infrastructure shift, spaces become available for colonization

of all kinds of new species and new activities. One famous example is Toronto's Leslie Street Spit, a defunct Lake Ontario port constructed from urban debris that famously flourished in response to human neglect and transitioned from hideous industrial by-product to "widely cherished feature" and world-ranked birding site.[25]

But when such spaces are viewed more carefully, the romanticism can fade. Biodiversity is often found only in larger, better-managed, and well-established urban parks. And biodiversity can be more a reflection of the expansion of human development into the wild than an embracing of it. Wildlife and certain plant species become labeled as pests and experience a precarious rather than nurtured existence. Thom Van Dooren and Deborah Bird Rose have written about how humans have targeted flying foxes residing in urban parks in Queensland with smoke bombs, water cannons, firecrackers, and noise machines.[26] An increasing number of humans are occupying orphaned spaces, too, forced in by increasingly high costs of living and lack of good jobs and social support. People who set up house in orphaned spaces suffer from constant vulnerability to crime, as well as food, water, and hygiene insecurity, not to mention unpredictable visits from authorities seeking to drive them out.[27]

Puzzle pieces of vacant land dot cities and exurban areas. Such spaces cost us in their disciplining—fencing, mowing, and applying pesticides—but we also lose the potential benefits of spaces connected in more diverse ways that might help to more fairly distribute resources and provide support to people in all parts of a city. People who invest in such spaces—connecting into them as guerrilla gardeners or other caretakers, trying to grow food or trees, for example—can lose years of soil-building or tree-nurturing efforts in a single morning when the city sends in a bulldozer to clear a piece of once-vacant land for a new development.[28] The routine creation and maintenance of orphaned space feels tragic, a symptom of a febrile land ethic. It is in part the material expression of planning and culture that persists in creating anonymized space—disconnecting people in the name of a master plan of efficiency—and thinking in terms of "systems" instead of stories. The promise of orphaned space is not a matter of restoring something lost, chasing a vision of a past ecological balance or a utopian notion of fine-tuned master urban

ecology, but the opportunity for diverse stories, for something unique to bubble up.

Maintaining orphans is work. As any ecologist knows, the land contains tremendous forces constantly pushing to reconnect (or invade) any "properly functioning" infrastructure. Consider the price we pay to maintain a "smooth" space. We fence, plant monocrops (Kentucky bluegrass is a favorite), mow, spray pesticides and herbicides, riprap waterways, channelize with cement, and cover in asphalt. Such activities "police" space, keeping flows of succession at bay and limiting the presence of people and other life.

In *The Forest Unseen*, David George Haskell offers a wonderful description of this policing, comparing a small patch of forest—which he calls the "mandala"—to the orphaned space of a golf course. "A golf course's ecological community is a monoculture of alien grass that emerged from the mind of just one species," he writes. In contrast, "the mandala's visual field is dominated by sex and death: dead leaves, pollen, birdsong. The golf course has been sanitized by the puritan life-police. The golf green is fed and trimmed to keep it in perpetual childhood: no dead stems, no flowers or seed heads. Sex and death are erased."[29]

We spend billions maintaining that strange country. Pollution of waterways from pesticide use is increasing—especially in cities. Overall, the proportions of urban streams contaminated with one or more pesticides that exceeded an aquatic life benchmark increased from 53 percent between 1992 and 2001 to 90 percent from 2002 to 2011.[30] Space can also be isolated by virtue of toxins that discourage connectivity. Brownfields, large and small, persist as problems everywhere, blighting neighborhoods and poisoning groundwater. (At one extreme, the great ocean garbage patches might even be considered orphans—areas in the ocean increasingly populated by plastic waste and being deprived of more diverse connectivity as a result.)

More recently, the production and maintenance of orphaned space are coming into focus as people confront lack of green and open space in an increasingly urbanized world, social isolation, economic inequity, gentrification, urban heat islands, flood management, and food insecurity. We're amassing increasing data about, for example, the role of trees in combatting heat islands and boosting mental health,

and how capturing rain where it falls can ease the burden on increasingly overwhelmed stormwater infrastructure. New ideas are being generated about how to create spaces that grow things, including food, and that also improve public safety, biodiversity, food sovereignty, and more. The dearth of meaningful and welcoming open space became painfully clear in the pandemic-related lockdowns beginning in 2020, with billions of city dwellers stuck at home and limited space outside within which to be safe.

Looked at holistically, the spaces of our public infrastructure, which can be aqueous and atmospheric as well as terrestrial, represent enormous challenges and, correspondingly, opportunities. Many of the water and sewer systems in the Great Lakes region are over 150 years old, for example, and with system expansion prioritized over maintenance, the costs of protecting drinking water and the health of streams, rivers, and lakes are increasingly overwhelming. There is a politics to the geography of orphaned spaces and neglected infrastructure; their distribution negatively impacts some people more than others. Louisville, Kentucky, for example, has lost an average of 54,000 street trees *a year* to development, storms, pests, and old age, leaving it with a tree canopy of 37 percent, well below other cities in the region. The resulting urban heat island effect raises temperatures by more than 10 degrees in the city, with poorer, and less green areas of town seeing the highest temperature increases. Long-term neglect of infrastructure exposed already disadvantaged Houston residents to increased risks from flooding, and across many U.S. cities, the neglect of parks and street trees and a concentration of heat-producing asphalt coincides with lower-income neighborhoods.[31]

Orphaning is a generous category, perhaps overly so. But at the risk of too general a concept, I want to suggest a conceptual continuity allowing us to glimpse a radical position in which all land contains and exhibits life and potential. There is no such thing as wasteland.[32] When we deny the anonymity of land or territory, we step toward alternative land imaginaries—ones with new inhabitants, visitors, and relationships. As Ukeles understood, the practices of orphaning space reveal value-laden hierarchies that denigrate landscapes of maintenance and care and allow (some of) us to pretend to escape responsibilities of our own social reproduction. The combined pres-

sures of urbanization and the unpredictability of climate change are creating chaos, but also opportunities for new relationships to our structures of maintenance that might serve more of us better. At the root of this project to love orphaned space is a new vision of how to better dwell on Earth.

I've explored orphaned spaces in Fargo, North Dakota; along the Arizona-Mexico border; and in Madison, Chicago, and New York. My tour guides have largely been artists, challenging the forces that create orphans and pulling in new actors, building new networks and alliances, and causing trouble for the institutions dedicated to maintaining business as usual. By working in orphaned spaces, it seems to me that the artists create opportunities for moments of transcendence—an expanded awareness of existence—even as they tackle everyday, on-the-ground problems. Motivated by feelings of care and responsibility, they work across technical and scientific boundaries and rethink cultural heritage. They investigate the emotional experiences of different landscapes, exposing wounds of racist, exclusionary human histories as well as buried ecological tales.

In Chapter 2 I share ways that urban "voids," to use Barad's term, have been written about in the context of the environment, urban space, and infrastructure. I write about the skills and tactics of revisioning our dwelling spaces as part of efforts to rethink our "right to the city," following Henri Lefebvre, and building new networks via a process I call, following Isabel Stengers, the "diplomacy" of art. I argue for the role of care in generating new heterogenous assemblages, or publics, around concern for orphaned space. I aim to be specific, to go beyond the idea of an easy, "natural" conviviality in order to pull into focus the human and other-than-human labor of building networks.[33] Toward that end, in the second chapter, I posit three proposals or conditions for loving orphaned space, which I return to in each of the following chapters to help organize my thinking about this kind of endeavor.

Chapters 3 through 5 feature three case studies—from Chicago, the Bronx in New York City, and Fargo respectively—of different artist-scientist and community collaborations that address the orphaning of space. I use each case study to explore cross-cutting themes about urban space, right to the city, caring for Earth, and

thriving amid insecurity.[34] I tell the story of an abandoned gas station lot on Chicago's South Side—the site of School of the Art Institute of Chicago sculptor and professor Frances Whitehead's project *Slow Cleanup*, which she described to me as "just the right speed." I discuss how she reorients research in phytoremediation—the use of plants to clean polluted soil—to include factors related to human-plant relationships and environmental injustice. Her work literally pulls long-buried pollution into view in a grand gesture, offering an opportunity to reflect on automobiles, gas stations, redlining, and the petroleum industry. Working to put artists' knowledge to practical use to a city agency, Frances challenges the conventional categories of urban zoning to create a palette of possibilities. Abandoned transportation infrastructure, she shows us, is part of our cultural heritage. Telling the tale of this artwork weaves together a history of gas station economies, the unevenness of Chicago's real estate market, the travesty of leaky underground storage tanks, giant soil hydrocarbons, and plants playing alchemist with phytoremediating microbes.

The Bronx River in New York, once a summer destination for people living nearby, was, in the second half of the twentieth century, both literally and figuratively disappeared in the South Bronx by development, pollution, highways, and the role of the borough as waste site for the New York metropolitan area. In Chapter 4, I introduce artist Lillian Ball and describe how her work builds on a long history of resistance in the Bronx to grassroots environmental injustice and how, through her *WATERWASH* installations in New York, she aims to offer a systemic solution to gnarly urban hydrology problems encountered in cities everywhere.

In an almost ironic juxtaposition with the neighborhood's urban grittiness and concrete perpendicularity, Lillian Ball's project is sparkle and curves, a fantastical interruption of business as usual. The artist's project creates a stage from which people can view a working performance of plants "caring" for the city. This is not just an intellectual reckoning but an effort to bring spectacle, sensuality, and new relationships to the Bronx River as it makes a reappearance. The space opened by her project requires a slowing down of both people and water, creating opportunities for residents to connect to

a river made invisible by conventional infrastructure. The creation process is not straightforward; relating the unfolding of the project reveals how this work pushes against the grain. I rely on Isabelle Stenger's notion of "the diplomat" to argue for the role of art in bringing actors together in projects, including humans and nonhumans too often ignored.

In contrast to the slow-moving and homogeneous snowscape presented to us in the Coen brothers' movie *Fargo*, I found the city a diverse and tumultuous place. In Chapter 5 I chart Fargo's uncomfortable relationship with floodwater and the tremendous amounts of human energy and concrete dedicated to taming the Red River of the North. I describe how artist Jackie Brookner was brought to Fargo to help city residents practice "creative agency" in rethinking the giant stormwater basins that dot the city. Her efforts helped expose surprising disconnections in these spaces—not only to water but to "New Americans," as they are referred to in Fargo—refugees brought to the city from places so devastated by war that there is no longer a home to return to. The art confronted the "livability" problems of a stormwater basin and at the same time pushed the city to face its challenges in truly welcoming refugees and the diverse cultures they represent. The artist and her colleagues created occasions for the diverse inhabitants of Fargo to encounter each other and to engage in an expanded range of sensorial experiences with land, plants, animals, and water as active participants.

In the final chapter, I follow my friend John into another orphaned space, this time a farm field. He begins our walk describing how glaciers formed the rolling, yin-yang shape of the land and speaks of decades of row cropping that also shaped what we see. His vision for this space provides entry into concluding thoughts on the efforts of environmental artists and others in challenging current frames for our use of Earth, especially as we create spaces dedicated to our own maintenance. I describe the ways this work offers a feminist challenge to fractured geographies and to societal mores that separate off working space as lesser. I discuss why artists have been well suited to take advantage of a moment in time when openings to "love" orphans present themselves. I revisit my three conditions for loving orphaned space and summarize the contributions of this work in redirecting

the science and technology of infrastructure to address systemic problems like abandoned gas stations and racially fragmented public spaces. I consider the issue of precarity, a dominant theme in so many of these efforts, and discuss how anyone might go about loving an orphaned space. The expansion of our narratives about what can happen in such spaces is key, reflecting opportunities for two-way relationships—including with animals, plants, water, wind, and other environmental players—even at a time when so many possibilities appear to be increasingly risky or shutting down.

In their capacity for expanding sensitivities to orphaned space and their fearlessness in taking on new knowledges and diverse skills, artists have charted adventurous paths in orphaned spaces. Their stories help us see territories to reclaim and cherish as part of a whole that sustains us all.

2

Caring in Orphaned Space

> After the revolution, who's going to pick up
> the garbage on Monday morning?
>
> —MIERLE LADERMAN UKELES,
> *Manifesto for Maintenance Art 1969!*

> Resistance and change often begin in art.
>
> —URSULA LE GUIN, speech at
> the 2014 National Book Awards

As a girl, M. Jenea Sanchez ran back and forth between her house in Agua Prieta, Sonora, and that of her aunt, who lived nearby. That she crossed an international boundary, she tells me, never entered her mind. We are having lunch at a café north of downtown Douglas, which sits on the Arizona-Mexico border. Jenea recalls that a fence was built along the border at some point in her childhood and that when she was in high school, sometime in the 1990s, the fence was reinforced, becoming taller and more formidable. She remembers U.S. president Bill Clinton launching his "tough on drugs and immigration" efforts, passing the Illegal Immigration Reform and Immigrant Responsibility Act of 1996, for example. Steel fencing was extended miles out into the Arizona desert from the centers of Arizona border towns like Douglas, Nogales, and Naco, and high-intensity lighting was added. Border Patrol agents increased more than sixfold. Working together, the fortifications pushed undocumented border crossers into more remote areas, and more people died, the desert an increasingly lethal landscape.

After the attacks of September 11, 2001, Jenea Sanchez saw the U.S.-Mexico border fence in her backyard undergo a third metamor-

phosis. President George W. Bush more than doubled border security funding after the attacks, reaching $10.4 billion in 2006, and signed the Secure Fence Act, which called for 700 miles of new pedestrian- and vehicle-barrier fencing. To accomplish this, the Department of Homeland Security waived the Endangered Species Act, the Wilderness Act, the Archaeological and Historic Preservation Act, and dozens of other environmental and cultural protections, the largest dismissal of law in U.S. history. Migrant deaths along the Arizona border jumped from 104 in 2001 to 271 in 2005, and those are just the recorded ones.[1]

Waves of xenophobia and fear sweeping the post-9/11 United States crashed down in border towns like Douglas. The fence was reinforced with 18-foot-high metal slats repurposed from the decks of aircraft carriers. The new fence, as it ran through Sanchez's desert town, was spotlighted at night, and government agents took control of a 60-foot-wide strip of land adjacent to the fence, which they cleared and patrolled. Jenea Sanchez and others still crossed to see relatives, of course, but only through increasingly militarized, official ports of entry.

During the Trump administration, the physical armoring of the border moved into another, much more monumental phase: the border wall as a defining symbol of a nationalist, xenophobic presidency. Towering concrete and steel structures lurch across new areas of the Sonoran Desert, obliterating hillsides of vibrant and resilient wildlife, sundering Tohono O'odham tribal lands, and endangering desert oases.[2] There is no regard for water or migratory animals, not to mention border cultures. Posted to the border in the summer of 2018, in anticipation of a never-realized vision of hordes of caravanning immigrants storming the border, the U.S. army, with little to do, wove rows of concertina wire through the iron slats of the fence as it ran through quiet neighborhoods in Ambos Nogales, a town straddling the border about 100 miles west of Douglas.

Jason De Leon, in his book, *The Land of Open Graves*, writes about how U.S. border policy activated the desert landscape as a mortal partner. The desert has been engaged to turn the borderlands into a violent and repellent space, he writes, "a strategy that largely relies on rugged and desolate terrain to impede the flow of people from the

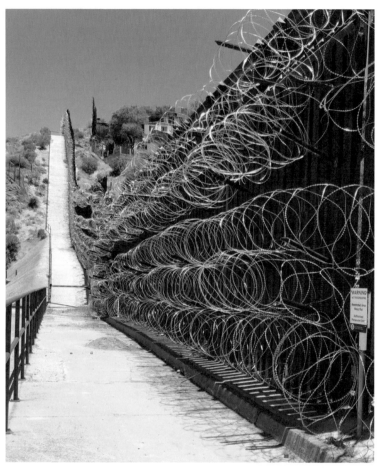

Figure 2.1 Posted to the border in 2018 in anticipation of caravanning asylum seekers from Central America, the U.S. army, with little to do, wove rows of concertina wire into the border fence as it ran through quiet neighborhoods in Ambos Nogales, about 100 miles west of Douglas. (Reprinted by permission of Veronica Gonzalez.)

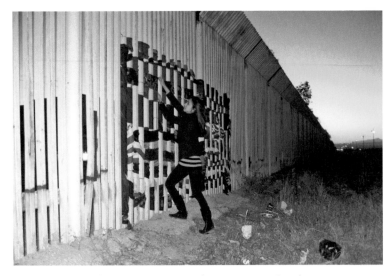

Figure 2.2 *Border Tapestry*, 2008, by M. Jenea Sanchez. (Reprinted by permission of M. Jenea Sanchez.)

south." He argues that the U.S. government—more specifically, the Border Patrol—has intentionally set the stage so that other actants—the heat, arid climate, and rugged terrain—can do "most of the brutal work."[3]

Thousands of migrating people, many never identified, have lost their lives in the borderlands. And every layer of border fortification further erodes cultural, familial, and social networks that have long defined the border region, as well as threatening plants and animals that make the borderlands home.

In response to the policies and programs that orphan and police the border as dangerous or empty, Jenea Sanchez occupies.

For *Border Tapestry* (2008), the artist borrowed fabrics belonging to her mother, an American citizen, and her grandmother, who is from Mexico. She wove the colorful cloth back and forth through slats in the iron fence, displaying the "interdependence of the generational fabrics, tied together to remain united," and transforming the fence-as-barrier to a supporting warp in a tapestry of her family.

In *Tapiz Fronteriza de la Virgen de Guadalupe: Healing the US-Mexican Border* (2009), Jenea Sanchez and her collaborator, Gabri-

ela Muñoz, made paper out of plants growing along the border. They painted images of Our Lady of Guadalupe on both sides of 12-by-8 pieces and wove them through the border fence—a reminder, she says, that the border is culturally rich, valuable, and even a sacred place. Over time, the paper slowly disintegrated, returning the fibers to the earth that originally sustained them. The borderlands are celebrated as a creative, regenerative place.

In subsequent years, Jenea Sanchez, married to Douglas's mayor, frequented the space as a representative of the city administration, working to connect the cultural life of her town and its sister city of Agua Prieta, Mexico. She aimed to celebrate the two countries and cultures and reveal the border as a multidimensional space. It has a history and living human and nonhuman networks that persist, even under the surveillance and suppression of a state working to sever connections and orphan the space.

Working with her counterparts on the other side of the fence, she helped host festivals to celebrate cross-border connections. Participants pulled up chairs and played chess through the slats. Musicians positioned on either side created music together. For one event, artist Ana Teresa Fernández painted sections of the fence blue so it blended in with the enormous desert sky above, making the barrier visually disappear. At another binational event, artist Lauren Strohacker projected images of border wildlife on the fence, a reminder of the jaguar, pronghorn, rabbits, quail, and other desert dwellers who make the border region home and whose migrations are disrupted by the increasingly formidable barrier.

Jaguar once resided in the southwestern United States, but they retreated to the mountain wildernesses of northern Mexico decades ago as ranching and development pushed them out of Arizona. Occasionally, adventurous jaguars make their way north, and when their images are caught on motion-triggered cameras set out by hopeful wildlife scientists, communities celebrate that jaguars might someday again reside in the mountains of the southwestern United States. Every reinforcement and addition to the border fence diminishes that possibility, but people still hope.

"The majority of our community along the border see themselves as one," Jenea told me. "Our binational connections are not only ec-

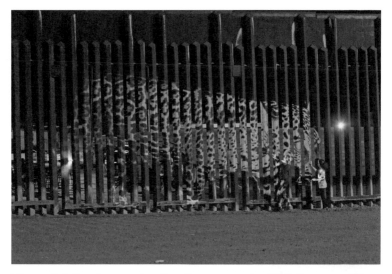

Figure 2.3 *Un-Fragmenting/Des-Fragmentando*, 2017, by Lauren Stro-hacker. Binational projection of images of foxes, rabbits, ocelots, and other migrating wildlife threatened by the U.S.-Mexico border wall. The project was made in collaboration with the Northern Jaguar Project and supported by Border Arts Corridor of Douglas, Arizona; the Mexican art organization Casa de la Cultura; and the Mexican environmental educa-tion organization Conciencia y Educación Ambiental. (Art by Lauren Strohacker and photo by Kendra Sollars, reprinted by permission.)

onomically driven. We are interconnected by our ecology, family, and culture." Jenea Sanchez feels the emptiness maintained by the Border Patrol as a betrayal of historical connections as well as the potential for new ones. She knows this political line intimately, her own feet having crossed it innumerable times as she has moved between fam-ily households. Her work pulls our attention to the border, pushing back against narratives of it as impenetrable and dangerous with sto-ries of it as a connected homeplace, full of people and other beings, their cultures, struggles, and memories.

As part of her work *The Mexican Women's Post Apocalyptic Sur-vival Guide in the Southwest: Food, Clothing, Shelter, y La Migra* (2017 and ongoing), the artist has created a large-format portrait series of "survivalists," women who made their way to the borderlands from

Figure 2.4 *Lupita*, from *The Mexican Woman's Post Apocalyptic Survival Guide in the Southwest*, 2017, by M. Jenea Sanchez. (Reprinted by permission of M. Jenea Sanchez.)

further south and are now living in Mexico needing to invent new ways to make a living.

"It's about food, shelter, livestock, but also surviving *la migra*," she tells me about the women who gaze out from their portraits, their hands wrapped around seed packets, baby chicks, cell phones, garden tools, and rabbits. "It celebrates the women's stories and their survival skills in the desert. My work makes visible their survival, and asks: At what point do you decide that, because of hunger or violence, you are going to attempt to cross the border? We need to consider, as fellow human beings, what drives a person to make that decision."

Jenea Sanchez sought to blend her role as an ambassador for Douglas, building connections with the bustling town on the "other side," with her work as an artist, occupying a space broadcast to the world as barren and dangerous. "Resist the orphaning," demands the work of Sanchez and her collaborators. Their work refuses the anonymity

of an international border, offering instead a region rich in cultural legacy, personal memory, and a breadth of human and other characters with diverse stories and struggles.

How do we think productively about disappeared spaces and the processes of orphaning that maintain them, void-like? On what occasions do they become more—and less—visible to us, and importantly, what types of contexts allow for new and meaningful engagements?

My tour guides into orphaned space expose the norms and policies that produce it and reveal how much territory is maintained (expensively) as only partially alive, partially connected. Their work exhumes history, memory, and the pain of lost connections and explores new relationships that might emerge. Sanchez, like Ukeles, challenges the value-laden distinctions made between spaces of maintenance and those we imagine can be a source of transcendent feelings of connection. She offers an invitation to consider how specific places of maintenance are already meaningful to us. If you, or someone else, cares about a space, no matter how small, degraded, or dangerous, perhaps that's the beginning of an important relationship. Sanchez cares about the border, embracing it as a place of memories and different forms of life. Her work challenges the orphaning, gesturing to how such disciplining tramples personal narratives and destroys the survival strategies of different beings as well as symbolic places of origin.

In a parallel vein, Val Plumwood writes about what she calls the "culture split"—attitudes allowing us to honor a singular celebrated "homeplace" on one hand while ignoring and devaluing the multiple origin sites of our economic and ecological sustenance on the other. This conceptual split, she contends, allows a costly yet convenient lack of comprehension of the social and ecological consequences of our actions. We reveal the limits of our thinking when we single out and honor "home" places consciously identified with self while "disregarding the many unrecognised, shadow places that provide our material and ecological support."

We must own these "shadow places," Plumwood insists. "These places remote from self, that we don't have to know about but whose degradation we as commodity consumers are indirectly responsible

for, are the shadow places of the consumer self. The places that take our pollution and dangerous waste, exhaust their fertility or destroy their indigenous or nonhuman populations in producing our food, for example, all these places we must own too."[4]

Plumwood's ideas suggest we expand our geographies of "home." She credits the concept of "country" she learned from Aboriginal person Bill Neidjie, whom she quotes as saying, "You got to hang onto this story because the earth, this ground, earth where you brought up, this earth he grow you."[5] This country is a connected, active agent and coconstituter of our lives. Such concepts can help us link our "shadow places" near and far, suggesting we might be responsible to what sustains us and also that such connection may exert affective power. Deborah Bird Rose describes the Australian Aboriginal peoples' concept of brilliance or shimmer, an aesthetic response to a vibrant world. The brilliance is a kind of motion—an ecological pulse, that surges, grabbing you and connecting you for a moment to an emergent but ancestral power, as Rose explains.[6]

These ideas may seem far afield from orphaned urban infrastructure, and I am very cautious about misappropriating concepts from Indigenous thinkers. I share such ideas as provocation for those of us who dwell on Earth with a feeble sense of our own connection and responsibility to it. I see resonance with what motivates my tour guides making journeys into workaday spaces that, seen in a new light, "grow us." The explorers take on the challenge of connecting humans and others via projects that involve infrastructure as well as feelings, meaning, and inspiration. As I relate in the case studies to follow, such projects lure us in, offering a moment of brilliance, our attention captured and expanded.

I am not after some essentialized definition of orphaned space; instead, it's the ongoing disciplining of Earth I'm thinking about—a routine, often state-led generation of space, frequently in the service of infrastructure. What processes create and maintain such a magnitude of workaday space so effectively disappeared from our perception? And who bears most of the burden of their uneven geographies? Geographers have a great deal to say about the social production of space, of course. John Agnew contrasts notions of exchangeable "space" with what Italian geographer Franco Farinelli describes as

"place"—a "surface that is not equivalent to any other, that cannot be exchanged with any other without everything changing." Peter Jackson has observed that the terms space and place can seem rather primitive to geographers and others who dedicate themselves to studying "where and what" questions. Instead, he sees a perennial "tension" between place and space, which "requires continual reassessing . . . in light of a changing world, both material and of knowledge." Jackson views the state as a "space-producer," imposing spaces on places. The colonization of place and creation of the "void" that Karen Barad describes is the same state making in which, as Jackson writes, "worlds of non-European places were converted into new worlds of European spaces."[7] For Jackson such dynamics are in need of continual assessing. Spaces have a way of being transformed and claimed as places, and a place can be one's backyard; it can also be the entire Earth. Bringing orphaned space into focus does not automatically shift it from space to place, nor is "place" always an easily defined or desired end.

I'm interested in the dynamic nature of orphaned space, how it is produced and maintained but also how its order is challenged as it becomes tangled in new emotional, ecological, and other connections. It starts with the orphaning, the generation of exchangeable, disembodied space that is easy to ignore. As "empty" space it is possible to look past degradation and perceive disconnectedness as perfectly normal. I want us to recognize the ongoing churn of world making that produces orphaned space, as well as a resisting, generative set of impulses that flow in to inhabit, make new stories, and weave new networks. In "Walking in the City," Michel de Certeau describes how a city's formal order—reflected, for example, in "constellations" of official place names—can be worn away by the individual actions of those who walk between them. The footsteps open meanings and directions such that they become "liberated spaces that can be occupied . . . a poetic geography on top of the geography of the literal, forbidden or permitted meaning." As the stories I share in this book reveal, there is no clear before and after; orphaned spaces employed in the service of infrastructure remain working space. Furthermore, occupations of orphans are often temporary, produced by uneasy negotiation as much as radical transformation.[8]

I say more later in this chapter about Henri Lefebvre's concept of "right to the city." My thinking about orphaned space certainly benefits from his writing on the production of space as a "secretion" of society through which specific power relations and daily routines are maintained. Lefebvre describes the social activities that produce space: everyday routines, more formal planning and zoning efforts, and the maintaining of "representational" spaces, the latter "redolent with imaginary and symbolic elements" and rooted in history. He distinguishes two types of generated space: "abstract"—homogenized smooth spaces perceived according to their exchange value—and "differential," in which people privilege practical use and inclusiveness.[9] Describing the relationship between the two, Lefebvre writes that abstract space is "buttressed by non-critical (positive) knowledge, backed up by a frightening capacity for violence, and maintained by a bureaucracy which has laid hold of the gains of capitalism in the ascendent and turned them to its own profit." Abstract space also, however, "harbours specific contradictions. . . . Thus, despite—or rather because of—its negativity, abstract space carries within itself the seeds of a new kind of space. I shall call that new space 'differential space.'"[10] Abstract space, for Lefebvre, requires a tacit agreement and commonality of use—a "spatial consensus" to which all agree—and also contains a "texture" that affords opportunities to create alternative, more inclusive spaces.

What might this struggle look like, especially as it concerns shifting relationships with nonhuman beings and objects of infrastructure? Lefebvre acknowledged a material "underpinning" to the social activities that create space, and this book is all about refusing the notion of disconnected, dematerialized space in order to account for the material histories of all the territories we inhabit and the geographies of all our shadow places. In her book *Vibrant Matter: A Political Ecology of Things*, Jane Bennett writes about materiality, and how she uses "a touch" of anthropomorphism to move beyond ontologically distinct categories of beings in order to apprehend "variously composed materialities that form confederations." As I've written about elsewhere, those confederations can be elusive and confusing, and we turn to narrative to organize our understanding of what is going on and to motivate and organize action.[11] I'm attempting to un-

derstand not just any relationships, but specifically caring—action in orphaned space based on a sense of obligation and belonging. Bennett describes her project as driven by the goal to theorize a strange "attraction"—what she calls, at one point, "an irrational love of matter."[12]

Caring is not easy. Policy scholar Deborah Stone argues that in contemporary definitions of human care, while we have a clear sense of private care—the intimate efforts among people who love one another—public care is on the other side of a deep chasm that separates our hopes from our nightmares. Dependence and care are a "badge of shame" in our society, she observes. "Simple words like love and care are notably absent from the public vocabulary."[13] Stone dissects the negative implications of care policies that emphasize data, efficiency, and managerial oversight and suggests that the frontline care work (relationship building, honoring a sick person's identity and sense of self, and attending to the moves and needs of each unique body) should be appropriately recognized and paid as "at the top" in a hierarchy of work. She also tackles the division between physical and emotional labor, offering "caring communities" that might provide the security of public responsibility and protection but also the warmth and intimacy we imagine and often practice in families. A missing but critical element in discourses about care, Stone says, is the acknowledgment of love. "Love is not a word that rolls easily off the tongue in policy settings," she writes. We are terrified of its suggestion of unbounded compassion and giving, not to mention the unprofessional implications. Nevertheless, love—caring *about* someone not just *for* them—has a way of showing up uninvited, she observes, as a significant element for many frontline caregivers for whom the work turns into a labor of love. Love is an emergent property, generated by interactions with someone or something.

Journalist Madeline Bunting argues that caring is "countercultural." In our societal fixation on individual independence, achievement, and goal-driven hyperactivity, care—both receiving it and providing it—is associated with low status. And providing it is predominantly an activity carried out by women. Bunting looks to Western literature and philosophy for insights into the fraught na-

ture of our relationship with care. She relates how, in Goethe's *Faust*, the protagonist obtains wealth and power after a pact with the devil until a couple in his kingdom are murdered. He encounters an old woman, who calls herself "the eternally anxious companion" and who chides Faust for "never having known her," or feeling compassion for his own people. As punishment she takes away his sight. Care is complicated, Goethe's story tells us, and while dependence, needing it, may invoke fear, refusal to care is blinding.[14]

How to practice more care? How to extend our feelings of care beyond other humans to include Earth and other beings who dwell and depend on it? It's nearly impossible, in this era, to ignore the importance and vulnerability of the planet we all live on together. How we can commonly care for it, however urgent, is often an anemic discussion, dwarfed by a discourse of technical metrics and "managing" impacts.[15] We converse in the bureaucratic language of efficiencies and the technicalities of inputs and outputs. We hold back attention from what might compel us to love and be care-full, distracted by a profit-driven adaptation of science and technology to clean up after care-less behaviors.

Bunting also discusses *The Great Gatsby,* describing it as a tale of recurrent American anxieties, in which "carelessness reveals corruption." Gatsby chases an ultimately destructive dream involving someone who is careless toward him. Pulling a dusty copy of *The Great Gatsby* from my bookshelf, I was reminded of Fitzgerald's description of the valley of ashes—an orphaned space whose description in the book precedes the entrance of someone else, also fruitlessly chasing such a dream.

> About half way between West Egg and New York the motor-road hastily joins the railroad and runs beside it for a quarter of a mile, so as to shrink away from a certain desolate area of land. This is a valley of ashes—a fantastic farm where ashes grow like wheat into ridges and hills and grotesque gardens where ashes take the forms of houses and chimneys and rising smoke and finally, with a transcendent effort, of men who move dimly and already crumbling through the powdery air. . . .

> The valley of ashes is bounded on one side by a small foul river, and when the drawbridge is up to let barges through, the passengers on waiting trains can stare at the dismal scene for as long as half an hour. There is always a halt there of at least a minute and it was because of this that I first met Tom Buchanan's mistress.

There are resonances here between the people and places Fitzgerald chooses to produce for us, both damaged by carelessness.

Revealing the systematic undervaluing of care work has long been a feminist endeavor. Cindi Katz wrote about the "fleshy, messy, and indeterminate stuff of everyday life" to describe the nonwaged labor of social reproduction and how this important caring of people such that they are "produced" for the workforce is a social contradiction deep in the workings of capital. Nancy Fraser similarly observed how capitalism "systematically" undermines our capacity for social reproduction, linking it into a "general crisis" of care that encompasses economic, ecological, and political strands, all of which intersect with and exacerbate one another. Feminist work has also explored care as political strategy and a source of critical inspiration for imagining a better future. Focusing on the survival tactics of migrant laborers in the United States, geographer Altha Cravey writes that "shifting our perspective to the microgeographies of social reproduction gives us the tools with which to imagine alternative models of globalization that might spring from more egalitarian social relationships, from social and economic justice ideals, or directly from creative translocal ways of living and self expression." In her book *Matters of Care*, María Puig de la Bellacasa works the notion of care to expand beyond a focus on the human world to discuss our necessary and omnipresent entanglements and interdependencies with nonhumans.[16]

These arguments illuminate care as the always-necessary-yet-taken-for-granted work of nurturing and maintaining. They also provide a framework for understanding care as a site of resistance and a source of inspiration and, potentially, action. Orphaned spaces become literal grounds for struggle, where there are opportunities to ask and answer differently questions about the value of the space, and what care entails.

Building new relationships of care can run counter to other structures. Take, for starters, our established frameworks for understanding vacant and open spaces in cities. Urban scholars have created typologies of abandoned lands resulting from a retraction of industry and manufacturing and outmigration, for example, or the sloppy bits left over from conventional planning and development. Fun terms include "temporarily obsolete abandoned derelict sites (TOADS)" and "zombie properties," as well as "marginalia," "liminal space," "dead space," "stalled space," and "terrain vague."[17] Such spaces are often viewed as unfortunate remnants, mistakes from unforeseen impacts of planning. Assumptions follow that better planning, creative green infrastructure, equitable policies, and better block design can all be deployed to disappear urban orphan spaces, connecting them as functioning elements in a well-ordered city. Left untouched are questions about the deeper impacts of lack of emotional connections between ordinary people and the spaces around them, limited community control over public space, the dominance of private property regimes and real estate markets in planning—the burdens of which have fallen most heavily on people of color—and especially weak and uneven investments in public space.

Critically, vacant spaces are materialized geographies of racism and classism. Anne Whiston Spirn worked for years to "read" Mill Creek, in west Philadelphia, investigating why certain areas prospered while others crumbled and remained vacant. Observing a broad band of vacant land and buildings following the course of an undergrounded stream, she established that the area was a floodplain, causing many homes built there over the years to flood and crumble. Lack of investment in the area fueled by redlining and misguided urban "redevelopment" projects maintained the persistence of empty and weed-filled lots, despite local attempts to organize, as successive city-led efforts attended only to superficial drivers of the emptiness.

Spirn reminds us that in trying to read any orphaned space, we must observe what is present and work to unearth influences in the past and across distances. "People mold landscape with hands, tools and machines, through law, public policy, the investing and withholding of capital, and other actions undertaken hundreds or thou-

sands of miles away," she writes. "The processes that shape landscape operate at different scales of space and time: from the local to the national, from the ephemeral to the enduring."[18]

Orphans are everywhere, routinely produced yet rarely making an impression. How have we learned to live with them in such comfortable myopia?

Infrastructure, historically, has been designed to be supremely efficient, to remove personal responsibility for the humdrum of providing one's basic needs. Large-scale infrastructures (and their accompanying administrative support) managing water, electricity, and transportation were once seen as great levelers, creating a consistently defined and valued subject. Each independent individual is purportedly provided the same set of supporting services, freeing them up to pursue (a particular type of) freedom. In the first half of the twentieth century in the United States, progressive ideals of technical efficiency, public administration, and democratic process helped shape a national infrastructure "rollout" along with the emergence of expert-based bureaucracies to support them. Access to knowledge about infrastructure, resource management, and distribution became associated with schooling, licensing, exams, and particular sets of experiences, all dovetailing with the Progressive Era's faith in science and technology to rationally solve problems. Municipalities created nonpartisan commissions to handle infrastructure, and applicants for city jobs had to pass exams. Experts used increasingly specialized language, and urban bureaucracies became girded by legislative mandates around sets of standards and other requirements. Even as the policies of the time created structures for local engagement in urban planning via referendums, town halls, and primary elections, a sociology of expertise sidelined and stymied hands-on grassroots involvement. Participatory structures were fettered by assumptions about what useful knowledge sounds and looks like, as well as a culture that disenfranchised local knowledge.[19] Infrastructure enables many of us to sustain ourselves and move about, free to produce and consume in a formal economy. We don't necessarily want to see our supporting infrastructure, nor do we quite have the time for it. "We are used to others doing things to take care of us," says my friend Lou, a landscape architect and promoter of what he calls "little *a*

architecture." He has dedicated his work to community-led urban design and alternative building technologies like straw-clay construction. "We get comfortable, until something goes wrong, but then we don't know how to participate," he says. The price has been the cost of knowing how to engage in and defend robust public participation in public space.

I think about Jane Jacobs's *The Death and Life of American Cities.* A close observer of the spatial gangrene of the late 1960s urban body, riven by new highway construction, she despaired about top-down "planning theory" and advocated for more attention to "a most intricate and close-grained diversity of uses that give each other constant mutual support. . . . The science of city planning and the art of city design, in real life for real cities, must become the science and art of catalyzing and nourishing these close-grained relationships." As Frederick R. Steiner observed in *The Living Landscape*, planning in the United States, with its legacy of private property protections, remains a fragmented effort, undertaken primarily by powerful vested business interests. Planners in the United States, he writes, tend to be either "realist" administrative planners, who work within existing governmental and bureaucratic structures (often to the detriment of the less well represented), or "adversary" planners, who tend to work "outside," with community groups organizing around issues such as, for example, resisting a controversial highway project. They may win battles but lose against the persistent onslaught of the machine of profit-driven urban development. In *The Geography of Nowhere*, James Howard Kunstler painfully details urban America's death by countless injuries from out-of-control, cookie-cutter urban development: "Eighty percent of everything ever built in American has been built in the last fifty years, and most of it is depressing, brutal, ugly, unhealthy, and spiritually degrading." Parking lots are the quintessential orphaned spaces by virtue of their design to do just one thing. In *ReThinking a Lot*, author Eran Ben-Joseph describes parking lots as the "most salient landscape feature" of our cities, with tremendous impacts on the experience of pedestrians and on viewsheds, not to mention increasing polluted runoff and heat islands.[20]

These expectations of infrastructure as holistic, independent systems, designed for efficiency and managed by experts to facilitate

Figure 2.5 Satellite images of Toledo, Ohio, which has some 41 percent open space according to the *Atlas of Urban Expansion*, reveal the dominance of parking lots downtown (*top*) as well as a plethora of vacant lots but little public open space in the neighborhoods to the west (*bottom*). (Reprinted from Google satellite view.)

industrial and commercial activities, lead us to routinely create isolated spaces, defined by a narrow functionality that is, ultimately, unfriendly to human health and wellbeing. We have parking lots for stationary cars, we have city parks for limited recreation, we have train tracks and stations for transportation between destinations, we have streets for moving cars, and we have catchment basins for rainwater running off streets, roofs, and other hard surfaces. And typically, these places don't do anything other than what they are, often

exquisitely, designed to do. In the name of efficiency and our faith in technical expertise, we routinely dedicate large amounts of territory to a single function and its management to a group of experts based "somewhere else."

So, as Lou points out, many of us, our basic needs met, get comfortable. We expect that system to perform homogeneously across time and space, and we become upset when there are surprises. Anything that wasn't "planned in" to a space can become constructed as a "foreigner."[21] And our lack of practice with engagement has meant our imaginations are flabby, our patience fragile, and our awareness of problems masked. And this is a vulnerability. Because even as we are now much more skeptical about the modernist promises of the rational city, and more aware of uneven distribution structures for safe water, electricity, traffic, oil, information, and other services, as well as hidden social and ecological consequences of anemic and policed public spaces, as Anne Spirn revealed, we are less prepared to act. Furthermore, building new relationships of care is precarious; projects to reimagine public space can flower briefly and then wither, vulnerable to a shift in public administration and funding; to a lack of community connection; to water, plants, and animals that refuse to cooperate. Whether it involves working with city agencies or acting as guerilla gardeners, those who occupy orphaned space and struggle to create meaning there frequently see their efforts evaporate. Community gardens, for example, often suffer from lack of long-term, stable funding; a low profile in formal urban planning; and vulnerability to profit-driven property markets. They also struggle because of blindness to the diverse care work on which they depend, the specifics of which are often invisible to those in decision-making capacities.[22]

But now is a good time to keep at this project. Infrastructure is emerging from the shadows.

Writing about the fiscal disasters and neoliberal "rollback" after the financial crises of 2008, scholars described the "splintering" of cities and the emergence of more individualized, often privatized governance regimes, as the state retreated from commitments.[23] Extreme weather and shrinking financial support for repairs and upkeep compounded the problem so that, in cities everywhere, once taken-for-granted urban infrastructures became increasingly de-

scribed with words like "broken," "fragile," "vulnerable," and "uncertain." But in the ensuing decade, increased pressures of urbanization and its uneven impacts on the disenfranchised have made infrastructural spaces even more precarious. And for many, the notion of a dependable, formal infrastructural configuration has never held water. The work to bring orphaned space into focus as potential sources of empowerment maps well onto political struggles over access to infrastructure. Looking at the extension of urban water supply outside Durban, South Africa, for example, Alex Loftus and Fiona Lumsden argue that the expansion of a formal water network, while it opened up territory for the consolidation of power, also deepened and widened oppositional networks. And often a heterogenous range of connections and processes characterizes infrastructure more than a single system. In Delhi, India, where the central water supply infrastructure reaches less than half the city's residents on an everyday basis, Yaffa Truelove describes "gray zones" of informal networks, technologies, and governance structures by which many people obtain the water necessary to live. Writing about the exclusionist logics of modernization efforts in the city of Kinshasa, Democratic Republic of the Congo, Filip De Boeck describes how in order to survive, a disenfranchised resident must "socially position oneself within as many different collectivities as possible." The official urban politics threatened these overlapping supportive networks, however, "orphaning" many urban residents by defining them as out of place in a more "modern" urban environment. He describes the government's efforts (rounding up "vagabonds," clearing away informal housing, destroying community gardens, replacing trees with high-speed boulevards) as an "attack on precisely that crucial creative capacity which is a *sine qua non* to belong, and to belong together, in the city."[24] His example shows how the disciplining of a city toward a neoliberal ideal is the same blade that orphans humans and space.

This resonates with how geographer Mark Purcell writes about Henri Lefebvre's notion of right to the city: "Lefebvre sees the right to the city as a struggle to 'de-alienate' urban space, to reintegrate it into the web of social connections."[25] Lefebvre saw specialization and compartmentalism destroying the life of cities, and offered the no-

tion of "autogestion," a taking control of the management of produc-
tion. "The right to the city is necessarily also a claim for autogestion,
and vice versa," writes Purcell. He is particularly concerned that such
claims, as envisioned by Lefebvre, go "beyond" the state rather than
seeking better integration with it: "Participation means inhabitants
increasingly coming to manage the production of urban space them-
selves. As they engage in real and active participation, their own col-
lective power is revealed to them, and they increasingly understand
themselves as capable stewards of the urban and its collective life."[26]
At the end of this chapter, I lay out three conditions for this "active
participation" in the production of space. In the stories shared in this
book navigating beyond the state is not so much a refusal to engage
as it is crafty interaction. Building the capabilities to creatively and
independently occupy orphaned space involves transferring knowl-
edge and resources, and leveraging advantages from within the state
to assist those outside of it.

Equitable occupation and management of space is the key concern.
We lack public spaces where urban dwellers have opportunities to be-
have in ways not predefined by someone else's idea of what is appropri-
ate, especially behavior external to formal economic production and
consumption. Such behaviors often are relegated to ephemeral spaces
and times, rather than being anchored in our own lives via desire or
necessity. But the state is certainly not monolithic, and there is a wide
variety of tactics and strategies for resisting, negotiating, disrupting,
and expanding business as usual, all of which can be deployed to mag-
nify awareness of orphaned space and broaden imaginaries of how it
can be occupied. Purcell emphasizes that being capable stewards of the
urban requires imagination and daring to think about worlds not pos-
sible under current conditions. This is a kind of revolution, he ar-
gues, one built from everyday acts of resistance and creation.

Desire to participate is just a beginning. In comparative research
on urban trees in different Canadian cities, geographer Janina Kow-
alski has investigated the thicket of urban policies that limit public
engagement with public trees.[27] Looking at fruit trees in public spac-
es, she notes how conventional thinking about urban trees—revealed
in unfounded fears over damage to trees, accidental poisoning, pes-

ticide drift, and personal injury—has led to a lack of integration between people and the trees they live with. She offers a contrasting example from the Canadian city of Victoria, which sits on an island and has had previous experiences with food insecurity; city park staff, oriented to thinking about trees in multidimensional ways, are educated to work with people and help them "learn to care" about and for trees.

Describing the efforts of Seattleites to organize themselves to advocate for local control over open-space planning, geographers Andrew Karvonen and Ken Yocom describe a bottom-up "civic environmentalism." Residents' efforts toward "collective action," they write, emphasize the local scale as the venue for reworking complicated relationships between people and their material environments and a commitment to deliberative and action-oriented forms of political engagement. Far from producing community consensus, though, the process revealed a diversity of opinion—a reminder that deliberative democracy does not guarantee consensus, as some issues will always be contentious and intractable.[28]

Speaking about "the Fargo Project," which I delve into in Chapter 5, city planner Nicole Crutchfield described the ways artist Jackie Brookner challenged and altered standard city processes and policies as she sought to implement a community project around stormwater. At one point, Jackie wanted to pull a layer of concrete channelizing water at the bottom of a large stormwater basin in order to allow the water a freer flow. Her idea set off alarm bells; no one had attempted something similar before, there was no knowledge about potential outcomes, and city engineers had no way to evaluate the potential risks. "In search of a meander," is how the artist and planner jokingly referred to their efforts, which were ultimately successful but required years of conversations and data gathering to raise comfort levels about taking on the experiment. "There's red tape every step of the way," says Nicole. "So, the challenge is to find out what is the red tape? Why is it there? How to get around it? That's why these projects take so long to happen, they really rely on communication and relationship building."[29]

I think this is related to Lou's ideas of "learning how to participate" and a notion of care that exceeds a minimal definition of social

reproduction. What is the breadth of all that compels us to behave in caring ways? "It isn't taught in school," he says. "Everything you do is learning, all the mistakes, the attempts to communicate in a community when people don't agree." Lou calls this "design literacy"— the basic ability of each and every one of us to know what it takes to be involved in inhabiting the spaces around us so they bring us joy. "Place is key to identity, self-preservation, and empowerment," he says. "It's caring for you."

Orphaning processes differ across space. Such spaces are intentionally produced by the great structured metabolisms of wealthy cities as well as randomly produced by unanticipated occupations, the retractions of postindustrial towns, or the willy-nilly chaos of informal development. Working to "see" orphaned space and understand its potential for new relationships with our own maintenance requires a fundamental rethinking about how we live on and with Earth—especially, but not only, as urban citizens. It also requires acts of resistance. There are forces at work maintaining the void, as Plumwood and Barad have made clear, and claiming orphaned spaces as places that matter—and as stewards of the urban—means moving against the grain.

This is an important moment. As cities struggle to adapt, there's growing excitement about urban "greening" and multiuse infrastructure, working at multiple scales to manage an increasing breadth of "ecosystem services," such as flood management, air purification, water quality, beautification, supporting wildlife, generating energy, and growing food. Many of these approaches take a "systems" framing, working to embrace previously orphaned spaces and give them new life and purpose as part of a better-integrated and ecologically sensitive whole. And while many of these efforts, as part of discussions around concepts like resilience and ecology, may have been thin on the politics initially, proponents have increasingly embraced the "for whom, what, when, where, and why" of such efforts.[30] The goal of many such projects is to develop "good" urban ecologies.

But how do we decide what is good?

The "greening" of cities to address environmental justice problems has had the adverse impact of increasing housing costs and property values and creating a cascade effect toward gentrification

and the displacement of the very people the green space strategies were designed to benefit. Geographers Eric Swyngedouw and Maria Kaika argue that the implicit imaginary of nature that underlies much of the "ecologically informed" urban planning discourse is articulated around the myth of a primordial nature that is "inherently harmonious, balanced and dynamically equilibrated." The goal of sustainability, thus framed, becomes to "restore" some kind of society-nature balance. Chasing after the false notion of natural urban ecological balance leads proponents away from fundamental issues such as equity and access to rights, they argue. And in a real-world context in the era of climate change, a primordial nature has become a far less convenient partner in planning. Political scientist Timothy Luke similarly laments the hollowness of the term "sustainable city" and the rise of "merely revolutionary green capitalists, environmental entrepreneurs or well-trained managerialists." He notes that the term "sustainability" in its original seventeenth-century meanings implied a bearable or defensible activity. Thus, the slow violence of industrial development, as well as fast industrial disasters like Bhopal or Fukushima, he says, might be better comprehended as what the world has come to embrace as sustainable—that is, bearable—behavior. Geographer Bruce Braun similarly critiques the "soft infrastructures" that promise to work "with" nature to protect New York City's coastline from sea level rise. Proponents, he says, defend their approaches as part of "a long-overdue adaptation of urban life to the unpredictable rhythms of the ecological world." For Braun, however, this approach only leans further into a problematic top-down, outside-in ecological managerialism in which nature appears as an "object and means of government" and society and nature form a "single integrated system to be managed."[31]

The politics of orphaning need to stay in focus. What are the forces that orphan, and at what cost? And in occupying them, where do we look for ideas and inspiration and meaning? Importantly, how do we decide who and what is part of a good ecology? The stories I share here illustrate some tactics and strategies used by artists to broaden conversations and expose decision-making processes and make them more collaborative. This is not to be taken for granted. As these projects reveal, unexpected issues and participants arise

when one ventures into orphaned space. And while breaking down exclusionary structures is a broadly shared goal, "foreigners" challenge notions of easy coexistence—examples from the stories in this book include rainwater collected in a giant basin, hydrocarbons polluting soil, and refugees with limited places to gather together.

A tendency to view infrastructure as a whole, to talk about a "system" as a phenomenon that can only be addressed as an entirety, creates particular challenges.[32] One casualty of this tendency is the conclusion that no matter how bright the promise of site-specific grassroots efforts, without attendance to a larger balance of power and the organization of production, these projects will remain bright spots in an otherwise depressingly uneven infrastructure landscape. The possibilities of these spaces being reappropriated away from local control lurks in the shadows, fueled by a larger context of relations of production and property ownership and ignorance of the nature of the care work needed to sustain that control. The occupations of orphaned spaces I describe are plagued by precarity. Too easily, nurturing relationships grow thin, resources dry up, and outside forces sweep in and flatten what has been built.

I have begun to understand that using permanence and systemic impact to measure success may be part of a suspect drive for mastery, a search for a security related to some kind of final comprehension of and control over a "good" system. Instead, the experiences I share in this book reveal that despite risks, people care anyway. Examples abound of people working to care, currently and in the past; people stepping up to protect, connect, and build. History contains many powerful examples. In addition, each neighborhood or community faces its own set of challenges. There is no easy, one-size-fits-all approach, even as different communities resist forces working at much-broader scales, such as housing crises and deindustrialization. There is no way around the need to engage with each orphan as a particular place and moment.

One reason I want to share these stories is to build our confidence in our gestures of caring for Earth, despite the precarity and risk. The rewards, even if they feel fleeting, are important, generating our seed bank of ideas and experiences as well as the emotional flexibility for continuing to do the work. One very important point to make

along these lines is that many projects I describe are led by white people whose work exposes how orphaning has overwhelmingly negatively impacted people of color. I want to be careful. I don't share these stories as some kind of transferable model. The work of the white people I describe benefits from and builds on deep histories of fights for environmental justice by people of color. Nor am I advocating that people in disadvantaged and overlooked communities, already unfairly burdened with their role in maintenance infrastructure, should assume more labor as they "participate" in greening projects. I am proffering these stories in order to describe and honor the labor of care, and to help build a larger store of examples of how communities might benefit from more intimate relationships with wasted space around them. There are many community-led efforts springing up in diverse orphaned spaces, and I aim to add to the pool of stories and experiences as well as offer a broad set of ideas that might connect such efforts. Ultimately, I argue that building caring relationships in orphaned space is not a drain but a source of power.

My trips into orphaned space have woken me up. The void is visible, thanks to my tour guides. But there's a lot to occupying that is pretty messy. Working in such space has a way of uncomfortably dragging in what the "city" would rather ignore. Who and what are welcome? How do we acknowledge the history, especially if it is ugly or painful? And how should we think about future ecological partnerships when historical models are useless? If water, for example, is not one thing to all people, how should we recognize those different valences or characterizations in decision-making about management of a space? To take on questions like these, projects in orphaned space can become enormously, almost agonizingly considered—each one a work of science and art. Wrapped up in the design are questions about specific ecology and history but also bigger-picture thinking about cultural isolation, disenfranchised residents, siloed knowledge, landscapes shaped by racism, polluted stormwater runoff, and the urban costs of abandoned land and rivers literally disappeared as they are turned into waste corridors.

And such messy collaborations take time. What I call here the artists' "diplomacy" refers to the effort to pull diverse actors, includ-

ing many who are not human, into acts of creation they would not have been able to imagine otherwise. These places have unique contexts, histories, and complexities. Drop-ins and plop art don't work.[33]

To illuminate the nature of this work, I offer three conditions for loving orphaned space.

Condition #1: Reject the void. Following Ukeles, we can exercise a feminist critique of space "disappeared" by virtue of its role in maintenance work. We are encouraged to seek out the politics of the disappearing: where these spaces are located, why they disappeared, and who is served, and disserved, by that disappearance. We can reject the categorization of some land and water as "wasteland"—or even as just single-purpose "working" space not worthy of thought. We open up possibilities for new ways to pay attention and care, and we can have confidence that our caring matters, even when no one else seems to care.

Reading space is complicated and takes time. The job becomes to look beyond the routine creation of orphaned space and try to understand what is going on, even if it means engaging with uncomfortable histories, uneven geographies, and unbalanced ecologies. And as Anna Spirn laid out, orphaning occurs at different scales and time frames, and understanding what has been disappeared, how it is maintained in invisibility, and what might emerge is a multidisciplinary, long-term (in human time) venture. Some of the work is close in, as tight as a soil analysis. Other parts of the work are bigger picture, requiring investigations into the flows of a watershed or the layers of human occupancy from now to hundreds of years ago. How orphaned spaces are maintained by forces of development, urbanization, environmental management, and so on are all part of a bigger picture.

Condition #2: Practice "diplomacy." Occupying orphaned space moves against the grain of a disappeared infrastructure and involves a slowing down to account for the bits of plastic, Styrofoam, candy wrappers, polluted soil, layers of cement, and so on. It involves relationship building, enticing those not interested, or not accustomed to being heard or included, to participate—human as well as other

beings. It involves caring, engaging a variety of strategies to communicate, and practicing respect but also being crafty about how to work with participants of divergent interests to forge ahead even in the presence of contradiction and conflict. This is alliance building along the lines of what Isabelle Stengers has written about in the figure of the diplomat.[34] The work is one of making new connections where others do not see them. It also involves a creation and transfer of resources, tapping into where they exist and making them accessible where they are needed.

When it comes to expanding relationships with humans and other beings, as authors like Richard Louv in *Nature Deficit Disorder* and Douglas Tallamy in *Nature's Best Hope* have observed, many people have had so little experience with a diverse, robust natural world that there is little common knowledge and a lot of fear of the unknown. For Tallamy, even backyard experiences can help expand awareness. But for many, of course, there is no backyard, which speaks to the potential of occupying orphaned space, and why good diplomacy is needed to entice and build new relationships.

Condition #3: Cultivate a collective imagination. Making orphaned space matter cannot rely on "understanding" as it is delivered from any single discipline or perspective. This is not a matter of returning to nature, for example. As I describe in the ensuing chapters, there's a lot of creative ecological thinking required. In many orphaned spaces, the work of maintenance must continue. This requires creatively engaging with the science and technology of maintenance, reorienting technologies, shifting priorities, and inventing new tools. The tour guides I've followed into orphaned space seem not to fear specialized knowledge, transgressing boundaries to engage with science and technology in ways that challenge dominant paradigms and ontologies and seek a distributed expertise. And by refuting a singular nature, and especially a vengeful or victimized one, the projects present forward-looking opportunities for people and also plants, animals, and other life to play new roles and to collaborate in creative, surprising ways.[35] This generative open-endedness is key, especially in our era of frighteningly dynamic climatic events and widespread extinctions that leave many people vulnerable to conser-

vative "doomsday" ecological narratives and political hopelessness. The past is not a reliable guide, and the seed bank for the future is thin. How shall we assemble?[36] Pursuing the idea of collective imagination opens up opportunities to bridge the divide that so absolutely renders our truth seeking and knowing about the world from what allows us to experience it meaningfully—perhaps to experience a shimmer.

A thread connecting the stories I tell in this book is that as people bring orphaned space into focus, uncomfortable histories can emerge. Issues of racial and environmental justice surface in all these stories, buried layers for which many pursuing "greening" projects are not always prepared. But the work I feature here, as it seeks to be sensitive and responsive to local ecology and to honor history and memory as well as build new alliances and redistribute resources, offers opportunities not only for the exposing of past abuse but also a reckoning.

Together, these conditions organize what I've learned traversing orphaned space. What I hope translates is that giving a damn, even where no one else does, might just be normal. The risky, vulnerable work goes beyond reproductive caretaking into the realm of loving. These projects all offer a double movement. It is, on one hand, the foregrounding of the important work of maintenance as a feminist call to reject the disappearing and denigration of care work and to invest it with meaning and importance. On the other hand, it is also a demand for more participation and control in public spaces of human maintenance and to connect them to a dispersed "everyday politics" in which people take more control of the spaces of their daily lives and explore new facets of being dwellers motivated by love for Earth.

Gas Station Alchemy and Cultural Heritage in South Chicago

> The dirt says, "I know how to go about
> unsettling settlement . . ."
> —JD Pluecker, *The Unsettlements*[1]

Surrounded by sagging chain-link fence, the corner lot rests quietly under its cracked and crumpling blanket of asphalt. Soil, accumulated over decades in the fissures and depressions, hosts pockets of plant assemblages: marestail, broadleaf plantain, prostrate knotweed, crabgrass, and dandelion. They are colonizing, their roots expanding the cracks, their growth and decay building up more organic matter and making soft landing spaces for new seeds blown in to take root. The occasional ragweed presents a taller flourish. This orphaned space, somewhere in South Chicago, once hosted a gas station. With the owner bankrupt and long gone and in a neighborhood with low real estate pressure, it has remained here for decades, mostly quiet, in a slowly expanding conversation with "weeds."

Underneath the plants and asphalt lie benzene, toluene, xylene, and ethylbenzene, all elements of hydrocarbon compounds from tank leaks and fuel spills. The chemicals are included in octane boosters like MTBE and BTEX. There are also diesel fuels, solvents, and degreasers in varying concentrations and depths in the soil. These "lenses" of contaminants have existed here for decades under

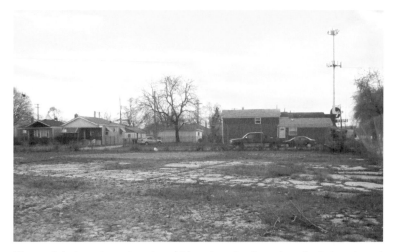

Figure 3.1 A project aimed at addressing the "typology" of abandoned gas stations, *Slow Cleanup* piloted the use of ornamental, flowering, and fruiting plants in remediating polluted soil in sites like this one. A collaboration of the artist, the City of Chicago, and academic, community, and conservation partners, the project established field trials of 80 previously untested horticultural plant species along with a parallel greenhouse trial at Purdue University. (Reprinted by permission of Frances Whitehead.)

their protective cap of asphalt, changing only if an underground flow of water shifts things around.

Plots like these are a common sight: the fence, asphalt, cement islands, colonizing plants, and contaminated soil are found at hundreds of thousands of abandoned gas stations—all nodes in a vast network enabling the culture and technology of the automobile. Shuttered gas stations are testament to a multifaceted and common story of small business owners and large oil and gas corporations; faulty fuel-storage technology and off-loaded economic risk; massive pollution of underground aquifers and drinking water supplies; and sweeping environmental regulations unevenly implemented. Along with the inestimable costs of poisoned ground water and blighted communities, federal, state, and local governments have spent billions over the past four decades chasing underground pollution from leaky gasoline storage tanks, with the associated costs driving many

small gas stations out of business and leading to many properties sitting abandoned for decades.

It's a common sight, yes, but strangely out of focus given its ubiquity and the toxicity of what is underneath. Following the first condition to reject the void, I'm curious about the history here. What happened? And what kinds of ecologies and politics maintain this orphan?

The gas station is as American as apple pie, an icon and facilitator of the "open road" as highways unfurled across the nation, especially after World War II. Gas stations powered the American car culture, enabling millions to get the hell out of Dodge, Go West, or just get to work. In the 1970s and 1980s, gas station franchises supported millions of small business owners, including many immigrants, all taking advantage of available credit and low down payments to open up mom-and-pop gas stations.

But an insidious problem was slowly developing underground. During the early 1980s, it became clear that the underground storage tanks, many now decades old, were failing, leaking fuel into the surrounding soil. The slowly migrating toxins began to appear in groundwater-sourced drinking water supplies across the country and to produce gaseous emissions that made people sick. Many of the tanks, composed of single-walled bare steel, had begun to corrode, especially along the pipes connecting the tanks to the pumps. The practice of "dipsticking"—dropping long rods to the bottom of a tank to determine the fuel level—was found to weaken and over time puncture the steel tanks, which then leaked fuel into the soil. One 1984 report indicated that 75,000 to 100,000 USTs, or underground storage tanks, were leaking and that as many as 350,000 USTs would start to leak in the following five years. Worse, in what appears to have been an effort to avert liability, many oil companies had divested tanks to station operators, especially in the late 1970s and early 1980s, leaving small business owners holding the—well—tank. Oil companies had at least some knowledge of tank leakage issues as early as the 1930s and had begun developing new technologies to avoid the problems. Rather than retrofit or replace aging equipment at the many stations at which they owned tanks, however, oil companies appear to have programmatically divested themselves of many tank systems during the late 1970s and early 1980s, often for nomi-

nal sums. The average cost of site cleanup was $85,000 in 1989 and $135,000 in 1990.[2]

Underground storage tanks (which were installed not only at gas stations but also at taxi and construction companies, marinas, airports, fire departments, and other agencies) began to leak and became a hidden and ever-expanding menace, a nationwide problem that continues to endanger drinking water supplies in every state. Their history exposes a lack of regulatory teeth to protect drinking water as well as a vastly inequitable regulatory system especially taxing for small business owners and communities of color.[3] Successive waves of legislation were created at the state and federal levels to prevent contamination and then to deal with abandoned sites when bankrupted owners, unable to meet regulations, gave up.

The scope of the problem and its human impacts are encapsulated in remarks made by New York congressman Thomas Downey at Superfund reauthorization hearings in March of 1985. Noting the vast nature of the problem as well as the lack of regulatory oversight, he stated:

> In mid-1983, nearly 100,000 gallons of gasoline, from storage tanks belonging to a gasoline station in the Bluebell Lane neighborhood [of North Babylon, New Jersey], leaked into the ground. As a result, the neighborhood has been inundated with fumes containing benzene, toluene, and xylene. These chemicals are dangerously toxic. . . . I requested assistance from the Environmental Protection Agency for the residents on two occasions and was denied both times. The responses I received clearly depicted an Agency bound by legal shackles. The Federal Superfund program explicitly excludes petroleum in its definition of hazardous substances. Therefore, EPA could not provide any assistance to the people of Bluebell Lane. . . . While the precise number of gasoline storage tanks range from 1.2 million up to 10 million, some have suggested that between 20 and 40 percent of all tanks are leaking.[4]

Nationwide, revelations of leaking underground storage tanks and contaminated drinking water led to the EPA Office of Underground

Storage Tanks (OUST) in 1985, and a 1988 rule (40 CFR Part 280) setting minimum standards for new tanks and requiring owners and operators of existing tanks to upgrade, replace, or close them. When the Leaking Underground Storage Tank (LUST) program began, there were approximately 2.1 million systems to regulate in the United States. The 1988 regulation set deadlines for owners and operators to meet the new requirements.[5] MTBE, the acronym for a common octane booster and a deadly carcinogen, was almost a household word.

The increased requirements of equipment and recording processes and fines levied for leaky tanks led to increased rates of gas station abandonment. In 1998, there were 800,000 noncompliant USTs, often because owners could not afford to investigate and clean up the contamination present. This, in turn, led to another wave of closures. At the beginning of 2002, President Bush signed the Brownfields Revitalization Act, with $50 million a year in grants and other resources for the cleanup of abandoned stations and other petroleum-contaminated sites. In concert with federal money and mandates, state and local governments continued the long slog of locating and cleaning up the underground petroleum mess.

By 2015, releases from tanks were far less frequent, although releases from piping and spills and overfills associated with deliveries emerged as more common problems. As of September 2019, the EPA reported that it regulated roughly 546,000 petroleum tanks and a total of 1.9 million had been permanently closed down.[6] But even after their removal, the legacy of those tanks remains, their sheer numbers staggering, not to mention the ongoing challenges for the municipalities of every size resting on top of sometimes thousands of small hot spots of chemically contaminated soil, threatening drinking water aquifers and stymieing new development.[7]

This larger story illuminates some of the forces driving the ubiquitous typology of abandoned gas station lots. Returning to South Chicago, other questions emerge. The lot has lain quiet for decades, the bankrupt owner long gone, the ownership defaulted to the city. The tank has been pulled, but the hydrocarbon molecules remain, lying heavy in the soil. Similar lots in other parts of town have been excavated and redeveloped. But not here. There's not a lot of money in this part of town for new development.[8] An orphaned gas station

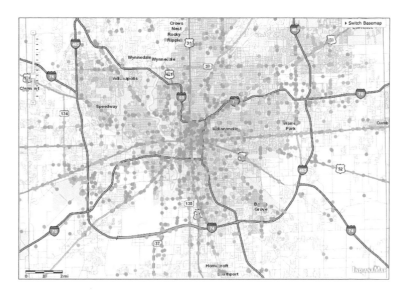

Figure 3.2 The Indiana Department of Environmental Management reports almost 16,000 underground petroleum storage tanks around the state, with 8,089 leaking (orange dots) and 8,302 not leaking (green dots). This close-up of central Indianapolis reveals the widespread distribution of the tanks. (Credit: UST_IDEM_IN: Underground Storage Tanks in Indiana [Indiana Department of Environmental Management, Point Shapefile], digital compilation by Indiana Geological and Water Survey, 20181019. Figure © Indiana Geological and Water Survey, Indiana University, Bloomington, Indiana.)

site in a low-income neighborhood is a place in hiatus, connections stymied by regulation, legacies of racism, asphalt, pollution, and chain-link fence; all process slowed to a crawl. Such sites are invisible to us partly as a function of their ubiquity and unremarkable nature and partly because so much of what orphans them lies underground, out of human sight.

Still, things can happen here, only slowly—exactly where sculptor and School of the Art Institute of Chicago professor Frances Whitehead found a toehold.

Slow Cleanup, Frances's project on gas station remediation pursued in collaboration with the City of Chicago's Department of Innovation and Technology and Department of Environment, began in 2009 under Mayor Daley. As Frances explained to me, *Slow Clean-*

up was about how doing things slowly can be doing things at the right speed. She worked with Dave Graham, a brownfield specialist with the city, and Paul Schwab, a professor and specialist in soil environmental chemistry. The project centered on a research project into "rhizodegradation," the potential of soil microbes fostered in a plant's root zone to dismantle contaminating petroleum hydrocarbons. Along with building new relationships to plants and microbes, Frances also centered social inequity and the uneven impacts of such lots on marginalized communities. She reoriented the production of scientific knowledge to center those who are typically left out of conversations about uses of urban space.

Frances was keen to leverage her skills and position at the School of the Art Institute of Chicago to work with the city; she argued that artists have important contributions to make across institutional contexts. She aimed to link art and the practical by providing examples of the power of artistic training to city governmental agencies and arguing for the larger role of culture in solving environmental problems. As she explained to me later, after working for years at the community level she wanted to expand beyond limits to that engagement. One way to exert more influence was to go where the rules are made. "I realized I needed to infiltrate further up the food chain," she told me.

Artists' training, she argues, enables artists to see patterns of all sorts, in part because they traverse multiple disciplines and different modes of production. She created the Embedded Artist Project aimed at involving artists in city government programs to contribute to problem-solving and sustainable urban design. Besides offering expertise in understanding cultural value, Frances emphasizes that artists are synthesizers as well as creative, working across a diversity of areas of expertise to solve problems to achieve artistic vision. She also explained to me that artists are accustomed to tight feedback loops; they compose *and* perform, design *and* execute. In addition, she said at one point, they aren't afraid to ask "dumb" questions. Learning about how she tackled her project, I came to understand better what this meant.

Abandoned gas stations present a kind of typology, Frances explained when I visited her in her house near downtown Chicago.

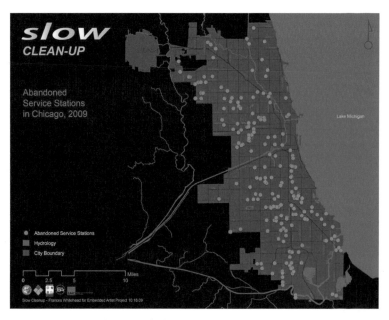

Figure 3.3 From the City of Chicago's abandoned service station inventory of hundreds of sites, Frances Whitehead selected a pilot site based on hydrology, contamination levels, and potential support from neighbors. *Slow Cleanup—Civic Experiments with Phytoremediation* (2008–2012), Frances Whitehead. (Reprinted by permission of Frances Whitehead.)

"When you look across gas station sites you see similar pollutants, and similar layers of asphalt, gravel, leaking tanks, etc.," she said. It was a beautiful, cloudless July day in 2011, and she gave me a tour. She and her husband had designed and built the "carbon friendly" house with solar panels, wind turbines, and geothermal technologies. It's tucked in among a row of more traditional, upper-scale Chicago homes.

I had called Frances the night before to be sure we were still on for a visit to her remediation project site on Chicago's South Side. She had told me that Paul Schwab would be there in the morning as well. Frances had found Paul by researching the published literature on phytoremediation, the use of plants to clean polluted soil, air, and water. After reading about his work on root-microbial interaction in

the soil, she reached out, explaining that she was working on hydro-carbon remediation by plants with the City of Chicago and needed to consult with an expert. She described her role as an "embedded artist" with the city. He replied by asking her if her project needed an "embedded scientist." I think that was the beginning of a productive relationship.

When Frances began her project, there were over 400 abandoned gas stations languishing on the City of Chicago inventory.[9] Especially in places like the South Side, the lots have been a persistent drag, a negative for real estate values and community perceptions of health, safety, and vibrancy of neighborhoods. And, of course, this is where there is real need. As city lawyer Jessica Higgins documented in Chicago: "Brownfields tend to be concentrated in older, predominantly minority and low-income neighborhoods from which manufacturers and businesses have fled and in which market forces will not prompt redevelopment. Such neighborhoods are faced with numerous social and economic issues, and empty and unproductive brownfields carry with them a host of problems that contribute to an overall condition typically described as blight."[10] Although Chicago's brownfields program is impressive, cleaning up well over 13,000 acres of industrially polluted land, she notes that its programs have done less well at reaching and serving the communities who live in lower-income areas. This can be observed in terms of how community members are included in decisions about new land uses, in the types of job-creation programs implemented, and in the ways the redevelopments have ultimately contributed to gentrification.

A "sustainable" solution to abandoned polluted gas station sites had to be multidimensional. For one, there was no digging and dumping polluted soil elsewhere, which would just move the problem to a new location; it had to happen in situ. Any new engagement at the plots needed to respond to its conditions—the people and environments around the site. "I wanted to change the story and perceive of brownfields as cultural heritage," Frances told me, adding that she starts from "the premise that everything is cultural."

When I arrived to visit Frances, she and Paul Schwab were carrying flats of four-inch potted plants from her courtyard garden out to his car. He was taking them to his lab at Purdue for a greenhouse

experiment on their ability to remediate hydrocarbons, a sister test to plots being planted at a gas station research site. I recognized many of the plants, prairie beauties like blazing star, bee balm, coneflower, and Joe Pye weed. When Frances understood that many of the larger hydrocarbons typically found in the soil of abandoned gas stations are remediated in the rhizosphere by microbes and are not taken up into the plant itself, she saw an opportunity.

Phytoremediation encompasses a broad range of engagements, with a variety of mechanisms and targets. Plants with long tap roots and high evapotranspiration rates can help minimize water infiltration, thus keeping contaminants from moving with the flow of water. Certain trees, like poplars, can pump and treat groundwater. Physically, plants can provide buffers for water flow underground, or air flow up above to prevent blowing dust. Some plants are great at withstanding both flooding and drought and can thrive in catchment areas, helping remove and trap sediment and other contaminants from stormwater. Others can be planted in a wetland, helping to hold water in place, and slowing the eroding rush of stormwater and filtering out soil and other elements. Floating mats of plants can also filter contaminants from water. Long-rooted trees and shrubs can degrade contaminants deep in the soil profile. Some fast-growing shrubs are tolerant of organic contaminants and help degrade the hydrocarbons.

But research into these capabilities of plants has been a start-and-stop affair, stymied by the long time horizons the plants require to get the job done, the research needs served by neither the typical federal grant-funding timelines of two to four years or the fast turnaround demands of the private sector.[11] Artist Mel Chin aimed to bring attention to the potential of phytoremediation in his 1991 project *Revival Field* at the Pig's Eye landfill in St. Paul, Minnesota, also a Superfund site. He collaborated with a scientist to research the efficacy of "hyperaccumulators"—plants that actually take up into their leaves nasty heavy metals such as arsenic, selenium, nickel, cadmium, and zinc. He enclosed a small area of the landfill with chain-link fence subdivided by paths and separating different varieties of plants from each other for study. He sought funding from the National Endowment for the Arts, which initially accepted and then rescinded support, citing questions of aesthetic quality: Was this art?

The funding was eventually reinstated, with Chin arguing that the project was a kind of sculpture using the tools of biochemistry and agriculture. Although the work is unseen, he explained, "an intended invisible aesthetic will exist that can be measured scientifically by the quality of a revitalized earth. Eventually that aesthetic will be revealed in the return of growth to the soil."[12]

The challenge Frances saw for plots scattered around her city, especially those that lingered for decades in lower-development pressure areas, was the meager palette of known plants confirmed to help degrade petroleum contamination. What about plants that people wanted to live with? What kinds of activities and new connections might occur in these spaces that would make them an asset to the neighborhood? She conceived of a "swatchbook of phytoscapes," with functions like small tree bosque, winter color, fragrance, biofuels, birdscapes and bugscapes, fruitscapes, and prairie. Her vision revolved around creating small landscapes that would be inviting to people and also include plants engaging with the contaminants underground. And that required a reorientation of research.

The research on phytoremediation has typically been done at agricultural research stations and has focused on tall grasses and agricultural plants, which are not well suited for small plots and the diversity of applications Frances envisioned as benefitting urban neighborhoods. Nonagronomic plants, including ornamental, habitat, fruit bearing, and prairie forbs, remained, and remain, largely untested. After exhaustive literature reviews, phone calls with specialists, and a lot of "dumb" questions, Frances created a database of almost 500 plants with promising root structures that looked like they might generate microbial activity capable of dismantling petroleum hydrocarbons. From that list she determined dozens of potential new remediators in ornamental and horticultural varieties of flowers, shrubs, and fruiting trees. These included trees like serviceberry, redbud, and persimmon; shrubs like indigo bush and dogwood; and flowering plants such as asters, purple coneflowers, prairie smoke, and evening primrose.

"I believe there is a solution and all I have to do is find it," she explained to me later. "I'm not afraid to not know, to bug people to death, and I just call people up and if they can't help, I call the next person."

Figure 3.4 Part of Frances Whitehead's research involved creating a database of 475 native and horticultural "remediator candidates"—plants with promising root morphologies for soil remediation that also might be popular in yards and gardens. *Slow Cleanup—Civic Experiments with Phytoremediation* (2008–2012), Frances Whitehead. (Reprinted by permission of Frances Whitehead.)

She described the "days of searching" the Internet for photos of plant roots and the phone calls she made to connect the "plant roots guy" with the "soil guy." In making the final decisions about which plants to test, Frances said, "I did this really intuitively and it drove Paul crazy, he would have wanted a more statistical way, but I had to factor in my own interests—whether it was good visually and a fit in the landscape. I had to just go for it the only way I know how. I eventually got the list down to one hundred and thirty-seven."

Rhizodegradation, as noted, is the breakdown of organic contaminants in the soil by microbes. These soil microbes, which help plants by making nutrients in the soil available to them, are nurtured by plant root exudates such as sugars and alcohols—because what better way to make a party? The exudates offer a source of carbs for the

soil microflora, enhancing their growth and activity, along with other chemicals that get them moving. The plant roots also loosen the soil and transport water to the rhizosphere, or root zone, thus additionally making life good for the microbes. It's a burgeoning set of relationships about which we have a lot more to learn.

This process of building up the microbial community and breaking down the pollutants takes decades, hence Frances's use of the word "slow." While plant-microbial symbiosis can be at work cleaning up underground, she imagined the site above as an engaging, colorful, fragrant space, productive of food for birds, insects, even people. And that's why the relationship between the site and the surrounding community was so important. For her initial installation, Frances chose a site near Chicago State University enabling her to offer an opportunity to a class of environmental science students, many of whom lived nearby, to be involved in the research. Their work taking soil cores augmented the city database of the locations of lenses of petroleum and other contaminants at different locations and depths. Frances also wanted to connect with the neighbors, which was a challenge as she couldn't physically open up the plot to them because of safety issues and to protect the research project. She reached out to the local alderperson, who, after hearing the plan, endorsed her efforts and suggested the site be named the Cottage Grove Heights Laboratory Garden.

"We refer to this as the knowledge site," Frances summed up. "We are growing knowledge here."

We traveled together in her truck from her house, driving south on highways for some 20 minutes. When we arrived, I observed a site that looked nothing like a classic research plot. The Cottage Grove Heights Laboratory Garden was laid out along a series of lines radiating out from the entrance and dissected by arcing smaller paths. The triangles curved gently as they expanded, marked by black metal edging. Frances explained how she'd laid out the site to be a kind of performance for the passersby—"like Versailles." The radiating lines, which divided the plots within which some 80 different plants species were being tested, moved out from vantage points coinciding with places in the fence where people could stop, view the gardens, and read signs that informed them of the experiment their neighborhood

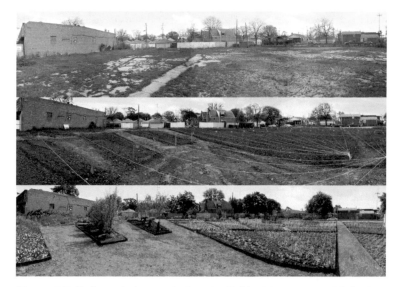

Figure 3.5 Before, during, and after the field trials were established on the abandoned gas station site. *Slow Cleanup—Civic Experiments with Phytoremediation* (2008–2012), Frances Whitehead. (Reprinted by permission of Frances Whitehead.)

was hosting. One goal of her design, as Frances described it, was a "reversal of the power dynamics" associated with similar grand geometric space plans. It was built as a performance for the neighborhood, the design integrating research, aesthetics, engagement, and, slowly, economic benefit as the plants did their work. Nearby residents would see and smell flowers, hear bees and birds, and, she hoped, understand how their neighborhood was hosting an experiment generating information of potential use to people just like them.

Through Greencorps Chicago, an environmental job-opportunity program, the city agreed to provide maintenance of the site for three years, including planting and then watering once a week in the growing season. But this arrangement created friction. Frances described how having her School of the Art Institute of Chicago sculpture-class students lay the edging instead of the Greencorps workers was a point of contention with program leaders; she was adamant that achieving just the right curve of each bed, and especially working

with metal, was a job that required special training. The city program administrators wanted participation in the project and opportunities for their workers. In addition, the racial dynamics were hard to overlook, with the largely Black workers providing the hard labor for the site. It was to balance tensions like these that Frances worked to build a local sense of ownership of the project, engaging Chicago State University students and the neighborhood alder in research planning.

When I saw it, the garden was largely planted, with young trees and bushes at the back of the space (I recognized a native honeysuckle and a persimmon) and lower-growing plants, some of which were in bloom, closer to the entrance point. The deepest-rooting plants were placed where the underground gas tank had been. There is a "hot spot" of TCE (or trichloroethylene) at the bottom of that area—about 10 or 12 feet down. Poplars have been tested frequently for this type of situation, but Frances was investigating the potential of cup plant, or *Silphium*, to do the job since they have very deep roots and are also "gorgeous kick-ass plants." After spending time at the site, she discovered a low, much-wetter spot toward the front right corner, requiring an adjustment to the plant choices. I saw a few empty spaces among the plots, and some of the plants were struggling or had died, although many of them looked fairly well established.

As she designed the planting plan, choosing longer-rooted plants over the deeper lenses of contamination, she also created a seasonal flowering "clock," clustering flowering plants together according to bloom time, moving from left to right from April to October, and, with the trees in the background, blooming a "frothy" pink in the spring. The performance would last all growing season, reminding everyone nearby of horticultural rhythms. Among her ambitions for the project, Frances aimed to make visible the sequences of "plant time," using flowers to pull people's attention to the shifts of botanical life and from there to demonstrate the power of the associations at work: the conversations among root, microbe, and hydrocarbon. "I wanted to revalue slowness, deep work, and help the public understand why this is so important, on a neighborhood basis."[13]

I was especially captivated by Frances's tale of the Wortken, an enormous roadbed-building machine she repurposed to prepare the site. A big challenge was the feet-thick gravel bed lying underneath

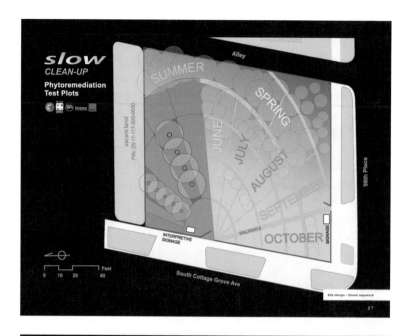

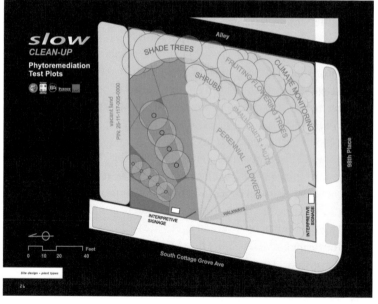

Figure 3.6 The design of *Slow Cleanup* was informed by seasonal plant rhythms (*top*) as well as color and plant architecture (*bottom*). *Slow Cleanup—Civic Experiments with Phytoremediation* (2008–2012), Frances Whitehead. (Reprinted by permission of Frances Whitehead.)

the asphalt and cement, again an element typical of most gas stations. The question was how to integrate enough organic matter to support the plants without disturbing the lenses of pollutants lying just underneath. The rotating blades of a Wortken proved to be the answer, although this solution was discovered only after weeks of making phone calls to construction companies and road-building specialists.

There were other hurdles. She explained to me that she'd had the asphalt and concrete from the gas station pulled off for recycling but that because of the three inches of topsoil that had developed on top in the 20 years since the station closed, the recycler wouldn't take the material. It had to be trucked to the landfill. It was the only part that went there, she said, and that was a mistake since the topsoil was "good stuff." There are other possibilities, Frances suggested later, especially in small plots, to leave such hardscape in place but kick-start the rhizoremediation by doing gridded or decorative saw cuts into it and planting a series of engaging designs.

In 2011, the project suffered what many such public endeavors experience, and funding was pulled by the incoming city administration of Rahm Emanuel. Unwilling to continue upkeep, the city yanked the plants and removed the edging. Frances moved to other sites to continue her work with plants and people.[14] But Paul's research team was able to continue the work begun at the greenhouses in Purdue and eventually determined 12 new species of flowering plants found to aid the dissipation of contaminants in the soil—all but one never before tested. The list includes:

- Purple coneflower, *Echinacea purpurea*
- Blue giant hyssop, *Agastache foeniculum*
- Horse mint, *Monarda punctata*
- Rattlesnake master, *Eryngium yuccifolium*
- Alum root, *Heuchera richardsonii*
- Yellow coneflower, *Ratibida pinnata*
- Wild bergamot, *Monarda fistulosa*
- Prairie dropseed, *Sporobolus heterolepis*
- Yarrow, *Achillea* sp.
- Catnip, *Nepeta cataria*

- Foxglove beardtongue, *Penstemon digitalis*
- Evening primrose, *Oenothera biennis*

Other promising plants include several species of flowering tree: black cherry, red-osier dogwood, downy serviceberry, and fragrant sumac.

How does one engage with and transform, but not necessarily disappear, history? Landscapes have been fertile ground for planners, geographers, art theorists, and others thinking about how humans activate the environments and spaces around them, particularly as we create patterns that communicate some messages and hide others.[15] Denis Cosgrove, in an iconic 1984 essay about landscape and European Renaissance art, laid out how the composition of landscape paintings of the time provided viewers with a sense of mastery in which much of the material conditions of rural life, especially those related to labor, were hidden or romanticized. Grant Kester made similar observations about the compositions of eighteenth-century English landscape gardens and the herculean labor required to make "nature appear natural." Ecological restoration efforts in damaged landscapes risk "distracting from historical trouble," as Elizabeth Spelman has observed, while often done with good intentions, such restorations can erase history and the shameful actions tied to it in dangerous ways. Stephen Daniels, referring to work by John Berger, describes the "duplicity" of landscape, a quality that cannot be resolved but serves as a signal to inquire into the politics and histories of how landscapes are made and maintained. He writes, "We should beware of attempts to define landscape, to resolve its contradictions; rather we should abide in its duplicity."[16]

It's interesting to reflect on this notion of the duplicity of landscape. Indeed, some of the labor for planting this municipal art production was provided by Greencorps via a carceral system constructed out of racial injustice, labor that was not evident in the final product. Yet, contrary to obscuring a history of contamination, Frances's work was generated by hidden pollutants, surfacing and seeking to transform them via a people-plant-microbial alchemy into flowers, fragrance, texture, color, fruit, and more. She offered a new take on gardening for the twenty-first century—a way to understand garden

plants not only as beautiful and often ephemeral companions, but also as partners in the work of attending to legacies of injustice and pollution.

It's also helpful, thinking through *Slow Cleanup*, to return to the three conditions for loving orphaned space. Following the first one to "reject the void," the project helps us comprehend the vast landscape, not only above but also below ground, orphaned by car culture. The project gestures to the costly and racially uneven legacy of spilled oil and gas that sickens people and continues to orphan space, especially near those already disadvantaged by discrimination. This legacy can be hard to comprehend, lying invisible underground. Part of the power of *Slow Cleanup* is, to quote Ukeles, how it "flushes up into our consciousness" the persistent contaminants in these numerous shadow places. By manipulating the science and technology of phytoremediation, Frances, working with Paul Schwab, pulls this legacy into view, transformed. Contrary to a simplistic ambition to beautify a landscape, the extravagance and complexity of her design can be seen as a radical centering of the perspective of nearby residents rather than, for example, importing an external ecological vision of "natural" landscape on the site.

The manipulation of science, technology, and aesthetics in *Slow Cleanup* ties into what I say more about in the next chapter regarding the "diplomacy" of art (condition #2). Not much about this project fit with standard operating procedures for the City of Chicago, whether the application of phytotechnology, the aesthetically driven design of the research plots, the selective engagement with programs like Greencorps, or the time required to search out a Wortken. Challenging business as usual will always pull people out of their comfort zones. While this is risky, and people situated within organizations are often not in positions to take those risks, the benefits in terms of realizing new solutions and engaging with new partners can be enormous. Frances's persistence and willingness to go against the grain were critical ingredients to loving that orphaned space.

Slow Cleanup benefitted from a close art-science collaboration, an example of condition #3 to use "collective imagination." Paul Schwab and Frances worked together to reorient phytoremediation technologies to include a new suite of research objects—specifically,

a new set of people-friendly plants that can help combat soil contamination and provide pleasurable company where there was previously only a depressed conversation. The choice of plants to work with was confirmed via the science of plant root-microbial interaction but also an artist's intuition. As Frances put it to me: "As a sculptor you *have* to understand the material you work with. You have to know all about different processes, and the science, the chemistry, etc. Technology and art have never, until the last 100 years, been thought of as separate. I have to make a place where people can see they are not separate."

This kind of "ontological transformation" of the objects and relations of research is a critical contribution of art-science collaborations, a fleshing out of the possibilities of inter- and transdisciplinary research.[17] Attentive to the surroundings and the historical conditions perpetuating the languishing of the site, Frances employed the "grand gesture"—but inverted its orientation toward those typically not gestured to. Her work generated a new suite of characters and relationships in the narrative of such orphaned landscapes.

Artists have a history with toxic landfills and the alchemy of plants, microbes, and soil. As mentioned before, Mel Chin's *Survival Field* aimed to exhibit phytoremediation as an underground "sculpting" of the land. Other creative efforts exploring gas stations and phytoremediation have designed miniature gardens that gesture to car culture while including plants that remediate soil and water. Is this "beautification"? We are suspicious of design as it obscures originating ideas—baiting audiences with a lovely but deceitful form. This apparent independence of design is often referred to pejoratively as propaganda, notes Zachary Kron writing on the challenges of engaging with repugnant and toxic objects. But he also notes, "We must also consider the value of propaganda not as an enticement to embrace that which is sinister, but to endure that which is difficult."[18] Abandoned gas stations, like many orphaned spaces, are bereft of much that is attractive to humans and other life. The role of *Slow Cleanup* in making endurable the challenge of proximity to a toxic space, where purification happens only on "plant time," is convincing.

While the list of promising new horticultural remediating plants stands as a durable result of Frances's aesthetically charged research,

the precarity of the specific context of the project is hard to miss, a commonplace occurrence for any project funded by political administrations. The project reveals, even while seeking to go "higher up the food chain," the limits of local control over such spaces. The short duration of the project allowed little time for Frances to generate the type of local interest and support that might have somehow overcome city bureaucracy. By excavating the history of gas station site contamination and abandonment, we can begin to untangle the global reach of the factors at work generating the "typology" of this orphaned site and the ongoing conditions for the precarity of local control and involvement, even while burdened by the risks and ongoing negative impacts.

And this is not a problem of the past. The contaminating layers in the soil remain, both in old gas station sites and in new ones made every day. Writing about the "slowly dying" fossil fuel industry, Bill McKibben describes 93,000 inactive oil and gas wells in Alberta, Canada, as "orphaned"—the companies that owned them bankrupt, leaving wounds in Earth, leaking greenhouse gases into the atmosphere and contaminants into the soil and water table, and saddling taxpayers with the cleanup bill.[19]

As we move forward to contend with the myriad "wounds," Frances's project suggests how we might wrangle with the forces enabling the creation—as well as the abandonment and orphaning—of such contaminated sites. Her work populates our imaginations with new ways of connecting and enduring by providing new technologies for both inhabiting and healing.

4

Artist Diplomacy on the Bronx River

> We never know what a being is
> capable of or can become capable of.
>
> —ISABELLE STENGERS, *The Cosmopolitical Proposal*

I first met artist Lillian Ball in person when she picked me up in her Prius one July day in downtown New York City. She was on her way from her apartment in Tribeca to the site of her environmental art project *WATERWASH ABC* in the Bronx. As I got into her car, I noticed right away the small, bright-eyed dachshund sitting in her lap. "This is Naya, daughter of Neptune," Lillian announced. The dog regarded me calmly and with way too much formality for me to consider offering a pat on the head. Besides, as Lillian stepped on the gas and moved into traffic, I became too distracted by her very fast driving to pay attention to anything inside the car.

Over the next few days, as she showed me around the site and introduced me to some of the many people she was working with, I continued to struggle to keep up. Lillian was always on the move: driving, walking, moving items, showing me things, talking with people. It seemed she was never doing less than three things at once. She was in the middle of a very intense field season, she told me, putting into the ground a far more complicated installation than she had ever attempted, balancing contractors, working with a private landowner and businessperson, applying for city and regional permits, and en-

gaging youth workers and volunteers. It was also high summer: it was hot, and potted wetland plants, native grasses, and flowering plants as well as small woody shrubs, all needed care and to get planted into the ground as quickly as possible.

What I eventually learned about the totality of all her work would take me a while to sort through. The variety of types of relationships involved in her project, for example, and her often surprising combinations of problem-solving and apparent flights of fancy were initially a challenge to evaluate. It was tempting to try to partition her work, to separate out the concrete, enduring objects, and to consider the rest window dressing or personal idiosyncrasy. But eventually, after thinking over the myriad unexpected twists and turns and diverse challenges in her project, I came to see her perpetual motion as generating a kind of atmosphere that fostered new interactions and relationships. I describe this work as "diplomacy," a term inspired by philosopher Isabelle Stengers and that forms a critical component of condition two for loving orphaned space.[1]

Stengers, in her "cosmopolitical proposal," observes how enormously human lives are shaped not only by other humans—politics as we know it—but also by other sentient and nonsentient beings, or "things." She describes how human-centric perspectives mask our impacts on and vulnerability to these things—an argument akin to Bruno Latour's observations of the myth of human control and domination of the world and his contention that "we have never been modern." Her goal is a better politics—one that responds more effectively and ethically to the kinds of real-world problems generated and defined by other beings and things around us in the world. The question is, as she puts it, how "our human politics can construct its legitimate reasons in the presence of that which remains deaf to this legitimacy."[2]

She also argues in her proposal that people need to become open to previously overlooked agents and relationships in order to reconsider thoughts and feelings as they are provoked by things and beings. A key move here is to shift our notion of humans as independently thinking and therefore exceptional. She writes: "What makes us human is not ours: it is the relation we are able to entertain with something that is not our creation." With this responsive approach

to the world, humans might become "spokespersons claiming that it is not their free opinions that matter but what causes them to think and to object, humans who affirm that their freedom lies in their refusal to break this attachment."[3]

The power of these ideas, for me, is that once we understand our humanness as an emergent property of our *relationships* with other beings and things and grasp that our maintenance as "human" depends on our relationships with others, we might begin to perforate the conceptual and performed boundaries that ultimately compel us to orphan, to sever ourselves from the world. All beings and objects (even technologies and concepts such as neutrinos), for Stengers, become fair game for "political" consideration; all those relationships become consequential. The work of interrupting anticipated processes and making space for different voices and relationships, Stengers suggests, is the work of "diplomacy." She uses this term quite differently from our conventional definitions. In her context the work of a diplomat might be seen as a troublemaker rather than a peacemaker. Humility and attentiveness to the voices of those not often included in conversations are also in the tool kit. But let me explain.

Lillian's Bronx site, when I first saw it, was just a slip of land hidden behind a massive warehouse—bare earth sculpted with two depressions. The Bronx River floated quietly alongside, its banks mostly riprapped, with large muddy areas exposed at low tide. Along the back of the warehouse ran a long pipe, set up to divert stormwater from the parking lot where we left her car. Previously, any rain sheeting off the streets and parking area shot straight into the river, carrying with it auto grime, sediments, and other pollutants. With Lillian's design, the water would instead be shunted to a rock-lined pool sculpted into the earth, slowing it down so it could drop some of its load of sediment and other particles. The water would then flow into a wetland, where a range of different plants could go to work remediating more of the pollutants. When the water eventually percolated down into the river, it would be far cleaner and moving much more slowly than if it had run directly off the streets and parking lot.

That day I joined a planting work crew—a group of teenagers, most of them local, who arrived by wooden boat to the site. They were working with Rocking the Boat, a youth development organization based

in nearby Hunts Point. Lillian was pleased to be able to collaborate with this group, she told me, hiring a team of youth to help her get the plants in the ground. Rocking the Boat teaches kids to build wooden boats, which they use to navigate the Bronx River and other waterways around their home. At least that's the surface goal. The organization is also dedicated to helping them finish school and learn a range of skills from urban river ecology to collaboration and leadership, to carpentry. "We use the somewhat uncommon mediums of traditional wooden boat building, maritime skills, and environmental science to help young people grow and develop into whatever they want to be," director Adam Greene explained to me.

Occasional birdsong broke through the constant rumble of trucks across the Bruckner Expressway bridge and the throb of air traffic overhead. With the tide out, the kids had to tie their boats downstream and make their way, in tall rubber boots, through the brush and mud, navigating rocks at the water's edge. The day was already hot, and the youngsters squabbled over who got to wield the hose to water the plants waiting to be put in the ground. Dozens of different species were in pots in the shade near the warehouse, some bound for the wetland while grasses and shrubs were planned for the upland area above. I watched their sand-coated fingers as they teased out small wetland plants from plastic trays, massaging them to loosen the bound-up roots. I wondered what they would remember of this intimacy. Will these little plants thrive, and will these kids come back to watch them grow?

"It's OK," Lillian told a young man concerned about ripping two small plants apart. "You have to break some—there are plenty of roots there." I listened as she described all the potential relationships they were helping build: how flowers will provide pollen for bees and other insects, muskrats and ducks will enjoy chewing the pickerelweed leaves, the cabbage white butterfly will love to hang out on the blazing star, and mockingbirds will enjoy the staghorn sumac berries during the winter.

This was hardly an experienced planting crew, and the team moved slowly. They would end up taking weeks to get all those plants in the ground. And while some of the plants perished in the pots, it turned out that this slow, drawn-out attention to the young plants was a ben-

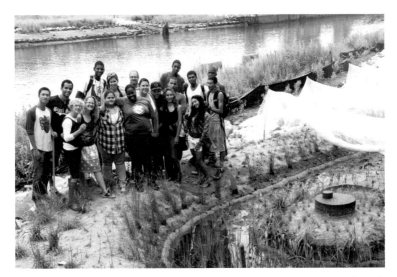

Figure 4.1 *WATERWASH Bronx River, New York*, 2009–ongoing, by Lillian Ball. The artist, front left, and participants from Rocking the Boat installed 8,000 native wetland plants. The recycled-glass overflow in the wetland drains excess water to the river in rare cases of inundation. (The temporary netting protected the young plants from hungry birds.) (Reprinted by permission of Joaquin Cotten.)

efit. One of the consulting scientists on the project I spoke with later said the job could have been done more efficiently—and, indeed, a group of well-meaning adults from a bank in Manhattan, hearing of the project, had volunteered to venture up to the Bronx for a day to get the job done. But the spread-out nature of the planting and the care, with people watering over an extended time period and protecting the very young plants from predatory birds, helped them get more established even in the hot weather. Many ecological restoration efforts fail at exactly this step when plants put in quickly die from neglect in the following critical weeks as they are left on their own to establish themselves in a new environment.

Later that day, the owners of the carpet and furniture warehouse showed up to walk around the site. I overheard them talk of their support, with one owner saying he remembered swimming in the Bronx River as a boy and that he'd like it to be clean enough for his grand-

son to do the same. Later, however, Lillian almost blew a gasket when other employees showed up to talk to her about using her planned viewing platform of the river as a place to sell roofing and stucco alternatives. She intended it to be a spot for viewing the river and the wetland she is installing. Selling roofing does not fit in with an ecological art installation, she insisted, saying her decision was "nonnegotiable." After we finished planting for the day, we used stakes to arrange vintner's netting the length of the wetland, constructing a giant cocoon of sorts to protect the young plants against potential bird predators.

The next time I visited the wetland, months later, it was flourishing. Green and bushy grasses, cheerful orange milkweeds—the place lured passersby out of a world of concrete and asphalt, traffic noise, and urban grime onto a winding, shimmery path—a porous pavement constructed from recycled glass—toward an intimate viewing spot of the Bronx River. From the viewing platform, I could see the elongated oval of the small marsh, with arrow arum, pickerel weed, and bull rush emerging greenly from sitting water. The deeper rock-lined pool above helped slow the rush of water from the parking lot, releasing it more gently into the shallower wetland. The sandy soil of the wetland, undergirded by a thick but permeable rubber sheet to hold moisture during dry periods, filtered the rainwater even further before it flowed into the river. "The wetland will not be that wet most of the time," Lillian explains.

As nature's "buffers," wetlands are flexible, able to absorb large amounts of rain but also withstand periods of drought. Lillian informs me that up until only a few decades ago, much of this area along the Bronx River was still wetlands, part of an estuary—where river meets sea. The water here moves up and down with the tides and the changing flow of the river, a breathing in and out of water. The Bronx River is the only freshwater river in New York City, and many kinds of plants and animals thrive on this rich and spongy landscape. Alewives and herring migrate up the river, as do eels, which are born in the Sargasso Sea and swim back up as far as Westchester County. But most of the Bronx River's estuary was constructed upon, with only three or four areas currently labeled "wetlands" or being restored to

wetlands.[4] The river, as it flows through the South Bronx, is practically hidden—channelized and nearly erased from view by unbroken rows of businesses and large warehouses. Walking down the almost treeless Bronx River Avenue, past giant storefronts, laundromats, self-storage units, and other facilities, it is impossible to know there is a river very close by.

That juxtaposition makes Lillian's installation that much more dramatic. It offers a view of the river and the wetland as a kind of performance. The entire project is a dedication to water, with a sinuous blue-green path echoing the flow of water to the river. The work offers a break from hard surfaces and right angles. Stepping off a level sidewalk, the path curves downward to the river. As visitors walk along it, they can see the sun's light bouncing on the river as it emerges into view. The traffic noise recedes a bit and sounds of birds and wind in the trees begin to move to the foreground. The breezes moving downriver flow across a person's face and mess around in the flowering grasses and plants along the path.

My first thought upon visiting the project is that it is fantasy, a flight of mind to invest in such a whimsical retreat in the midst of concentrated urban concrete. But *WATERWASH ABC* is also a work site. Signage on the wall describes how the wetland plants are stabilizing soil, slowing water runoff, and filtering pollutants. Images of birds, fish, and other animals and insects accompany text informing visitors how the wetland supports other species, too. Readers learn how wetlands play a role in the health of rivers and oceans. Lillian engaged with shimmery glass, flowering plants, reflecting light, moving air, as well as many people all as part of an eminently practical and ambitious work of art.

The project is centered on a basic model of stormwater capture and remediation that she explains is "not rocket science." She wanted to address two core issues plaguing the quality of water in Long Island Sound and other waters of New York. One is to capture and clean water running off streets and directly into a stream or river. A second challenge involves water flowing down a drain into a sewer. When rain falls on a city, it runs off hard surfaces like roofs, sidewalks, streets, and gutters, picking up speed and collecting particu-

Figure 4.2 *WATERWASH Bronx River, New York*, 2009–ongoing, by Lillian Ball. The recycled-glass permeable pavement path leads visitors to a platform with a view of the constructed wetland at work and of the river. (Reprinted by permission of Lillian Ball.)

lates from car exhaust, trash, and other elements that pollute water. Conventional urban stormwater infrastructure, such as gutters and drains, moves water "away" as quickly as possible. Fast-moving water, as it shoots out of storm drains into creeks, scours banks and creek beds—eroding additional sediment and entrenching urban waterways into the land.

But one of the largest challenges for water quality in the Bronx River—and, indeed, for the waterways of many urban areas—are "combined sewer overflows," or CSOs. Up and down the Bronx River, numerous concrete pipe outlets—the overflows—gape from the banks. Combined sewers mix stormwater runoff with domestic sewage and industrial wastewater. During torrential rains, which in many areas are increasing because of climate change, city sewer systems become overwhelmed and have to release water, untreated, directly into a waterway. CSO events are a major water pollution con-

cern for the approximately 800 cities in the United States that have combined sewer systems, not to mention many others around the world. Water quality fines for the release of untreated sewage levied on upstream towns along the Bronx River, including Yonkers, helped create the fund supporting Lillian's *WATERWASH* project.

Lillian's model is based on the simple concept of capturing and filtering rain where it falls so it doesn't wash street debris into streams and rivers or move into the sewer system, creating the menace of a CSO event. This kind of wetland is especially helpful in mitigating what's known as the "first foul flush" of accumulated yuck after a period of dry weather. Such overflows contribute pulses of bacteria, pathogens, toxic chemicals, and nutrient-laden sediments directly into the waterways from thousands of such outlets. Some pollutants of these have been linked to exacerbating antimicrobial resistance in people. Nitrogen, primarily from sewage treatment plant overflows and residential cesspools, fertilizer, and stormwater runoff, stimulates blooms of algae—*Margoleffidinium*, *Alexandrium monilatum*, *Aureococcus anophagefferens*, and *Karlodinium*—devastating to fish and shellfish and sometimes people, too. Up and down the U.S. Eastern Seaboard, fish and shellfish populations have periodically crashed due to algae blooms. Eelgrass, which harbors numerous types of marine life, struggles to survive. Nitrogen also threatens people's drinking water.

Urban responses to the widespread problem of runoff and CSO events—as compelled by the threat of fines from the 1994 EPA National Pollutant Discharge Elimination System—include building separate sewer systems, storing water in vast underground reservoirs, and building more sewage treatment facilities. These "gray" alternatives are all expensive and, in the context of climate change, increasingly difficult to defend as dependably solving the problem. Not surprisingly, green infrastructure, a distributed and often less expensive approach to capture water from parking lots, street terraces, rooftops, and more, is an increasingly common, though less well-funded, part of the conversation.[5]

I note a large "overflow" drain in the middle of the wetland and learn that the site has its own version of a CSO. In case of a massive inundation, water will flow down the drain and into the river rather

than scouring out the marsh. Hurricane Sandy in 2012 gave the wetland just that sort of test. The installation survived. Lillian and others gesture to this type of small-scale intervention as part of a distributed, more ecological approach to cleaning up the waters of New York, providing local amenities like rain gardens, protecting eroding shorelines, and adding some resilience in the face of the looming threat of sea level rise.

There are good reasons, then, to protect and build wetlands, not only to absorb water but also to maintain healthy shorelines, clean water, and support wildlife. In response to increasing awareness of the many shortcomings of gray, or hardscape, infrastructure—the catastrophic levee failure after Hurricane Katrina and the slow disaster of the Atchafalaya River basin are examples—green infrastructure approaches have moved from a fringe idea to closer to the mainstream. New York is home to an impressive network of wetland and waterfront restoration groups, some of which are behind initiatives like oyster restoration in New York Harbor. However, the value of wetlands is still not readily apparent to many people—they are hard to sell as necessary, especially with so few remaining. Plus, the pressure to drain and build on land near waterways is continual, and laws protecting these areas are weak.[6] Hardscape responses to floodwater, such as dams, levees, and giant containment basins, continue to be a dominant response to threatened property.

The potential for green infrastructure moves far beyond confronting water pollution. How might green infrastructure be developed to support local communities, integrate new ways of knowing the water around us, and combat, rather than exacerbate, gentrification? Some of these questions were in Lillian's mind when she decided to undertake *WATERWASH ABC*. She had successfully completed a similar installation on Long Island near the town of Mattituck. She placed it at an eroding boat ramp that provided boat access to the water but otherwise orphaned the area from ecological and social connection. The badly graded shoreline allowed road runoff to scour ditches beside the boat ramp, flowing directly into Mattituck Inlet and washing out the *Spartina aterniflora*, a smooth cordgrass with spiky white blooms, and other plants growing there. *Phragmites aus-*

Figure 4.3 *WATERWASH Mattituck Inlet, New York*, 2007–ongoing, by Lillian Ball. Ecological artist Lillian Ball demonstrates how quickly water infiltrates with the recycled-glass permeable pavement, a key element in mitigating the amount of polluted street runoff entering waterways. (Reprinted by permission of Lillian Ball.)

tralis, a very aggressive plant, was moving in on the disturbed shoreline, making life increasingly difficult for other plants.[7]

Her design provided for a ramp of permeable pavement made from recycled glass to support vehicle traffic and a wetland swale to slow water coming off the nearby road and filter it before allowing it to percolate more slowly and cleanly into Long Island Sound. The site employed colored glass, signage, a viewing bench, and flowering plants in ways that complicate the space, luring in wildlife and welcoming people to linger. She worked with local environmental groups and the town to figure out the maintenance of the site, which would require yearly vacuuming of the permeable pavement and maintenance trimming of a band of *Phragmites australis*. The remaining plants help prevent shoreline erosion, but Lillian didn't want them to overtake the other wetland plants—which the reed will do as long as

conditions of disturbance and nitrogen-rich waters continue to dominate in the Sound.

In writing about her work, Lillian described how, after thinking for years of her environmentalism and art practice as two separate endeavors, the WATERWASH concept came to her all at once, bringing function and inspiration to overlooked spaces. "I envisioned a vegetated swale with native plants, permeable pavement, and educational signage explaining the need for non-point source storm water management in private as well as public places," she wrote. "The transformation of a neglected space into a public outreach park could inspire community commitment to storm water issues."[8] Lillian trademarked this "creative concept" as a design to slow water and slow people, offering a chance for water, and ideas, to soak in.

Although her art from the beginning reflected water imagery, Lillian, who has received a Guggenheim fellowship for her work, increasingly focused on environmental concerns. In 2005 she became involved in a community-led effort to preserve a wetland, Harper Preserve, which became the subject of *Leap of Faith*, an ecological video installation and her first body of artwork with serious environmental content. The native cranberries and threatened *Iris prismatica* in the preserve provided source material for her interactive game, *GO ECO*, based on the Asian game of Go and exhibited as a solo show for the Queens Museum of Art. *GO Doñana*, focusing on a threatened UNESCO wetland in Andalusia, Spain, expanded on that idea. In 2007, she curated *Called to Action: Environmental Restoration by Artists*, an exhibition of 12 creative strategies for ecological healing and restoration. As then editor of the journal *Ecological Restoration*, I read about that exhibition with great interest, and it led me to reach out to her to learn more. She explained how the show also served as a kind of research project for her, allowing her to learn about how other artists were blending art, activism, and environmental solutions.

In developing her model, Lillian pointed to her experiences on Long Island. "I previously worked with almost every plant I use in WATERWASH," she told me, explaining how, for years, she had labored to encourage native vegetation along the shoreline of a marsh near her home there. "Also, I'm a hunter gatherer; that is where my knowledge of nature comes from."

Most salient to me about her project work was the variety of novel collaborations involved—and in the context of not insignificant resistance. Looking at a completed project based on ecological design, one might be lured into perceiving it a straightforward affair—just "following" nature and the flow of water, for example. But building new relationships in orphaned space was far from obvious. *WATERWASH* was a model system informed by natural wetlands, but the execution of each installation as it developed in different orphaned spaces was its own intricate, many faceted effort. The permeable pavement, for example, required researching sources of recycled glass and different types of coatings that would allow water to percolate but stand up to foot, car, and boat trailer traffic. Lillian worked closely with one contractor she described as "masterful" with a backhoe and who was willing to work with her to test pavement options. This meant someone who was willing to take risks, experience failure, and keep trying.

"I spent a long time researching permeable pavement options and meeting installers to find a company on a similar wavelength," she wrote about the effort. "Bob Govenale, owner of Excav Services has a degree in geology and experience with environmental restoration . . . followed through enthusiastically with all our challenges and agreed to do it, 'just this once,' for the funds we had budgeted, far less than his usual fee." They settled on a permeable pavement made from postconsumer glass that would otherwise be landfilled and held together by a urethane made of 60 percent plant material that allowed for varied designs and colors. The installation had to provide effective water filtration but also meet aesthetic standards: "I wanted everything naturally curved which was novel for the installers," Lillian wrote.[9]

Lillian also had to convince the Southold town board of trustees, as some members were skeptical of the effectiveness of the installation and concerned about liability issues. Foot-dragging, which remained even after she'd secured full funding, gave way only in the face of her persistence, as she continued to reach out—making allies and, basically, refusing to go away. Permitting alone took weeks of paper shuffling. Her relationship-building work paid off in numerous ways: high school students showed up to help with planting and

trimming the *Phragmities*, a local business donated wood for the benches, and the sanitation department set up a couple of free dumpsters nearby during the installation. "Many artists are uniquely prepared to follow through in the face of adversity," she wrote. "Without that tenacity, I wonder how anything can be accomplished in the web of bureaucracy surrounding such efforts."[10]

Some elements remained elusive; Lillian was unable to secure the water quality testing equipment that would have determined the specific impacts of the filtering pavement. And measuring success was another question. "How can we possibly measure a place's value to the inhabitants inspired by it? When I watch the school children reading the WATERWASH signs, or see a boat returning with happy fisherfolk, or catch kayakers lunching on the benches adapted from Aldo Leopold's plans, I see the landscape in action," Lillian wrote.

For her Bronx version of the project, Lillian worked with faculty from Drexel University to design the wetland to handle the water load running off the parking lot. The design also included a hydrologic monitoring program. She was offered a list of plants for the installation that could thrive in tough conditions. When purchasing the plants, though, Lillian adjusted the list according to personal experience, favoring ones she had worked with, including unusual native plants that she "knew" as part of previous wetland restoration work. I listened in, at one point, to a meeting between Lillian and one scientist who was unfamiliar with some of her plant recommendations. He described her plant list as full of "prima donnas," but after meeting with resistance from her, he admitted that his own plant list involved "the usual suspects" and that he could not assure Lillian of any plant's survival because, as he put it, "who knows what's there in Bronx soil." (Urban soils routinely include bricks and other construction debris, topsoil, coal ash, municipal solid waste, and dredged material from waterways, all of which alter soil hydrology and chemical properties and, thus, how well plants thrive.)

And the plants themselves were another set of collaborators for Lillian to negotiate with. Wetland plants, rather than "taking up" pollutants, help break them down by altering the physical and chemical environments. Litter from plants supports bacteria that take on the pollutants, and wetland plant roots adapted to supply oxygen

even when underwater create a "steep redox gradient" at the root/ sediment interface, helping the microbes degrade the highly chlorinated hydrocarbons common in pesticides. The basic transpiration of plants and trees, which can rapidly take up large volumes of water, helps contain and control runoff.[11] But very little of this is an exact science, with a great deal of uncertainty both about the survivability of different kinds of plants as well as their "willingness" to handle whatever pollutants were running off the parking lot. Lillian consulted with environmental engineers and plant scientists to most effectively develop a design that stood a chance of achieving this goal. "The question we are asking is, is this a replicable solution?" one consultant told me. "Is this a one-off project or something we can do on a larger scale?"

We are all likely familiar with the often steep-sided catchment basins routinely installed behind warehouses and buildings to capture runoff. But few of these might be considered "social spaces," and without maintenance, they are often ecologically depauperate as well. With time, I began to grasp the extent and variability of the connections Lillian was making. There were few path dependencies here. Most of the people she interacted with were not used to working as she was requesting of them. Lillian had a way of upending the predictable hierarchy of expertise that might easily provide a "correct" answer, instead generating a persistent atmosphere of negotiation in which "expert knowledge" was evaluated specifically in the context of its application. I began to understand the project not only as collaboration but as the creating of something in the context of resistance. Lillian, through her furious pace and constant pushing against any assumptions about what "ought" to happen, was actually creating space, an opening in which to listen to that which is not listened to—the orphaned river, the struggling shellfish, the wetland plants, and also different groups of people not always so easily engaged in such projects. Her work with local people took time—a process of years—as she engaged different specialists to advise on the project, built a collaborative team of youngsters, and gained buy in from a private property owner.

After seeing the Mattituck *WATERWASH* installation, a representative of the National Fish and Wildlife Federation and adminis-

trator of environmental restoration grants derived from the fines levied by the state of New York against Bronx River polluters, suggested Lillian contribute a similar installation to Concrete Park, one of several greening projects along the Bronx River. During a visit to the park, built on the site of an abandoned concrete plant, Lillian looked around at the public park project underway and thought to herself, "the work here is already done." Thinking about storm runoff and the dominant role of private property in the countless small but collectively massive contributions to water pollution around New York, Lillian turned away from the public space and pointed across the river to a scrubby bit of green clinging to the riverbank and shadowed by a giant warehouse. "There," she said. "I want to work there."

In recent years a number of public parks and greenways have been installed in the uber-industrial South Bronx, especially along the river, thanks to decades of hard work from local groups like South Bronx Unite, Sustainable South Bronx, Youth Ministries for Peace and Justice, Partnership for Parks, and the Bronx River Alliance. Michael Kimmelman, writing about such public-private environmental efforts in 2012 for the *New York Times*, described the green spaces as "piecemeal and disconnected, half-measures and bureaucratic foul-ups"—but yet "hardly short of miraculous."[12]

Why so miraculous? To understand the accomplishments of Lillian Ball and others working on the Bronx River, it helps to revisit the three conditions for loving orphaned space. Taking condition #1, "reject the void," we're compelled to ask more questions about why areas of the river were disappeared in the first place. To understand the orphaning of the lower Bronx River and the sharp contrast to its reaches upstream—where it flows through wealthy Westchester County and the leafy Bronx Zoo, large trees overhang the water, and old mill dams have been reconstructed to help restore fish populations—one must engage with the role of the Bronx in New York City's maintenance.

The South Bronx has, for decades, provided dumping grounds and warehouse space for the rest of the city and low-income housing for many people who work in maintenance jobs in other boroughs. I remember images from the Bronx in the 1970s, when it became infamous as a "ghetto," plagued by arson and abandoned by the met-

ropolitan fire department. Stories circulated about how it was pos-
sible to walk across the Bronx River on the tops of all the cars junked
there. In the 1930s and 1940s, the Bronx was an attractive place for
people fleeing squalid tenements in Manhattan's East Side. As home
for a largely immigrant population, though, the Bronx was always
underserved by the city government and developers, resulting in
poor infrastructure and aging housing stock.[13] A most devastating
orphaning event was the construction of New York City commis-
sioner Robert Moses's Cross-Bronx Expressway, built between 1948
and 1972. The freeway, designed for "traffic relief," dissected 113
streets and avenues, hundreds of utility mains, and 10 mass transit
lines, shredding neighborhoods and forcing 40,000 people to move
from their homes. The construction required blasting through ridg-
es, crossing valleys, and redirecting small rivers. The presence of the
massive thoroughfare did nothing for the downward spiral of prop-
erty values, community infrastructure, and quality of life during the
municipal fiscal crisis of the 1970s and 1980s. The environmental
injustices have continued. Facilities relocated from Manhattan's wa-
terfront to the southern Bronx in recent years include a Consoli-
dated Edison power plant, a waste transfer station, the Fulton Fish
Market, and Fresh Direct, a 400,000-square-foot grocery-delivery
facility. As of this writing, the South Bronx, which is 43 percent Af-
rican American and 54 percent Latinx, hosts a third of the city's
waste transfer stations along with the 60-acre Hunts Point Coopera-
tive Market, a wholesale food distribution center (the largest in the
world), fossil fuel power plants, and extremely heavy industrial truck
traffic serving a FedEx hub and a newspaper printing and distribu-
tion center, among others. One community study found an average
of 304 commercial trucks driving through the heart of their Bronx
neighborhoods every hour, almost half of which were commercial
waste trucks—that's one commercial waste truck every 24 seconds.
People in the community, 43 percent of whom live under the federal
poverty level, suffer from disproportionately high incidences of obe-
sity, diabetes, cardiovascular disease, mental illness, and other chron-
ic health conditions, and asthma rates are much higher. According
to the Citizens' Committee for Children of New York, 2016 child-
hood asthma hospitalizations in the Bronx were over twice the rate

as the rest of New York City. People in the Bronx experience higher morbidity and mortality compared to their counterparts elsewhere.[14] But the inequitable and degrading use of the borough has not occurred without resistance. The Bronx remains home for many. People who live there speak of memories of swimming in the river and picking fruit from apple and pear trees in parks near the waterfront. Environmental and social justice groups have, for decades, organized to push back against its literal and figurative treatment as a dumping ground. In the late 1960s and 1970s, the advocacy group Young Lords—second-generation Nuyoricans whose parents had emigrated from the oppressive working conditions of the sugar and coffee plantations of Puerto Rico—organized and advocated for adequate sanitation and health-care services in the South Bronx. Matthew Gandy tells a compelling story of the Young Lords, who modeled their social and environmental justice work on the Black Panthers. He describes how, by asking their neighbors about their largest concerns, the group identified the deep resentment felt by residents of the Bronx for the litter and piles of garbage routinely ignored by the city's sanitation department. The Lords' "garbage offensive" in 1969 brought people together to literally sweep clean streets. More aggressive tactics to get the city to remove the trash involved placing uncollected garbage in the middle of the streets, blocking traffic. The politicization of the garbage issue highlighted the disparities in treatment between the boroughs, and, as Gandy writes, "by publicly sweeping the streets, they had extended the idea of home into the wider space of the city."[15]

The Lords went on to launch a broader set of campaigns, which helped foster a newly vibrant political element in the community. The organization dissolved in the presence of pressures from the Vietnam War and organized crime, as well as the general increasing industrial decline and fiscal crises so prevalent nationwide in the 1970s. But their legacy woven in the fabric of the borough's radical political history has helped inspire numerous individuals and groups to continue to resist the inequity and fight for recognition. Independent Bronx historian Morgan Powell documented the decades of work of Latinx and African Americans fighting to defend and restore the Bronx River. In her 2007 book, *Noxious New York*, Julie Sze

wrote of how activism flourished in the 1980s and 1990s in the Bronx in response to economic decay and the growing concentration of industries. She describes how activist groups in the South Bronx shifted their focus from fighting individual polluting facilities to actively engaging in community planning and community-based health initiatives.[16] When New York's garbage-handling system was privatized in the 1990s and new proposals were made for truck-based transport of waste into Hunts Point, environmental leaders combined forces. The Bronx communities fought together against the Browning-Ferris/ Bronx Lebanon Hospital medical waste incinerator, which was built in 1993, doubling the rates of asthma of those nearby. It closed after 18 years of complaints and protests from neighbors.

And the "dumping"—and resistance to it—continues. In 2015, South Bronx Unite helped organize against a city-subsidized relocation of the grocery distributor Fresh Direct to a publicly owned 106-acre waterfront plot. The site had been leased decades earlier to a developer who promised a connecting rail yard to reduce truck traffic in the area. The rail yard was never built, but Fresh Direct succeeded in overcoming local resistance to build a sprawling 400,000-square-foot facility. There have been gains. After years of pressure, a "waste equity" bill, passed into law in 2018, caps the volume of waste that can be transported and processed in neighborhoods such as North Brooklyn, Queens, and the South Bronx.[17] A small step, the law suggests increasing awareness of the inequities in New York City's practices of maintenance as well as greater attention to all those working so hard to right them.

This history of state neglect and targeted environmental injustice, as well as the activist response to it, are all context for understanding the decades of orphaning forces acting on the borough and the river that flows through it. This is not to overlook that the Bronx is a vibrant, productive, meaningful place, only to acknowledge that it is so in the context of external forces of deprivation. Condition #1, "reject the void," pulls that history into focus, providing insight into the specific forces at work that have orphaned the Bronx and the river and also illuminating the grassroots activism and network of groups dedicated to rejecting the void and building new connections. Lillian, moving into that context, became part of, and was en-

abled by, that work. Building on it, she was able to generate new re-
lationships: connecting to a private landowner, working with local
people, and broadening the discourse around green infrastructure.

As noted, unlike Concrete Park across the river, *WATERWASH
ABC* is sited on private land. Knowing how much of the river is cut
off from residents in this part of the Bronx and owned by commer-
cial businesses, Lillian conceived that a *WATERWASH* created on
private property could serve as a model for how other businesses could
invest in small-scale green infrastructure practices that would help
capture storm runoff from roofs and parking lots and begin to recre-
ate a distributed "wetland" system. She imagined also that shoppers at
the furniture warehouse might appreciate the flowering native plants
and small green wetland and become more open to installing small
runoff-mitigation spaces, like rain gardens, on their own property.

The manager of the ABC Carpet warehouse had grown up in the
Bronx, and was receptive to a number of sustainability efforts, in-
cluding a green roof. But Lillian's project was a new prospect, and the
variety of elements to negotiate seemed endless at times, from the con-
cern of security to ensuring the long-term maintenance of the site. In-
terim issues were always popping up, such as the incident with em-
ployees proposing to use the viewing platform to sell roofing materials
or complaints that cleaning graffiti off the outside fence was a waste
of time. At one point, an employee dug a trench in one side of the wet-
land after a manager insisted it was causing flooding in the basement,
a problem the designers insisted was not new and was caused by other
factors.

To achieve her *WATERWASH* installations in the context of such
myriad challenges, Lillian persisted with a combination of generos-
ity and single-minded drive. Thinking about her project in the con-
text of similar efforts to connect orphaned space in diverse ways, I
began to see patterns in the work. This led me to condition #2—that
the work of pulling in new players and navigating divergent points
of view requires practicing "diplomacy."

For people involved in government agencies or businesses with
standard operating procedures and protocols, such projects are fre-
quently experienced as surprising and even threatening, as artists
bend rules and create unanticipated situations. Some people I spoke

with expressed surprise and delight at having their work engaged with in new contexts. Neighbors and members of community groups, often enthusiastic, were also puzzled by what was being asked of them and distracted by their already busy lives. Nonhuman participants had their own ways of surprising all involved: water flowed in ways no one could explain; plants flowered or died without explanation; birds, insects, microbes, and other wildlife came and went, often mysteriously. Lillian challenged conventional expectations about standardized plant lists, for example, or typical colors and dimensions of pathways. This attention to what might seem like unnecessary detail could also be understood as an effort to honor something often overlooked, like the flow of underground water. Certainly such work defies expectations of maintenance space, insisting it be seen and celebrated. This kind of careful labor, I suggest, is also overlooked, and Stengers's writing on diplomacy is useful in that task.

In *The Cosmopolitical Proposal*, Stengers writes of the "idiot," a character whose presence challenges others and "demands that we slow down, that we don't consider ourselves authorized to believe we possess the meaning of what we know." She continues, "the idea is precisely to slow down the construction of this common world, to create a space for hesitation regarding what it means to say 'good.'" [18] The work of diplomacy involves opening up spaces in which an "idiot" perspective has weight and participants are unable to pursue business as usual. The result might or might not be a recognition of possible new relationships of care. The goal of diplomacy, Stengers makes clear, is not some universal agreement among all parties but is instead an active thinking and participation. It is not always clear what will emerge.

In terms of confronting an easy definition of "green infrastructure," for example, Stengers's notion of diplomacy provides leverage in the face of the ecological mandate of "re," as in "restoration," "reconnection," or "return." There are *not* easy decisions made based on what is natural or ecologically good, a diplomat might insist. Instead, diplomacy involves bringing together new ideas and relationships in a context of uncertainty. Lillian Ball's diplomacy involved creating encounters that unsettled institutionalized processes of the city's environmental management and provoked in people an awareness of

the complicated relationships of care that surround them. Lillian's diplomatic efforts extended to plants, soils, and microbes, as well as the water we all rely on to live. What isn't evident, in looking at the serene view, is the hand-to-hand political work. It required a willingness to tangle, to push people out of their comfort zones, to take risks with new plants and new people as part of the conversation.

"It's about negotiations and constant vigilance. I have to be there thinking about all this all the time," Lillian expressed to me at one point. "Everyone has their own area of expertise, but I am thinking about the big picture and negotiating and bargaining with people to create something that looks right. This is why I like to work with the same contractor and environmental scientists because once you work with someone, they know how you think and what you want. You are teaching people constantly. 'These native plants like sand,' for example, and 'invasive plants will grow here if you put in dirt with Miracle Grow in it!'"

Environmental and community art projects can be notoriously difficult to write about and assess. Critical moves to realize the work disappear just as they succeed. We can look at a completed project and see it "making sense." But making sense is negotiation—with people and with other beings. It is helpful to begin with "typical" ecological patterns and natural cycles, but this is not the place to end. Orphaned space, once you refuse the notion that it is empty, can be noisy. Who is there, and what are they trying to say? As anyone who has worked as or trailed a farmer, ecologist, or other field scientist knows, "hearing" nature is a complicated process. One does not merely plunk down in a field and "listen." Skills are needed to be an attentive, sensitive listener, but in order to interpret messages to create meaning and action, other tools are necessary. Artists, as they are trained to self-teach and take on whatever knowledges might be required to pursue an artistic vision, can be adept at gathering new skills for engaging with diverse ways of knowing. I witnessed artists embrace technology and scientific knowledge in their work, but not be overwhelmed by them as final arbiters of truth.

A diplomat's work, writes Stengers, is rather like that of an eighteenth-century chemist creating the conditions for a new reaction, an emergence. The process of *WATERWASH*—and *Slow Cleanup*,

too—might well be seen as a kind of chemistry, an inter/reaction made possible by the artist as she solicited the involvement of people and things in a project that demanded attention to what has been overlooked, insisting on new relations and synergies. And as chemical reactions can cause noxious fumes, I also observed artists' diplomacy creating social friction. The creative process was at times both disturbing to those involved as well as enabling, creating a result that no single participant could have accomplished alone.

"I've come to terms with the fact that it isn't exactly the way I want it," Lillian said at one point. "I've had to make compromises and for a variety of reasons and because they are something I can live with. But at least I am the one making the choices."

Stengers's diplomats, above all, resist the trap of "pacification"—the notion that there is some greater good or ecological balance that will work for all. For sure, *WATERWASH* maps nicely onto conventional definitions of green infrastructure, but a closer look at its production reveals numerous moments of diplomatic maneuvering, making space for new ideas and grounding it in place with new relationships.

A few years after visiting the site, I read that the owners of ABC Carpet sold their building. Checking out Google's satellite view, I could see Lillian's path but little of the wetland or plantings in the upland area. I reached out to the artist and learned that after ABC Carpet sold the property, the installation was renamed *WATERWASH Bronx River*. The space was sold to a company that leases out warehouses and industrial real estate properties and is currently being used as a distribution site for Amazon. Although Lillian worked extensively with the new owners to maintain the site as close to its originally intended state as possible, her efforts were met with far less interest, and the upper grassland area was substantially "tampered with" and public access largely shut down. The wetland area, however, was still going strong, with Rocking the Boat continuing to maintain it up until COVID-19-related closures.

The maintenance work aspired for is only partially being maintained. The project succeeded for a time, slowing people and slowing water, and set an example of what might be possible on private land. Ultimately, though, in the softening of a business and the sale of a

Figure 4.4 *WATERWASH Bronx River, New York,* 2009–ongoing, by Lillian Ball. A member of the Rocking the Boat job-skills team enjoying a view of the wetland he helped install. The observation platform fencing was salvaged from the nearby old Yankee Stadium. (Reprinted by permission of Lillian Ball.)

"private" riverbank, it succumbed to larger forces that orphan, severing slowly unfurling commitments to care. The timeline required to hear diverse voices and build trust is a long one and requires strong local participation. A key element of this participation is investing in a broad creative agency. In condition #3 for loving orphaned space, I refer to this as "cultivating a collective imagination," an idea central to the project I describe in my next chapter.

5

Water and Other Foreigners
in Fargo, North Dakota

*The more I lingered in the garden, the more I began to
wonder if the land held memory, kept stories. . . . In trailing
rabbit tracks, whispering back to the wind, and catching rain
in my hands, I was gathering story, my mother's story.*

—MARK ANTHONY ROLO, *My Mother Is Now Earth*

The wind was vigorous, whipping the empty plastic bag I was
carrying into a thing obsessed. The North Dakota spring chill
slid up my sleeves and down my collar. I was walking toward a
large grassy bowl dug into an otherwise very flat cityscape. Backs of
apartment and commercial buildings ringed the giant space. I could
see the parking lot for a YMCA and, further away, a sign for the Boy
Scouts of America.

Loretta, whom I'd just met, gave me blue disposable gloves to help
her pick up trash (I had offered). I imitated her and pulled my hood-
ie on over my head, cinching it around my face. My rain jacket went
on top—a tight fit, but worth it for the warmth. We walked down
into the basin, which was surprisingly deep. The wind receded dra-
matically. We wandered around the expanse somewhat unsystem-
atically, drawn by the ragged bits of white Styrofoam, paper, golf
balls, and similarly sized items. There wasn't a ton of this bigger
stuff, but the site was marked by concentric lines of a finer-grained
detritus: cigarette butts and tiny bits of plastic floated in by the last
storm and left behind as the floodwaters retreated. The basin, some

quarter of a mile across and 30 feet deep, is designed to hold flood-water during heavy rains in this very flat landscape.

We were preparing for an outdoor ceremony to kick off a workshop that Loretta, a photographer and poet, was helping host. The workshop was organized by a group of artists in Fargo to bring community members together to talk about this basin and brainstorm ideas for new ways to connect it ecologically and socially. Loretta picked up a plastic bag from the cement-lined channel running along the flat bottom of the basin. After being showered with mud as the wind whipped the grimy bag around, she found that it smelled terrible.

The city mayor's office helped sponsor this gathering in 2012 to work with the community to devise new uses for the 18-acre, windswept expanse while at the same time maintaining it as a stormwater catchment basin. The city kept the grass mowed, but other than the cement-lined channel and a few volunteer cottonwoods making a stand in one corner, not much seemed to be going on. The bowl is rare topographical relief in Fargo, which sprawls out in impressive flatness. The city occupies the extensive plain of a long-gone glacial lake, leaving much of the city as level as it gets—except where people and water have molded the earth. The sound of heavy traffic from nearby four-lane boulevards, mall parking lots, and an interstate freeway is carried in by the wind. Giant cement outlets gape in the corners. It feels like emptiness in waiting.

The basin is waiting for water. It is one of some 20 such "holes" across the city, dug to collect and hold water running off streets, roofs, and parking lots so that pumps working to move water from the city's flat lands into the nearby Red River have more time to do their job. The basins fill to various depths many times a year and usually empty within a day or two. Without them, neighborhoods across the city would regularly inundate. Regulations in Fargo require that developers install or have access to basins like these and other flood-management infrastructure.

But people in the city have been questioning the presence of these basins. Fargo is a growing city, a growth fueled in part by gas and oil development in the western part of the state. As the city has grown, these enormous windswept spaces have become discomfiting eyesores, interrupting flows of people and dividing neighborhoods. Far-

Figure 5.1 Fargo's Rabanus Park stormwater containment basin before the project got a start. A key challenge for collaborators was creating a meandering stream in place of this cement-lined channel. (Photo by the author.)

go's growth is a pattern typical of many fast-growing cities—mini-malls, cookie-cutter subdivisions, and apartments connected by wide, traffic-heavy roads. People who love this town have begun to question the pattern. Are we making the best use of our spaces?

From what I learn about Fargo's long history of battling floods, however, this rethinking of infrastructure is surprising. It seems risky. The region's flat landscape, heavy snowfall, and northward-flowing Red River create the perfect conditions for flooding. While most Midwestern U.S. rivers run south to the Gulf of Mexico, the Red River runs north. Separated by the Laurentian Divide (the continental break that runs from Montana to the Labrador Peninsula), rivers and streams in the northern and eastern parts of North Dakota flow to Hudson Bay. This makes for trouble. As the snows melt and rivers and lakes to the south begin to thaw, waters push into yet-frozen land to the north. The frozen ground can't absorb the spring snowmelt, which

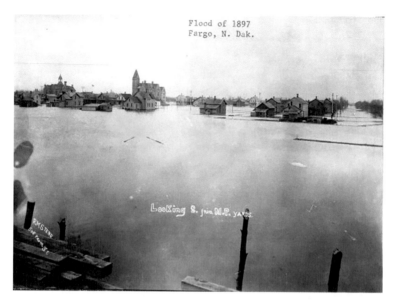

Figure 5.2 A view of Fargo from the Northern Pacific rail yards during an infamous spring flood of 1897, an early instance of the many dramatic floods marking the history of the town. (Image by R. M. Stene.)

presses downstream, sometimes creating massive ice dams. For weeks at a time in the spring, water can build up with no place to flow.

Massive flooding is at the core of the origin stories of white people here in Fargo. North Dakota State University historian Ross Collins quotes an observer describing a flood in June 1861: "The valley at one time resembled an immense sea, to which, looking from any point on the Red River, no boundary could be defined, except perhaps to the eastward, in which direction the heights of the Mississippi could be faintly discerned. The long black lines of timber, marking the course of the river, and its tributaries, stretching out into the plains, were the only landmarks."[1]

In the flood of 1897, the Red River crested at 40 feet above normal, and the entire downtown almost floated away. Spring flooding has occurred many times since, and the river, as it winds its way through downtown Fargo, is lined on both sides by massive earth dikes that loom high above the river.

Geologically speaking, the river is young and wanders easily out of its shallow banks, its floodwaters spreading unimpeded across large, flat areas in North Dakota. The Red is "one of the few rivers in the world that can run amok while practically standing still," observed Vera Kelsey in her 1951 Book, *Red River Runs North!* Even summer thunderstorms can cause serious flooding. In June of 2000, when more than seven inches of rain fell in eight hours, 50 percent of Fargo roads were flooded, causing more than $100 million of damage to the community. Compounding the flat physical geography, the draining of surrounding rich lake-bottom land for growing sugar beets and other crops has effectively removed 90 percent of all the region's wetlands, resulting in the loss of thousands of little sponges that once collected water in place. Thus, even a small amount of water spreads easily, flowing most anywhere humans have not built barriers or, in this case, bowls.

An aerial view of this part of the state reveals the ribbon candy twists and turns of rivers struggling to make their way in the flatness of North Dakota. The view also shows the cheek-to-riverbend development of the city. Even a small amount of misbehavior gets this river in trouble. If you take the long view—say, on a geologic timescale—humans have snuggled in next to a toddler of a river with a tendency to wander and explore. To "manage" the swollen, ice-filled springtime river and catastrophic sudden summer downpours, the city of Fargo has an impressive defense system. Its flood infrastructure includes over 500 miles of pipes and cement aqueducts, some 80 pumps to "lift" water into the river, and hundreds of storage basins.

More recently, all that has not been enough. Between 2009 and 2013, Fargo experienced 4 of its top 10 biggest floods. The worst of the recent floods was in 2009, when the Red River crested at around 40 feet, hundreds of people were evacuated, and many lost their homes. Many residents here talk of the trauma of the floods and the unpredictable water. My friend Ellen, who lives across the river from Fargo in Morehead, Minnesota, described the 2011 flooding as a state of siege. City residents were on 24-hour alert, working at all hours sandbagging, aiding people who'd been flooded out, and hauling ruined rugs and wallboards from homes. She shuddered, remembering he-

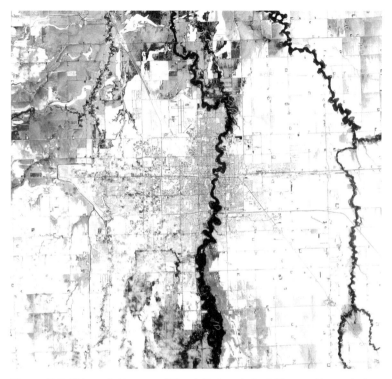

Figure 5.3 This aerial image of North Dakota's Red River at Fargo during a 2009 springtime flood reveals the rather tortured meanders of the river as well as the proximity of city to the river's path. (Jesse Allen, using EO-1 ALI data provided courtesy of the NASA EO-1 Team.)

licopters churning overhead, the constant news updates, and the preparations for fleeing at a moment's notice: "It was like a war zone," she said.

The most recent move to tame the river is a heavy lift: a $2.8 billion, 30-mile system of concrete ditches and gates, built in cooperation with the U.S. Army Corps of Engineers, with the capacity to redirect the river around the city. Winnipeg, Canada, which sits on the Red River further north, completed a similar diversion in 1968, at the time an effort second only to the Panama Canal. After flooding in 1997, the diversion project was expanded even more to manage increasingly large flows.

This history of battling water has shaped the structures and ethos of Fargo. With decades and billions invested in systems dedicated to containing and shunting away river water and stormwater, why is this city entertaining ideas of using flood infrastructure for anything else? Part of it has to do with the sheer amount of territory dedicated to flood management and the increasing visibility of these orphaned spaces as Fargo continues to grow. But, not surprisingly, the story is complicated. More is flowing into Fargo than just water.

One reason Loretta and I had picked up trash in the basin was in preparation for an opening ceremony before the brainstorming workshop to honor the legacy of Indigenous people on the land. Later in the day, I stood at the edge of the bowl, watching Native American dancers gather at one end near a small tent and microphone, their colorful headdresses small explosions of color against the monotonous green. Drummers gathered in a circle under the tent and began to pound. People trickled into the basin from the parking lot near the YMCA and gathered around to watch. After a dance, the crowd listened to a speech from Willard Yellowbird, a Fargo community leader; he began with a blessing. He welcomed the audience and said he hoped good things might happen in this spot. He described a desire to make this place a "creative commons," a place welcoming to different cultures and creative expression. He explained that a first step is gathering ideas from the local community for new uses of the basin. He imagined a "world garden," including native prairie but also plants for the people in Fargo, many of whom come from faraway places.

Contrary to the snow-white image of the city projected by the Coen brothers in the eponymous film, Fargo contains remarkable cultural diversity, much of it the result of refugee resettlement efforts led by Lutheran Social Services, which has resettled people in North Dakota since 1946. The largest groups resettled most recently are from Bhutan and Iraq; other refugees have arrived from Somalia, Eritrea, Sudan, the Democratic Republic of Congo, and Liberia. In the early 2000s, nearly 6,000 refugees from over 30 countries and speaking 50 different dialects made up about 8 percent of the total residents. While Texas takes in a much higher number of refugees per year, North Dakota leads the nation in number of refugees per capita.[2]

Figure 5.4 Native American ceremonial dancers create a dramatic contrast to the monotonous green basin and gray skies as they join a welcoming celebration kicking off the Fargo Project in 2012. (Photo by the author.)

But for me, an outsider to all this, the manifold irony of a Native person in the United States welcoming refugees—both of them displaced by war and extreme prejudice—to land owned by the city of Fargo, which was made famous to movie viewers around the world as the ultimate "white" place, was beyond disconcerting. I felt disoriented by the opening statements as well as by the size of this space, gouged by the city to battle floods, and by the amount of water anticipated to surge in from the cement pipes yawning in the giant basin's corners.

What was going on here?

In 2009, Fargo began collaborations with artist Jackie Brookner to help the city think about its relationship to stormwater. Jackie had built a career working with communities around the world to explore creative ways to think about urban rain. She dedicated herself to working with people to reimagine storm runoff and polluted water as a benefit and a gift. Jackie passed away from cancer in 2015, but

in the years leading up to her death, and in collaboration with city planner Nicole Crutchfield and other city residents, she created a model for occupying orphaned space.

At the center of her work was an ambition to generate what she called "creative agency" within the Fargo community. When I first met her in her studio and apartment in New York City, she told me she wanted to enable people to exercise imagination, an activity central to human well-being. Her participatory approach to the project, in combination with support from top people in the city administration, led to a remarkable unfolding, over years, of a wide variety of engagements and developments. A community-wide agreement to "reject the void" (condition #1) created by stormwater basin infrastructure opened up opportunities for Jackie and Nicole to "practice diplomacy" (condition #2). This work included challenging conventional processes and building alliances with diverse participants—from people in marginalized communities to city engineers to new plant communities. This was neither a straightforward process nor a short-term one. As large as that basin is, at times it seemed way too small to hold the flood of ideas and needs that flowed out of the creative research process. But the energy and diversity of thinking behind the Fargo Project exemplifies the power of condition #3—to cultivate a collective imagination. People from different communities, as well as the land, the water, and the plants—all expressed creative agency in that space once restrictions were lifted and participation was invited.

Jackie's artistic work was distinguished by what she called "living sculptures," such as *The Gift of Water 2001*, a pair of giant cupped hands made of a porous concrete and colonized with mosses.[3] The hands were part of an entirely natural filtration system for a public swimming complex in Grossenhain, Germany, where the water was filtered with the help of wetland plants, and without the use of chlorine or other chemicals. In collaboration with local volunteers, researchers, and students in Salo, Finland, Jackie created *Veden Taika* (*The Magic of Water*). The work involved an installation of floating islands with phytoremediating plants to help clean water and sediments in a retired sewage-treatment lagoon with a legacy of heavy metals and organic nutrients. Because an abundance of migrating

Figure 5.5 Artist Jackie Brookner (*center back*) with a group of youngsters she met during an early survey of the basin. (Image courtesy of the Fargo Project, 2012.)

and nesting birds use the lagoons, the pools were established as a European Union conservation site. The islands provided safe nesting sites for the birds as well as support for the plants. Wind-powered aerators beneath the islands oxygenated the water to stimulate microbial processes on the plant roots. During the warm months, a cloud of mist, powered by a wind-generated pump, rose over the islands several times a day. The misting is very important, Jackie told me; "it is a phenomenological sculpture that attracts people's attention and I hope affects them emotionally as a reminder that humans can do good things for other species."

Jackie also spoke often of the notion of "porosity"—that we are emotionally and physically far more connected to the world around us than our conventional constructions of identity allow. She spoke of her work as a challenge to the construction of such boundaries that allow us to consider ourselves as separate from our environments, and she sought to create opportunities for people to experience feelings of connectedness.

Jackie was invited to Fargo by a personal friend of the mayor who was privy to increasing concerns among members of the city administration about the negative impacts of rapid growth as well as of floodwater infrastructure. In 2009, the mayor asked Jackie to visit the city and meet with planners and engineers to discuss ideas for a project around the management of water as a "defining challenge" of the city. Jackie assumed she might work on a project involving the Red River, but city administrators, aware of public disagreements about the cost and environmental impacts of the impending massive diversion plan, asked her to instead look at the stormwater basins peppering the city. She teamed up with city planner Nicole Crutchfield, and the two spent a weekend driving around the city, talking with people and taking in the landscape. By the end of the weekend, a friendship had taken root, and Jackie had begun a long list of ideas about a project that would help the city of Fargo have a new conversation about its stormwater.

I got to know Jackie as part of a research project on environmental art-science collaboration.[4] When I sought her out to talk about her collaborative work with hydrologists, engineers, planners, and other technical experts to realize her work, she talked about how creative agency was a recent element infusing her work. She wanted to provide people with opportunities to express themselves creatively and participate in the making and maintenance of the urban infrastructures that sustain them. This agency, in her mind, was critical to a functioning society. As Jackie told me in 2011 about what would become the Fargo Project, "I've had communities collaborate to do *my* ideas, but this is different, this is their idea. And I think it's important. I needed to share authorship and provide opportunities where people could exercise their own ability to solve local ecological problems in creative ways. Having creative agency is really key, it's a key part of the pushback needed for democracy to work."

Jackie's ambitions—described in condition #3 as cultivating a collective imagination—compelled her to work with a diverse group of local people, including disenfranchised people living near these basins, to create a series of events to learn, listen, and gather ideas. Over the years she cultivated different approaches, figuring out how to communicate with non-English-speaking newcomers, creating a

"common language" with city engineers, and opening up possibilities for plants and water to participate in new ways.

One of the first steps Jackie and Nicole took to foster this collective imagination was to solicit a team of local artists to work on the project—people with roots in, and a feel for, the city. This team of some six to eight potters, poets, wood artists, designers, and others organized to seek the broad cross-section of people living near the basin and encourage their participation. "We learned early the power of invitations," Nicole said at a presentation on the project in 2020. "Our 'Bowlathon' got local potters to make bowls representing the basin and we gave those away to open a conversation about stormwater. We worked with Headstart to get kids' help creating placemats and wrapping paper for our bowls."[5] This process also led Jackie and her team to become more aware of the diversity of people living in Fargo—and of unmet needs.

As the project team in Fargo quickly found out, refugee newcomers can be hard to reach. Many have yet to learn much English, and there was little precedent to help them understand a participatory environmental art project. But as the artists rode buses, hung out in apartment foyers, attended community gatherings, reached out to schools, and held community meetings, it didn't take long for them to begin to hear some dominant themes from the people they spoke with. People needed places to gather and places to be outside—both of which were too rare for newcomers who were often without a car, a church of their own, or a community center. The town's distribution of green space is uneven. And people spoke of "incidents," such as the foofaraw caused by a ceremonial killing of a goat in a public park by one group of newcomers in preparation for a feast. As Nicole articulated to me at one point, "this project unearthed issues early on. Every group needs a place to gather, and many groups of refugees don't have community spaces."

Other kinds of trouble lurked at the edges of the discussion. As is the case in so many communities in the United States, a vocal minority of Fargoans were voicing hostility to refugees, saying, falsely, that they taxed the city's resources and caused crime. During my visits to Fargo, I heard people refer several times to the story of Pelican Rapids, a small Minnesota town not far from Fargo. The tiny

town had a nearby turkey-processing plant that relied on immigrants for workers. A first wave of newcomers arrived from Mexico and Central America in the 1970s and 1980s. This was followed by several waves of Bosnian and other refugees. During the 1990s the rural town expanded from 1,800 to 2,500 with people from Ukraine, Mexico, Belarus, Bosnia, Croatia, Serbia, Russia, Iraq, Kurdish Iraq, Vietnam, Cambodia, Laos, and Somalia. In the early 2000s, recent immigrants made up about 30 percent of high school graduates, and by 2007, 50 percent of elementary school students were from immigrant families. Support services like schools and hospitals were strained, housing became chronically short, and tensions flared. But a few community members took the situation as a challenge and created events and programs designed to introduce people to each other and bridge divides over cultural background. "Over and over again we tried to say this is an individual, this is a real person," organizer Joan Jarvis Ellison said of the efforts. "This is not a symbol for a Mexican. This is not a symbol for a Vietnamese. This is a real person. This is fun. This is food. Meet your neighbor."[6] It has worked. Undoubtedly there are still those who would complain, but the efforts to welcome newcomers and change the culture toward a more expansive, open place gained it a reputation for creativity and clearly inspired people in Fargo. Pelican Rapids presented a model of how places can adapt.

And Fargo, faced with rapidly emerging problems related to poor planning and unfriendly infrastructure, was looking for inspiration. The buy-in from people "at the top" in Fargo was critical to being able to move forward. It meant that busy people on city staff could feel comfortable taking the time to be involved and respond to artists' inquiries and that the more curmudgeonly were compelled to respond. It was a necessary authorization of time and space into which an emerging collaborative of artists and community members moved, empowered to question the status of the orphaned space, pull in new ideas, and exercise their imaginations about what might be possible. Flexibility was important, because it was not only newcomers who were being villainized.

The stormwater basins are part of a dominant narrative in Fargo, a town whose identity is shaped by the work of containing water, which frequently plays the role of an unruly or threatening character.

When water flows out of line, people become nervous. I heard city engineers complain about frequent calls from residents about even small amounts of standing water on their property: "We get contacted all the time from people complaining about water after a storm, when if they'd just wait a couple of days the water would be gone," one said at a meeting. The Fargo hydrologists and engineers I talked with recognized that a "command and control" approach to water has limitations. And while some bragged as they explained how they could build systems big enough to handle any flood, I also heard them acknowledge it would be at a social and economic price not worth paying. In a letter seeking funding for the Fargo Project, the mayor described how the barren landscapes of flood management "cut off neighbors and disrupt socializing."

"We know it's not pretty," one engineer told me.

Although city officials and scientists were acknowledging the orphaned nature of these spaces and the associated ecological, social, and economic costs, Jackie and her colleagues still had to reassure the people responsible for Fargo's flood management that they were attuned to the requirements of the basin. She took the time to learn and understand how the basins fit into the city's overall flood-management strategy and was respectful about the pressures city staff faced to create predictable and dependable infrastructure. She liked to tell of her first meeting with city engineers, when she was initially met with folded arms and chairs pushed away from the table. By the end of the meeting, she remembered, everyone's chairs were pulled forward, and she had crawled onto the table to better point at a large, spread-out map of the city. "I was told we don't speak each other's language," Jackie said of the beginning of the conversation. "But I told them, 'Well, we'll just create a new one.'"

In addition to research on the requirements for the basin to do its job regarding stormwater, the project team conducted water, vegetation, and soil surveys to determine more about the plant life and soil conditions of this strange, human-created landscape. I marveled at what was not known about the behavior of water in the basin connected by human-laid pipes. Where was that slow trickle of water from the northeast inlet coming from? A few years into the project,

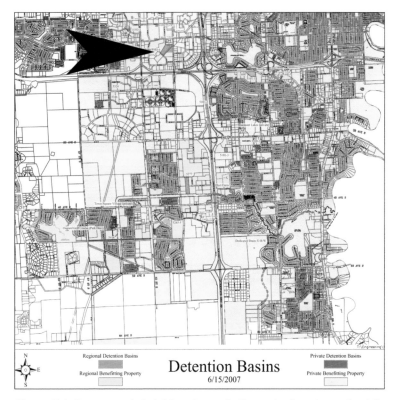

Figure 5.6 Orange and dark-blue shapes indicate the locations of public and private stormwater basins created for flood control in one area of Fargo, North Dakota. The arrow points to Rabanus Park, the location of the Fargo Project. (Image courtesy of the Fargo Project.)

it was determined that unsealed joints in the stormwater sewer pipes were allowing groundwater to seep into the basin. That small but continuous flow, an unintended element in the stormwater- and flood-management infrastructure, was eventually embraced and welcomed by project planners, who used it in providing for a meandering stream. Surveyors also discovered a few small colonies of cordgrass tucked into a wetter part of the basin. Other prairie plant species peppered the carpet of Kentucky bluegrass laid down when the basin was constructed in the 1970s. A soil survey revealed, much

Figure 5.7 Ceramic bowls, symbolizing the basin as a gathering place, were created by members of the Fargo Project artist team and passed out at a participatory design event for neighbors of the windswept park. (Photo by the author.)

to Jackie's delight, a cell of sand in one spot, which she pointed out would fit in well with a natural playground. "Getting my toes in the sand" had been specifically mentioned by one young neighbor.

The artist team spent its first year communicating and organizing gatherings to engage neighborhoods and taking the pulse of city residents about the stormwater basins. Jackie and Nicole settled on one, Rabanus Park, as a pilot in part because it seemed to be the most challenging. "If we could make it work there, we could do it in any other basin in the city," they told me. The basin serves the nearby West Acres Mall and sits near several highways and low-rent apartment buildings. The neighborhoods feel spread out, divided by busy, multilane boulevards lined with strip malls and fast-food restaurants. Among the first steps taken by project organizers was a design event where people were invited to visit the basin and then contribute their ideas (and for which Loretta and I removed trash in the

basin). Efforts were made to facilitate input from non-English speakers via alternative forms of engagement. At the collaborative design event, I joined groups of people—longtime Fargo residents and newcomers—sculpting damp sand into different earth forms within small models of the basin. We were offered "props" to help express our ideas: bits of twigs, lichen, and colored paper to indicate trees, flowers, boulders, and other elements. The models of the basin were beautiful—lovingly made, with the rough plywood edges sanded and a light application of something that made them smooth to the touch.

The site plan evolved out of months of interpreting the models, creating maps, and soliciting feedback. I followed Jackie to endless meetings. People asked for trees, which are too rare in the surrounding neighborhoods. They wanted quiet places to walk and places to garden. Bhutanese women pointed to the hems of their skirts where they'd sewn in seeds from home. Young adults wanted a place to perform spoken word poetry, and younger people wanted to be able to climb, touch water, feel sand, and see flowers.

It's remarkable, I thought, looking over the different models and lists of ideas generated by the outreach work. People want so many similar things: A place to sit in the shade. A place to walk in the sun. A place to play in the grass and sand. A place to take in a view. A place to gather and perform. A secluded place to get away for a while. A place to grow things. A place to see things growing. Everyone wanted to engage more of their senses and interact with a richer environment—a place that does all that and, in response to the needs of city engineers, also holds stormwater.

The final plan, hashed out over countless meetings between Jackie and Nicole and others, involved different types of prairie; community gardens (which were initially discouraged by the parks department as too messy); native plants, including a sweetgrass asked for by Indigenous basket weavers; a "listening garden," with slit drums and a giant wooden marimba to pound on; an overlook (a rarity in the flat landscape); a meandering path and waterway with trees that could provide a chance for reflection and quiet out of the sun and wind; an interactive water feature; and a small amphitheater of grassy benches built into the sides of the basin. Meanwhile, the basin would continue to perform its original function of stormwater containment.

Figure 5.8 A young visitor enjoys the *Listening Garden*, a sculpture by artist Dwight Mickelson created as part of the World Garden Commons at Rabanus Park in Fargo, North Dakota. (Photo credit: Amu Production for the Fargo Project, 2016.)

This latter element was no small feat, requiring endless computations and conversations to reassure hydrologists that any major landscaping would not compromise the ability of the basin to take in, and hold, the required amount of water. "There was red tape every step of the way," Nicole remembered. "We were always asking new questions: What is it? Why there? How to get around it? That's why it takes ten years. This project relied on communication and relationships."

As I worked with Jackie over the years, I heard her talk often about "deep listening," a phrase I struggled to not dismiss, the academic in me generating an internal eye roll imagining touchy-feely "sharing." But, over time, I gained respect for what the artist's process produced. Her considerate yet persistent method of background research, reaching out to diverse constituents (often by visiting them where they were working or living), attentive listening, and intuiting openings for inquiry led her in unexpected directions and tuned her in to unanticipated voices. She was radically open to new ideas as she sought a communal "imagining." I saw this enable her to push back against conventional story lines that easily found their way into the conversation but lacked a local and diverse constituency. The narrative of restoring native prairie, for example, was often featured in discussions, especially with the scientists she consulted with, and at one point the team considered hiring a team of restoration experts to do the site preparation and planting. But further investigation revealed

a lack of area-specific knowledge about prairie plants, as well as a dearth of plant material. Expertise and plant matter would have to be imported from Minneapolis, hundreds of miles to the south. And, more fundamentally, as the team learned about the costs and challenges of preparation, planting, and especially long-term maintenance of native prairie, questions arose around whether this notion of restoration flowed with what the local community was imagining. People were interested in prairie, but personal experiences actually produced commitments to specific plants. Some Native American women had suggested sweetgrass so they could weave baskets, for example. Others wanted plants from homes in faraway places, imagining fruiting trees to bring in birds or grass "nice to run in." How, the team was challenged, is the idea of "native" negotiated in the context of welcoming foreigners? In the end the crew backed away from a formal prairie restoration, choosing instead a piecemeal response shaped by specific ideas from community members. They decided to pursue locally defined events, programs, and plantings as they were generated by community involvement. In one example, the project organizers imagined a ceremonial planting of the native sweetgrass for Native American basket weavers. In response, the weavers shrugged. They were very busy, came the message, along with, "plant it already!" While this upset the organizers' anticipations of "cultural" activities for the space, they were compelled to acknowledge that the need for a ceremony was theirs and that what community members wanted was for them to put the plants in the ground.

At the same time, Jackie did hold strong ideas about what was "good." I observed her running interference on ideas coming from established sources of power or conventional and exclusive visions of open space (golf was one). Perhaps more importantly, Jackie's "deep listening" approach seemed to provide ballast in resisting a major pitfall for public and participatory art projects in which an artist's vision remains paramount to the outcomes. The art world has struggled to find a way to describe and critique public and participatory art works, pushing, as they do, at the boundaries of what is conventionally understood to be art and requiring new rubrics of evaluation and mechanisms for curating and exhibiting. Anyone familiar with the challenges of participatory and collaborative projects will recog-

nize concerns raised about authenticity, reflexivity, and participation. Observers of urban "public" art have asked: Is community-engaged art creating but not questioning space and concealing constitutive relations? As Rosalind Deutsch inquired of public art decades ago: Is it "in" but *in*dependent of urban politics? Miwon Kwon argued that contemporary art needs to move past glorification of the "site" and the "local" to pursue a relational sensibility that resists the "undifferentiated serialization" of places, and embraces "sustaining relations."[7] These are well-founded concerns, and the artists I've followed into orphaned space pursued numerous strategies to tie their work into place in meaningful ways, seeking to connect with particular publics emergent at each site, making room in the project design for input from a cross-section of different interests, and paying heed to both local and more distant influences. The connection between aesthetic vision and a drive to achieve a project, and our typical exaltation of artistic expertise combined with an anemic ability to collaboratively "imagine" and dream big especially about public commons, remain significant barriers. The struggle to maintain a distributed creative agency, to cultivate a collective imagination, was a core tension for the Fargo Project but also a core element in its mission.

And even as "deep listening" encouraged new voices and stories, how were those stories recognized, honored, or made "concrete" in the remaking of infrastructure as a more responsive public space? As their diplomatic work provided openings for new voices, the artists struggled to create meaning. "Between welcoming new residents, rethinking stormwater, and confronting racism, there were a lot of social goals embedded in the Fargo Project," Nicole remarked at one point. "Jackie saw this from the get-go, but we were blind to it, we were so caught in our day-to-day operations. Once I saw the barriers, it was like 'holy crap!' but that was Jackie's leadership, that was the gift—not being afraid to talk about and find the language to talk about stormwater *and* racism. It was a tall order to put on an artist, but we just didn't know any better. One thing artists can do is open up vulnerability, have conversations that others cannot," she concluded. "That ability to be vulnerable and to fail is not something you get to do in government."

Often, orchestrated events went in unexpected directions. During a visit later in 2015, I took part in a "community conversation" convened at the basin to discuss ideas about nature. I found the gathering in a small, one-room warming house perched on the edge of the basin with windows all around. Kon, a community liaison hired by the Fargo Project to facilitate outreach to people living nearby, arrived with seven men, all of whom seemed to be in their twenties and thirties. They had recently arrived from Somalia, Sudan, and Iraq. After sitting at picnic tables and enjoying a meal of chili and cornbread, we broke into small groups and were asked to go outside and work together to create "a nest" out of what we could find in the basin. It felt a bit awkward. "Just because some of these guys don't speak English well does not mean we should be treated like middle schoolers," I thought. And then, as we stood smiling at one another outside in the sun and the cold autumn air, one of our group leaned over and grabbed a bunch of long grasses, twisting the bunch into a circular shape. We followed his lead, adding other plant material, a bit of colored string, and leaves, all while sharing comments and joking. The exercise did exactly what it was supposed to do; the ice was broken.

We gathered back inside, and people spoke about their nests. A woman from Fargo, an invited artist, explained that here in the West we are all disconnected from nature and that she thought about that as she worked. She made her nest messy, she said, because we treat nature that way, as if it were garbage. Next, a gentleman from Iraq stood up. He introduced himself as a Kurd from northern Iraq. He spoke rapidly and in very competent English. His entire culture, which is very old, is built around nature, he explained. That nature is viewed as welcoming and beneficial, but not always. He described an important spring ceremony that takes place on a Wednesday in April and marks a time of renewal of the Earth, a celebration of peace and fertility. He spoke of red flowers that bloom at that time of year and eggs that are dyed, like at our Easter. The colors of the eggs represent the rainbow and the colors of a peacock. The flowers and colored eggs are woven into decorations and hung on people's doors, announcing, "Here lives a Yazidi. Good luck to this person."

Listening to him, I suddenly felt cold. I recalled the voice of a woman I'd heard on the news, a voice on the other side of desperation imploring for help for the Yazidi people. Later, I found her on YouTube. It was Vian Dakhil, a Yazidi MP in the Iraqi parliament, in August of 2014 beseeching her colleagues to do something to help her people from being slaughtered by ISIS.[8]

"I am only saying a tiny part of all I have to say," the Iraqi man finished with a self-deprecating shrug. My heart sank as I took this in. As big as this basin is, I thought, how can it possibly hold the enormity of the loss this story represents? I felt overwhelmed, realizing that his is but one of hundreds of such stories of the people in this city and in this room with me. To walk around a foreign place full of stories from a home that may no longer exist, struggling to hold on to a history that few in this new place know of and that is in danger of being forgotten—I had a glimpse of what being a refugee means.

I think about connections between land and memory and the writing of a friend, Mark Anthony Rolo. Mark had never intended to write about his mother, whose presence he thought remained too elusive. But one February afternoon, while walking through a snow-covered garden, he wrote, "The memory of my mother came to me like a drifting scent in the breeze, swirling through the branches of a nearby cedar tree. . . . The more I lingered in the garden, the more I began to wonder if the land held memory, kept stories." Two years later he published his beautiful memoir, *My Mother Is Now Earth*.[9]

I watched the notetaker struggle and put down the marker, uncertain of what to write. But the story was voiced, we all heard it. His story was recorded on video along with others. Facilitators worked to pull out patterns, especially ones they recognized and that held a familiar morality tale: Nature is everywhere, nature sustains us. But there was no ignoring the other threads: Nature is sometimes threatening, sometimes devastating. Nature sometimes makes no sense, displays no justice or permanence.

I thought about the project's goal of welcoming stormwater and refugees, both constructed as "foreigners" in Fargo by policies and prejudices that render them outsiders in need of containment and control, and that limit empathic connection. How could this project respond in any meaningful way?

The challenge to be welcoming is not rhetorical; anti-immigrant hate lurks in the corners, too easily fanned into venomous action.[10] I thought also about how gatherings like these are sometimes crafted to "engineer" an affective response, to pull attention away from important political realities of disenfranchisement toward some superficial notion of consensus and good. Marion Ernwein and Laurent Matthey, studying city park events in a Swiss canton, observed how programs were orchestrated in a way that shifted attention away from political issues—specifically, the city's top-down management of public park space. They argued against an "ethos of learning to be affected," exposing how a series of technology-assisted festivities celebrated individualized activities in the park, obscuring a shared history of the land and lack of public participation in the management of the space.[11]

For sure, some of the Fargo Project events I attended were orchestrated to generate certain responses, for example feelings of shared values around food, the outdoors, and celebration. But these events often generated unanticipated responses for which project members were not always prepared. I observed Fargo city staff organizing activities with set expectations only to find themselves unable to accommodate what was emerging. Jackie, with her focus on creative agency and community imagination, played an important role in holding the door open for the unanticipated and holding herself and her team responsible for making room for what could not be planned. And while sometimes there was no easy resolution, sometimes there was.

The community gardening space was of immediate interest to a number of groups of people living nearby, and once the land was secured from the city's parks department, staff of a community gardening nonprofit moved ahead with a "world garden" where people could join in and plant crops from their homelands. But during the very first growing season, participants expressed strong preferences for being able to garden alongside others who shared their heritage, knowledge, and cultural context. While occasional communal gatherings were not a problem, having no control over where and with whom one gardened was. While "celebrating culture" meant a general mixing and sharing of space for the white Fargoans involved, for groups of refugees struggling to maintain a sense of group identity

and cultural heritage, having their "own" space, however precarious, was critical. After organizers realized their desires, they stepped back from the "world garden" concept as they'd originally conceived of it. Specific areas of the gardens were designated for different cultural groups. The only demand for togetherness was a regular communal "workday" in which gardeners worked as a team across the full extent of the gardens, doing general maintenance and upkeep and sharing a meal.

A different example of collective imagination arose from working with water—an effort that I heard Jackie and Nicole refer to as "chasing the meander." As mentioned, a continuous low flow of water in the basin compelled the team to rethink how the basin might "welcome" moving water, rather than just serve as a container for it until it could be banished. They eventually agreed to try unleashing the trickle from the concrete channel at the bottom of the basin and encouraging it to flow and riffle as it might in settings not designed by humans. But that "experiment" required building a sense of comfort around uncertainty. No one on the city staff or the scientists consulting from North Dakota State University knew what might happen once the concrete was removed. As was true in the prairie restoration, knowledge specific to the situation was hard to come by. Would the stream entrench? Would it, once powered by a flood, undercut the concrete bib at the outlet?

"It was about ten thousand dollars' worth of an experiment," said Nicole. "We had to figure out how to develop internal communications and mutual understandings to be comfortable with the uncertainty. Also, I was nervous, trying to figure out my tolerance for risk. But it was the human connections that saved the day, built by Jackie's one-on-one conversations." After many conversations, the team agreed on a plan to remove the concrete bed. The concrete was pulled, and geology students from North Dakota State University spent a day digging and arranging rocks in preparation for how they thought water might want to move when it flowed in after the next rain. Then they waited.

Rain fell only days later, and in a September 2015 project report, North Dakota State University professor Jack Norland described what happened:

The first significant rain event on the new channel . . . result-
ed in a ponding of approximately five feet of water in the deten-
tion basin. The water coming from the inlet has enough pow-
er to already start a scour pool six inches deep at the edge of
the concrete . . . and I would predict in the area right down-
stream from the inlet to have a nice scour pool with meanders
and a channel several feet wide. This will produce a small
riffle pool system. The presence of the gravel will stop channel
incision. Further down the channel, with the power lost due to
the meanders, the water will move as run but at the end toward
the outlet there might be some meandering due to deposition
and a slowing stream.

The meander had arrived.

Jackie's death in May of 2015 was a tremendous blow. I had come
to consider myself a "lifer" on the Fargo Project, imagining traveling
north to visit over decades, watching the project evolve and staying
connected with Jackie and Nicole and so many other Fargoans I had
met and grown to love. But while project participants suffered in the
wake of losing her, they remained determined. Nicole and her team
continued to champion the project to the city administrators and
were successful in landing funding from ArtPlace America, the City
of Fargo, Fargo Park District, a National Endowment for the Arts
Our Town grant, and the North Dakota Outdoor Heritage Fund. The
funding allowed the team to complete several of the ideas generated
by neighbors, including the community gardens on the highlands,
the natural playground, the meandering stream and path with trees,
and the overlook, as well as to develop a series of programs that en-
gaged groups from schools and nearby neighborhoods in some of the
construction projects and maintenance. People are using this basin to
gather, sometimes without the Fargo Project organizers even know-
ing. In the fall of 2015, groups in the city organized the first Welcome
Refugee week, with over 200 people joining in to eat, talk, dance, and
tell stories.

The project opened up a process of investigation and collective
imagining that allowed Fargoans, new and longtime, to expand the
palette of possibilities for this once orphaned space. I was privy to

Jackie's searching, following her around to countless meetings all over town and with all sorts of groups and representatives of different groups and agencies. As she drew out stories and pulled in information from diverse groups, project participants had to contend with parts of Fargo's environment that had not been celebrated, desired, or wanted. Her efforts helped force the community to work through a diplomatic process pertinent to all urban environmental efforts: Who do we "let in"? Who is part of a good ecology of a place? It's not always comfortable for those involved: stormwater engineers have to take risks with water, city parks employees have to go a bit "wild" with plants, and neighbors need to be open about encountering new people. The distributed imagining meant listening hard to "foreigners"—refugees and stormwater, for example. However much this effort might fail at adequately responding to the losses of displacement, it was informed by new efforts of a community trying to be more open to expanded physical and emotional connections.

Like the volunteer native plants found in this basin, blown in by the relentless North Dakota winds, refugees may establish here or not. Roots take time to develop, and jobs and the draw of cultural communities elsewhere frequently pull people on to other places. But, while they are here, the basin now offers a new sort of welcome. Newcomers have a garden in which to plant seeds brought from home and a place nearby to share stories and dances and sit outside and find a green break from the gray, endless, high-speed boulevards that surround the housing complexes where many Fargo refugees have been placed. This spot offers more people friendlier space such that even if only for a short while, they might feel at home.

6

Meaning-Full Space

Now I have learned to read what sloping valleys and sinking
streets tell, what bud scars say. Landscapes are rich with
complex language, spoken and written in land, air, and
water. Humans are story-telling animals, thinking in
metaphors steeped in landscape: putting down roots means
commitment, an uprooting is a traumatic event. Like a living
tree rooted in place, language is rooted in landscape.

—ANNE WHISTON SPIRN, *The Language of Landscape*

Perhaps it is worth transforming the image of what a
street is. For the grand boulevards that lead to the places
of power, a labyrinth of interconnected streets could be
substituted, that is to say, a multiplicity of gatherings around
what forces thinking and imagining together, around
common causes, none of which has the power to
determine the others, but each one of which requires that
the others also receive the power of causing to think
and imagine those that they gather together.

—ISABELLE STENGERS,
In Catastrophic Times, Resisting the Coming Barbarism

I am following my friend John once again. He is walking rapidly, as
he does, moving up a gently curving slope. I can easily see the flow
of the land around me, as it's blanketed only by corn stubble. The
walking requires focus, each stride thrown off course as it collides
with dried-out stalks. This hill has been part of a conventional farm,
managed under a standard chemical regimen, for at least the last four
decades, John is telling me; the heck is beat out of the soil. Listening
to him talk about monocropping, moldboard ploughing, hardpans,
and dead soil, I begin to see this field as another orphan, a space dis-

ciplined for maximum production of corn and beans, its purpose maintained with agricultural chemicals and heavy machinery.

But as I continue to listen to John, my way of seeing shifts again. He describes a landscape in conversation with glaciers. We are walking in the Kettle Moraine area of eastern Wisconsin, a yin-yang undulation. I watch his hands as he talks about the hills of "moraine," rocks and sediment gifted by a receding glacial sheet, punctuated by "kettles," bowl-shaped depressions caused by chunks of ice that calved off and got buried in the slow churn as the glacier pulled back. He is especially captivated by the kettles nestled into the landscape; each one is unique, he points out. Similar types of plants, insects, and birds exist in each kettle but in different relationships.

The rich loam and clay soil here makes for good farming, despite the glacial debris. John points out a peppering of glacial cobblestone-like rocks capping one hill. He takes me down a rough gully, choked by scrubby trees and big rocks hauled out of the fields. It's also full of old iron—a washtub, paint cans, twisted straps. The gully tells of past cropping practices that denuded the higher ground and funneled rain and soil down this chute. It also harks from a time when there was no county dump.

New relationships are being created in this field. We're at Silverwood, a county park created on farmland donated in 2002 by Irene Silverwood. Irene and her husband, Russell, owned the farm, which he inherited from his father, who bought it in 1902. Irene Silverwood was a high school teacher in nearby Edgerton, Wisconsin, and imagined the land as a working farm and agricultural education center, as well as a place people might walk, ski, and enjoy the outdoors. John is part of a Friends of Silverwood Park group, folks with a lot of ideas. Where cornfields were once laid out in a continuous blanket, people now dream of "responsive" agricultural engagements, including agroforestry, pollinator plantings, wetland and prairie restoration, and lots and lots of fruit trees. John tells me about the groups involved in community gardening: the local 4-H, local school staff and students, Freedom Inc. working with Hmong families, and Operation Fresh Start, a youth mentoring program. He describes a persistent nudging of people in the county parks department, which has been

wary of some of these new ideas, worried about being stretched too thin.

I follow him into the cool quiet of some of the farm's 50 acres of oak savannah. The big bur oaks are visible in all their majesty here, the understory thickets of buckthorn and honeysuckle cleared away. Craggy arms stretch out laterally, telling of a time when these trees relaxed into the sun. Oak savanna was once 50 billion acres of habitat—now reduced to 30,000, John wants me to know.

He talks about four Oneota sites that have been excavated by archaeologists within four miles of Silverwood—Oneota being the name scientists have given to a prehistoric culture of the American upper Midwest. I sense an uneasiness. He has heard other stories—that there is a graveyard nearby, only occasionally visited, and someone has mentioned a massacre. Silverwood rests on what was 10 million acres of Ho-Chunk ancestral land, stolen by force, lies, and manipulation, the people dispersed. But not enough of this history has been shared. John tells me about one project in the works for fields at Silverwood to be offered to members of the Ho-Chunk tribe as a place for sacred crops and traditional practices. But it's just a beginning, an emerging conversation. And it's painful for people, John says. One has to be careful.

If a farm field such as this is an orphan, you might wonder, then where does this notion of orphaning start and stop? How can the idea avoid being so broad it loses any edge for discernment, any ability to guide specific action? My hope is that orphaning of space might offer a "stretchable" category, an invitation to look anew at all the land around where we live and to reject imaginaries in which so much space is meaningless. I see opportunities for people representing a spectrum of interests and relationships with their environments to initiate new conversations and actions about the meaning, history, and potential futures of such ubiquitous spaces.

Orphaned space becomes visible as people reject the routine manufacturing of single-use and degraded space, as they slow down to see and think differently and take actions that build new connectivity and networks and allow for new stories to be told. The projects I've elaborated on in the previous chapters have good company, as

there are more examples than can be counted of people with not-always-convergent interests coming together to challenge treatments of space that alienate people and perpetuate inequity.[1] This kind of work reveals our general lack of connection with spaces around us. It also highlights the range of activities involved in the diplomacy of connecting, the need to build our collective imagination of what might be possible. Too often, this kind of effort is defined in words beginning with "re," as in "return," "restore," "rejuvenate," and "re-connect." To be sure, it is important to look backward, to excavate history, to be prepared for reparations. But as we know, issues of whose history cannot be taken for granted. The caring work here involves the negotiation of a future. It's a looking forward in the absence of a predetermined plan or scientifically set agenda, especially an ecological one. It's an inquiry into how humans might better co-exist in a world marked by unprecedented change. This work is also shaped by the realization that narratives—the stories people tell about why they are here and what they care about—provide crucial lubrication as well as glue. We need our stories, and when we tell stories that resonate, it is a way of belonging.

Condition #1: Reject the void. Inspired by Mierle Laderman Ukeles, I offer the action of loving orphaned space as a refusal of a value-laden division we make between spaces of routine daily maintenance and the spaces we rely on for release and feelings of well-being and transcendence. The works featured here take the rejected, the hidden, the workaday, and the ignored and imagine new connections, a tangle of necessity and pleasure. The functional is embraced. The results reverberate beyond "enlivened" bits of physical space as they generate new ideas for who we are as humans, who we can expect to interact with during the course of a day, how we might feel. A key element is the idea that paying attention to what is often taken for granted or deemed ordinary is a critical step in how we flourish, ultimately making caring for what sustains us possible by defining it as important work.

I see this as a fundamentally feminist action, a refusal of a hierarchy that denigrates spaces and gestures of care and maintenance. It involves, as Ukeles has shown, a pulling into focus our refusal to

honor the labor and land that sustain us. A defining feature of our neoliberal world, as work like that of Nancy Fraser makes crystal clear, has been the dramatic erosion of structures of care. Whether in the public or private sphere, the work of maintenance is undervalued. In rejecting the void, however, we refuse the narrative of disposable maintenance space. We question arguments about efficiency, safety, and system "balance." We explore opportunities to honor ignored history, unmet needs, and suppressed senses. There is tension with how empty these places are and how they resist occupation because they are polluted, ugly, hot, cold, windy, muddy, boring, and so on. The work of loving orphans involves challenging their disappearance and also resisting a hegemonic notion of what is "good," inviting in a process of distributed imagining of what else can happen.

This is not easy, beginning with words. Following artists into orphaned space, we see how maintenance is not only about humans. Water, soil, and other beings are involved in our own maintenance and are in need of being maintained by us. Writing these words, I struggle in a language that defines water as a "substance." I sense the usefulness of deities. We all know from our personal experiences how water has character, that water is not all the same everywhere it flows. But to even move toward that elaboration involves resisting common uses of language.

The rejection of the void also involves embracing how each of us is connected, surrounded by and reliant on relationships. By refusing to accept the routine generation of degraded space as a normal and necessary aspect of our development, we become alert to the "contradictions" of abstract space identified by Henri Lefebvre. We look for ways to generate differential space in which we can privilege inclusiveness. The projects shared in this book rethink single-purpose infrastructure, organized to exclude, mitigate, minimize, and control. Expanding what infrastructure "is" challenges the neoliberal subject that conventional infrastructure produces. The projects described here do not make promises to meet a "triple bottom line"; instead, they identify sustaining relationships, provoke feelings, and engage senses. *WATERWASH ABC* occupied a disappeared riverbank, opening up a view of sunlight on a neglected river, and produced a model for green infrastructure. *Slow Cleanup* generated

ideas for how small brownfields cut off from ecological and social connectivity might be transformed to center those living nearby, provide sources of pleasure, locally grown food, biodiversity, and new knowledge about how to work with plants. The Fargo Project transformed a barren stormwater containment basin into a community space imagined by the people living around it.

These stories reveal how a sensitive attention to orphaned space invariably exhumes injustice. Shameful histories rise to the surface, even where these issues were not intended as a focus of a project. The erasure of experience, especially the sensualities that can be provided by more diverse environments, happens more often in overlooked and actively marginalized communities. Even spaces of "maintenance work," however, can host creative networks bringing in needed resources.

Condition #2: Practice "diplomacy." Grappling with the nature of the disruptive as well as collaborative work of loving an orphan space was a key motivator for me in writing this book.[2] In Chapter 3 I engaged with Isabelle Stengers, whose writing about diplomacy offers a way to think about the tactics and strategies involved in luring in diverse interests and making room for voices not easily heard. This work involves creating or taking advantage of an occasion, demanding, as Stengers puts it, that participants "slow down." It's an opportunity, Stengers argues, to reflect on what is held in common that provokes thought. We see the work of diplomacy in the expansion of Fargo's stormwater project to help residents confront their fears of floodwaters and also to include the stories and needs of members of Fargo's refugee community. Stengers describes the work of diplomacy as provoking ideas that would not otherwise emerge. There is discomfort in this role, and it is not easily undertaken by those already beholden to an institutional context. The occasions for discomfort were created as artists challenged established processes of decision-making as well as the conclusions reached. I saw new working arrangements, for example, in *WATERWASH ABC*, which pulled a private landowner into a collaboration with a long-hidden river and a youth development program, and also in *Slow Cleanup*, which brought together the design of phytoremediation research and the needs of a

neighborhood. I think of such efforts as forcing technologies, as well as the practice and production of scientific knowledge, into much-needed "context." *Slow Cleanup* exposed how plant phytoremediation has remained underdeveloped because of anemic government funding as well as a lack of interest from the private sector given its slow time frame and lack of monetary incentives. The project provided an example of what such context-focused and practically oriented research might look like with long-term support—research designed to solve the problems of people who live near brownfields. At the same time, its transformation of a standard research plot into an aesthetic "grand gesture" comments on the societal and racially inflected neglect of people who live in low-income areas.

The practice of artists—specifically the challenging and manipulation of social process—deserves recognition as diplomacy. Writing broadly about socially engaged performance art, Shannon Jackson notes the great heterogeneity in artists' "social practices," with some seeking to construct or create social bonds, for example, while others disrupt them. Writing about what he calls "reclamation artists," Malcolm Miles has described them "as communicators and researchers, and as intermediaries between those who have power and those who do not, a possibility derived from the autonomy claimed for art in the modern period, which allows critical distance and independence of viewpoint whilst . . . regaining a sense of engagement and interaction with diverse groups in society." Importantly, as Jackson argues, "the social here does not exist on the perimeter of an aesthetic act, waiting to feel its effects. . . . The de-autonomizing of the artistic event is itself an artful gesture." Seen this way, their insistence on relevancy becomes part of the radical gesture of such projects. They may be outside, but they refuse to be sidelined. This can be observed in both the proximity of their engagements with science and technology as well as their forcing of scientific and technological practice to be reconsidered in the context of its application.[3] In light of the authority the sciences hold as arbiters of truth, and the comparative marginalization of the arts in what our culture defines as "necessary," such engagements are impressive.

Another important point to make about the diplomatic work of condition #2 is how it involves strategic and tactical linking with

established structures of power, such as government agencies and research institutions, to create transfers of resources. As I have described, in many ways these projects suffer from the precarity of being outside of established institutions and processes—for example, those maintaining infrastructure. While this enables freedom, it leaves less security for continuity. But these projects strategically attended to larger-scale challenges already of common concern, such as stormwater management and abandoned gas stations. By concerning themselves with those issues, as well as with those of a local community, artists gained for their efforts both expertise and an authority that opened doors to funding and centers of decision-making. The *WATERWASH ABC* wetland, for example, was an opportunity for a landowner and businessman to contribute to his community. It was also an experiment carried out by scientists and engineers at Drexel University to build knowledge about solving local issues related to stormwater-runoff management and a site for the state of New York to send resources from a fund generated by fines on polluters upstream. The engagement of a soil scientist was critical for the work Frances Whitehead pursued with phytoremediation research. She aimed not only to benefit a particular neighborhood but also to provide verifiable data that could be useful to city agencies struggling to solve soil-pollution problems.

As I acknowledged in the beginning of this book, my stories involve white people developing projects in places populated by those barred from many privileges and often of color. I do not offer these studies as models for how such projects ought to happen. Instead, the aim is to clarify the nature of the work to pull the politics of orphaned space into focus, as it is hidden by racism and a disregard for what sustains us. We learn from examples of work in new locations and with diverse species, and that attract resources from elsewhere to make something new happen. This building of connectivity and transferring of resources is all diplomatic work.

The collaborations between artists and scientists were especially critical to these efforts, pulling in much-needed scientific expertise as well as that of city agencies and funding organizations. Scientists in academia and people in government agencies have access to tech-

nology, funding, and other material as well as symbolic resources. And while navigating the diverse interests of a collaborative effort can be challenging, it also enables the transfer of useful expertise and provided each project with a broader relevancy and base of support. As I detailed in the previous chapters, the information supplied by outside experts was rarely adopted wholesale. There was often discussion and negotiation and sometimes, as in Lillian Ball's ignoring of a standard plant list, a rejection. But there was also respect and commitment, a recognition of the value of scientific and technological expertise. So-called local and community planning is hardly inured to bad ideas. The diplomacy of connecting in orphaned space can take advantage of outside expertise and adapt standards so they fit a local situation but still avoid well-established pitfalls.

Condition #3: Cultivate a collective imagination. As revealed in Chapter 5, local resources have to be identified and cultivated for sustaining new processes of inhabiting and caring for orphaned spaces. It's the important distinction between place making and place keeping, resisting the notion that people from elsewhere are experts in defining place and creating new connections.[4] Swooping in from the outside can be the downside of place making if it erases history and fails to acknowledge the variegations of a distinct local landscape. It's a negotiation similar to what Isabelle Stengers refers to as "collective, and always situated, capacities to think, imagine, and create."[5] The research and "deep listening," as Jackie Brookner called her work, was informed by her desire to make space for just this kind of situated imagining. It began with her sharing control of the project with a local team of artists. She used buy-in from the city administration to broaden the boundaries of a conversation they themselves had started, insisting that stormwater engineers could share a common understanding and language with basket weavers, prairie plant enthusiasts, community gardeners, communities of immigrants, and stormwater in search of a meander. She acted as catalyst for imagining but also as a diplomat, holding the door open so those diverse imaginings were heard and responded to in specific project design. Part of her efforts to build a constituency for the Fargo Project involved creating opportunities

for people to share ideas and experiences as well as physical engage-ments in terms of leisure activities, building things, growing food, and eating together.

Cumulatively, this kind of work nurtures the emergence of new "narrative networks," in which people share a common and mutu-ally binding story about relationships with plants, animals, or a river, for example, in ways that help perpetuate collective action.[6] This bottom-up engagement includes other-than-human actors as well, reflected in narratives that shape new orientations to technology and new characters and relationships in previously overlooked, neglected spaces.

In Chapter 5, I described one event held to encourage people to discuss their ideas about "nature." What emerged from the discus-sion was complicated, and it felt tragic. It was also exceptional. Too often, in environmental work, we rush ahead, already comfortable with our definitions. It's important to resist a fear of what one might hear. As I discussed in Chapter 2, urban "greening" projects can suf-fer from just this problem, importing easy definitions of nature and leaving unexamined the assumptions behind such agreeable-sound-ing objectives as "native" plantings, "community" gardening, urban trees, and "local" food.[7] For sure, opening up our conversations about nature and listening to a diversity of perspectives on how humans relate to Earth can feel very risky. Such narratives sit uncomfortably with stories about Earth and humans as part of an integrated and ultimately sustaining whole. We run the risk of reinventing wheels or, worse, veering into narratives of empty spirituality or human-centered resource extraction. But the risk is worth taking, as the case studies here reveal. We are already paying the cost of not having these con-versations, as visible in the lack of stories people can tell about their own environments. The benefits of expanding people's experiences, developing new technologies of care, confronting land-based ineq-uities, and forging a new land ethic for *all* the spaces around us are enormous.

Altogether, the three conditions for loving orphaned space in-form each other; there are overlaps in the refusal to accept empty space, the senses engaged via acts of occupying, the refusal of easy decisions, and the creative ideas generated as a result. There are op-

portunities and, inevitably, violences. It's a matter of recognizing that ecology can be a kind of totalitarianism and of rejecting ready discourses of "balance," "sustainability," and "systems." Prepare for conflict, not only with humans but with troublesome plants, water, insects, and more.

Examples of people loving orphaned space are not hard to find. Projects are being pursued in all sort of locations as communities, faced with a gutted public sector and struggling against institutions designed to repress instead of safeguard, work to get organized, to develop their own distinctive notions of place, and to solve their own problems.[8] Due to the vulnerability of these projects, moving as they do into spaces not protected by long-term institutional commitments, it's easy to feel that loving orphaned space is a fool's errand. There are barriers—city administrations need income from expanding tax bases and real estate development, and current policies grease the skids for such development and make it difficult for citizens to participate in the ongoing churn of urban change. In addition, success is often defined according to how well such efforts connect to sources of jobs and income. None of the projects I describe centered that goal, and to some extent, they refused to be an easy solution to the state's problems. There's a double edge here—these projects aim to avoid becoming an instrument by which the state promotes a "growth agenda," but also engage the state to step forward and help maintain a more supportive notion of multiply-engaged infrastructure, attending to food insecurity, environmental injustice, heat islands, local flooding, and more.

Orphan spaces are all around us, waiting to be seen. Critical work needs to be done to shift land management policies and defend public space access, but that work needs to be fueled by direct, sensual experience. Walk. Sit. Occupy. Take photos and share them. Develop propinquity. Talk with, and listen to, whomever or whatever shares your orphaned space. Ask questions but also sit quietly and listen. What kinds of plants, insects, and structures are here? Who claimed ownership of this land—10, 50, or 250 years ago? What happens when the seasons shift? What can you learn about how this space is connected to others? Are there connecting pipes? Migrating birds? What, if any, is the official presence in the space? Lessons can be

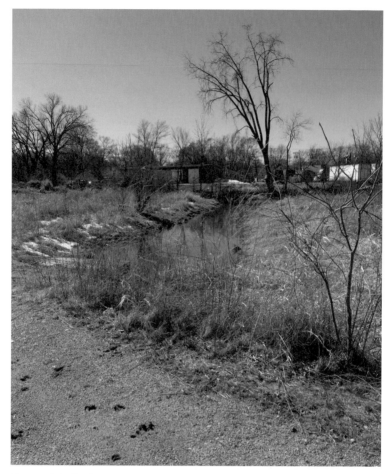

Figure 6.1 Orphan spaces are all around us, waiting to be seen. Walk. Sit. Occupy. (Photo by the author.)

learned about natural history and not-so-natural history.[9] It is important to avoid wasting all one's energy on policy change or flinging oneself against the brick wall of private property rights. Marshaling will comes first.

Your work will become collaborative. Others will already be there or want to be there. Share stories, keep the interest alive. You might experiment. I have found that if I regularly tend to a place—picking

up trash, pulling fallen branches off a path, nodding hello to those I encounter—I notice others doing more of the same. Attention to the orphan builds on itself. Get creative about resources, share seeds, and dumpster dive plants. Networks can be flexible and crafty. But also, be ready for networks to disappear. Resist and organize but be unafraid of ephemerality. As we've seen, orphans are places of vulnerability. The forces at work employing them as maintenance infrastructure do not yield easily, whether they are girded by a system of private property laws, urban planning standards that minimize "allowable behaviors," or the thicket of bureaucratic requirements anyone must navigate for official permission to be in an orphaned space. While creative things can happen, they can disappear when a city administration shifts, when a piece of land is sold, or when funding dries up. Loving orphan space is an act of resistance and persistence. It involves caring where it makes "no sense" in an ordinary calculus. As the first condition reminds us, it is an insistence to reject the void and the routine creation of abused spaces of maintenance. We can choose to see them and try to listen to their stories. Occupying is opening the door. It means broadening a conversation, trying to entice in those who are busy elsewhere, and risking building something beautiful that can disappear. After all, asks can be turned down and appeals denied, but there are often alternative routes in. And we will be the larger for our love of a place. Be reminded that there are tremendous benefits if, even in the short term, waters run clearer, a generation of bees find pollen, or a migrating bird has a place to stop. Maybe a person saw a river, ate from a community garden, or felt OK for a moment, maybe even inspired. It's a narrative that can sustain us even through bad times. A connected orphan opens eyes and minds and expands hearts. We need to do this—to remind ourselves of the relentless renewing energy and giving of Earth—and encourage more people to do the same. Each orphan is an opportunity to celebrate, care for, and give thanks for that generosity.

Now put down this book and go outside.

Notes

Chapter 1

1. Raul Lejano, Mrill Ingram, and Helen Ingram, *The Power of Narrative in Environmental Networks* (Cambridge, MA: MIT Press, 2013).

2. Karen Barad, "No Small Matter: Mushroom Clouds, Ecologies of Nothingness, and Strange Topologies of Spacetimemattering," in *Arts of Living on a Damaged Planet: Ghosts and Monsters of the Anthropocene*, ed. Anna L. Tsing, Nils Bubandt, Elaine Gan, and Heather A. Swanson (Minneapolis: University of Minnesota Press, 2017), G112.

3. Barad, "No Small Matter," G113.

4. Angeliki Balayannis and Emma Garnett, "Chemical Kinship: Interdisciplinary Experiments with Pollution," *Catalyst: Feminism, Theory, Technoscience* 6 no. 1 (2020): 1–10.

5. Marc Augé, *Non-Places: Introduction to an Anthropology of Supermodernity* (London: Verso, 1995); see also Matthew Gandy, "Unintentional Landscapes," *Landscape Research* 41, no. 4 (2016): 433–440.

6. Sheila Foster and Christian Iaione, "Ostrom in the City: Design Principles and Practices for the Urban Commons," in *Routledge Handbook of the Study of the Commons*, ed. Dan Cole, Blake Hudson, and Jonathan Rosenbloom (New York: Routledge, 2018), 235–255.

7. Robert Lee, Tristan Ahtone, Margaret Pearce, Kalen Goodluck, Geoff McGhee, Cody Leff, Katherine Lanpher, and Taryn Salinas, "Land-Grab Universities," available at landgrabu.org; also, Ruth Wilson Gilmore, "Forgotten

Places and the Seeds of Grassroots Planning," *Engaging Contradictions: Theory, Politics, and Methods of Activist Scholarship*, ed. Charles R. Hale (University of California Press, 2008), 31–61.

8. Emily Hamer, "Madison City Council Gives Green Light to Amazon Project on East Side," *Wisconsin State Journal*, April 1, 2020, available at https://madison.com/wsj/news/local/govt-and-politics/madison-city-council-gives-green-light-to-amazon-project-on-east-side/article_b2fa39a4-c709-5e68-b150-15b8e97957dd.html.

9. Some resources around the politics of green infrastructure include: Kenneth A. Gould and Tammy L. Lewis, *Green Gentrification: Urban Sustainability and the Struggle for Environmental Justice* (New York: Routledge, 2016); Laurie Ann Mazur, *Resilience Matters 2017: Transformative Thinking in a Year of Crisis* (Washington, DC: Island Press, 2018); Sara Meerow, Joshua P. Newell, and Melissa Stults, "Defining Urban Resilience: A Review," *Landscape and Urban Planning* 147 (2016): 38–49; and Jennifer R. Wolch, Jason Byrne, and Joshua P. Newell, "Urban Green Space, Public Health, and Environmental Justice: The Challenge of Making Cities 'Just Green Enough,'" *Landscape and Urban Planning* 125 (2014): 234–244.

10. Louise Erdrich, *The Night Watchman* (New York: Harper Collins Publishers, 2020), 44.

11. Geographers Stephen Graham and Nigel Thrift write: "For, as Leigh-Star argues, making the Heideggerian point once again, infrastructure systems are often physically and metaphorically veiled beneath the surface of urban life . . . [and] only tend to become manifest when they cease to function or when the flows sustained by them are interrupted." Stephen Graham and Nigel Thrift, "Out of Order: Understanding Repair and Maintenance," *Theory, Culture & Society* 24, no. 3 (2007): 8. Also, Susan Leigh Star, "The Ethnography of Infrastructure," *American Behavioural Scientist* 43, no. 3 (1999): 377–391.

12. Lillian Ball, "Called to Action: Environmental Restoration by Artists," *Ecological Restoration* 26, no. 1 (2008): 27–32; see also Liam Heneghan, "What Restoration Ecology Could Learn from Art Conservation," *Aeon*, December 15, 2020, available at https://aeon.co/essays/what-restoration-ecology-could-learn-from-art-conservation.

13. There is a great deal to say about environmental art. Assessing environmental artwork from the 1960s to the 1990s, Jeffrey Kastner and Brian Wallis wrote, "The great earthmovers who worked to forcibly rearrange the stuff of the natural world in an effort to mediate our sensory relationship with the landscape were succeeded by artists who sought to change our emotional and spiritual relationship with it. They, in turn spawned a third approach, that of the literally 'environmental' artist, a practice which turned back to the terrain, but this time with an activity meant to remedy damage rather than poeticize it." Jeffrey Kastner and Brian Wallis, *Land and Environmental Art* (London: Phaidon Press, 1988), ii. For a more recent perspective, see Amanda Boetzkes, *The Ethics of Earth Art* (Minneapolis: University of Minnesota Press, 2010). Many

environmental artists—including those I write about in this book and others, such as Newton and Helen Mayer Harrison—routinely engage with the "social" as part of their work. This broader development of "relational," "participatory," and "community" art has been described by many, including Nicolas Bourriaud, *Relational Aesthetics* (Paris: Les Presses du Reel, 2002); Harriet Hawkins, "Dialogues and Doings: Sketching the Relationships Between Geography and Art," *Geography Compass* 5 (2011): 464–478; Shannon Jackson, *Social Works: Performing Art, Supporting Publics* (New York: Routledge, 2011); Suzanne Lacy, *Leaving Art: Writings on Performance, Politics, and Publics* (Durham, NC: Duke University Press, 2010); and Grant H. Kester, *Conversation Pieces: Community Communication in Modern Art* (Berkeley: University of California Press, 2004). For more on Mierle Laderman Ukeles, see Kelly C. Baum, "Earthkeeping, Earthshaking," in *Critical Landscapes: Art, Space, Politics*, ed. Kirsten J. Swenson (Berkeley: University of California Press, 2015), 110–120.

14. Mierle Laderman Ukeles, "MANIFESTO FOR MAINTENANCE ART, 1969! Proposal for an Exhibition: 'CARE', 1969." Available at https://feldman gallery.com/exhibition/manifesto-for-maintenance-art-1969.

15. Aruna D'Souza, "The Art of Citizenship: Mierle Laderman Ukeles at the Queens Museum," *Art Practical*, November 10, 2016, available at https://www .artpractical.com/feature/the-art-of-citizenship-mierle-laderman-ukeles-at-the -queens-museum.

16. Wendell Berry, *The Hidden Wound* (Boston, MA: Houghton Mifflin, 1970), 142.

17. Also see Nancy Fraser, "Contradictions of Capital and Care," *New Left Review* 100, no. 99 (2016): 117.

18. Mierle Laderman Ukeles, "A Journey: Earth/City/Flow," *Art Journal* 51, no. 2 (1992): 12, 13.

19. Alex McInturff, Wenjing Xu, Christine E. Wilkinson, Nandintsetseg Dejid, and Justin S. Brashares, "Fence Ecology: Frameworks for Understanding the Ecological Effects of Fences," *BioScience* 70, no. 11 (2020): 971–985.

20. David Harvey, in a 2014 essay titled "The Crisis of Planetary Urbanisms," wrote, "Urbanization has increasingly constituted a primary site of endless capital accumulation that visits its own forms of barbarism and violence on whole populations in the name of profit. Urbanization has become the center of overwhelming economic activity on a planetary scale never before seen in human history." The essay appeared in *Uneven Growth: Tactical Urbanisms for Expanding Megacities* (New York: Museum of Modern Art, 2014), available at https://www.spaceandculture.com/2014/11/19/david-harvey-the-crisis-of-plan etary-urbanisms/. For more on patterns of urban growth, see Burak Güneralp, Meredith Reba, Billy U. Hales, Elizabeth A. Wentz, and Karen C. Seto, "Trends in Urban Land Expansion, Density, and Land Transitions from 1970 to 2010: A Global Synthesis," *Environmental Research Letters* 15, no. 4 (2020): 6, available at https://iopscience.iop.org/article/10.1088/1748-9326/ab6669#erlab6669s3. The authors state: "In North America, Europe, India, and China, the decreases

in urban population densities are much clearer in small-medium urban centers. Notably, overall urban population densities among the small-medium urban centers in North America decreased from about 3500 people km^{-2} to nearly 500 people km^{-2}, the lowest across all regions." They continue: "The pace of growth in cities strain municipal utilities, already having to function in increasingly fragmented and incongruent urban governance structures, leading to unequal access to several basic services across different parts of the city. Poorly planned or unplanned expansion of cities can also increase the socio-spatial segregation perpetuating unequal access to jobs, green space, and other amenities." For a fascinating take on European population decline and a curious "rewilding," see Cal Flyn, *Islands of Abandonment: Life in the Post-Human Landscape* (New York: HarperCollins, 2021).

21. Galen D. Newman, Ann O'M. Bowman, Ryun Jung Lee, and Boah Kim, "A Current Inventory of Vacant Urban Land in America," *Journal of Urban Design* 21, no. 3 (2016): 302–319; also, Shlomo Angel, Alejandro M. Blei, Daniel L. Civco, and Jason Parent, *Atlas of Urban Expansion* (Cambridge, MA: Lincoln Institute of Land Policy, 2012), online database available at http://www.atlasofurbanexpansion.org/.

22. Kevin T. Smiley and Christopher R. Hakkenberg, "Race and Affluence Shape Spatio-Temporal Urbanization Trends in Greater Houston, 1997 to 2016," *Land Use Policy* 99 (2020): Vol 99(C).

23. Michael Kimmelman, "Lessons from Hurricane Harvey: Houston's Struggle Is America's Tale." *New York Times*, November 11, 2017, available at https://www.nytimes.com/interactive/2017/11/11/climate/houston-flooding-climate.html. For ParkScore, visit Trust for Public Land, "ParkScore," available at https://www.tpl.org/parkscore.

24. "Hurricane Harvey: Impact and Response in Harris County," Harris County Flood Control District, May 2018, available at https://www.hcfcd.org/Portals/62/Harvey/harvey-impact-and-response-book-final-re.pdf.

25. Jennifer Foster and L. Anders Sandberg, "Friends or Foe? Invasive Species and Public Green Space in Toronto," *Geographical Review* 94, no. 2 (2004): 178–198.

26. Thom Van Dooren and Deborah Bird Rose, "Storied-Places in a Multispecies City," *Humanimalia* 3, no. 2 (2012): 1–27.

27. Open spaces in cities, especially streets, provide gathering places for people attempting to organize themselves and engage in political protest. As these spaces are surveilled, militarized, and policed in violent ways—for example, during the Black Lives Matter protests of 2020—they become increasingly dangerous.

28. Chiara Tornaghi and Chiara Certomà, eds., *Urban Gardening as Politics* (New York: Routledge, 2018).

29. David George Haskell, *The Forest Unseen: A Year's Watch in Nature* (New York: Penguin, 2013), 63.

30. Wesley W. Stone, Robert J. Gilliom, and Karen R. Ryberg. "Pesticides in US Streams and Rivers: Occurrence and Trends during 1992–2011," *Environmental Science & Technology* (2014): 11025–11030.

31. Megan Heckert, Joseph Schilling, and Fanny Carlet, "Greening Legacy Cities: Recent Research on Local Strategies for Reclaiming Vacant Land," VPRN Research and Policy Brief No. 1, 2016, available at https://vacantprop ertyresearch.com/wp-content/uploads/2016/02/20160210_Urban-Greening -Translation-Brief_FINAL-1.pdf. In city after city in the United States, African American neighborhoods are disproportionately affected by vacancy and abandonment. This is not a coincidence but rather the result of explicit and implicit racially biased planning, development, and lending practices. See Colleen Cain, *Fighting Blight in the Northeast-Midwest Region: Assessing the Federal Response to Vacant and Abandoned Properties* (Washington, DC: Northeast Midwest Institute, May 2016), available at https://www.nemw.org/wp-content/uploads /2016/05/2016-Fighting-Blight-in-NEMW.pdf. On aging infrastructure, see Lauren Carlson and Patricia White, *The Business Case for Green Infrastructure: Resilient Stormwater Management in the Great Lakes Region* (Detroit, MI: Urban Land Institute Michigan District Council, 2017). Research has found that formerly redlined neighborhoods are today 5–12 degrees warmer in summer months, are more likely to have Black or Hispanic residents, and have more paved surfaces and consistently far fewer trees and parks to cool the air. J. S. Hoffman, V. Shandas, and N. Pendleton, "The Effects of Historical Housing Policies on Resident Exposure to Intra-Urban Heat: A Study of 108 US Urban Areas," *Climate* 8, no. 1 (2020): 12.

32. Jesse Goldstein, "*Terra Economica*: Waste and the Production of Enclosed Nature," *Antipode* 45, no. 2 (2013).

33. In *Inventing the Social*, the editors set the stage for experimental research approaches that appreciate the "creativity of social life" and engage with the materiality and especially the agency of the nonhuman world: "It is important to recognise that not only social research, but also arts and design disciplines have, for some time, drawn attention to the special role of technology and material entities—such as buildings—in the conduct and performance of social life. The idea of the materiality of social life is of crucial importance in understanding how invention may be a characteristic of social research. Sociologists and anthropologists have long argued that it is not just practices, rituals and ideas that inform the ongoing performance of social life, but also the settings (such as buildings), infrastructures (such as electricity and radio) and environments (mountains, cities, the air) in which it unfolds." Noortje Marres, Michael Guggenheim, and Alex Wilkie, "Introduction: From Performance to Inventing the Social," in *Inventing the Social*, ed. Noortje Marres, Michael Guggenheim, and Alex Wilkie (Manchester, UK: Mattering Press, 2018), 20.

34. Much of the field research for these case studies was supported by the project *ART/SCIENCE: Collaborations, Bodies, and Environments* funded by

an Arts and Humanities Research Council/National Science Foundation grant (AHRC Grant No. AH/I500022/1; NSF Grant No. 86908) and AHRC Grant No. AH/L005034/1. See "ART/SCIENCE: Collaborations, Bodies, and Environments," University of Arizona, December 11, 2013, available at https://art science.arizona.edu/.

Chapter 2

1. See "Fact Sheet: The Secure Fence Act of 2006," White House Archives, President George W. Bush, October 26, 2006, available at https://georgewbush -whitehouse.archives.gov/news/releases/2006/10/20061026-1.html. "In 2009, an analysis of bodies recovered in the deadliest section of the border found that the risk of dying was 1.5 times higher in 2009 than in 2004 and 17 times greater than in 1998." Source: Maria Jimenez, "Humanitarian Crisis: Migrant Deaths at the U.S.–Mexico Border," ACLU of San Diego and Imperial Counties and Mexico's National Commission of Human Rights, October 1, 2009, 8, available at https://www.aclu.org/sites/default/files/pdfs/immigrants/humanitariancri sisreport.pdf; see also Krista Schyler, "Embattled Borderlands," 2017, available at http://storymaps.esri.com/stories/2017/embattled-borderlands/index.html; and GAO (Government Accountability Office), "Illegal Immigration: Border-Crossing Deaths Have Doubled Since 1995; Border Patrol's Efforts to Prevent Deaths Have Not Been Fully Evaluated," Report GAO-06-770, August 2006, available at https://www.gao.gov/new.items/d06770.pdf.

2. For example, see the visual storytelling project, "Atascosa Borderlands," available at https://atascosaborderlands.com/.

3. Jason De Leon, *The Land of Open Graves: Living and Dying on the Migrant Trail* (Berkeley: University of California Press, 2015), 5.

4. Val Plumwood, "Shadow Places and the Politics of Dwelling," *Australian Humanities Review*, no. 44 (2008): 139, 147.

5. Plumwood, "Shadow Places and the Politics of Dwelling," 145. Plumwood is citing Bill Neidjie, *Kakadu Man* (Canberra, Australia: Mybrood, 1986), 166.

6. Deborah Bird Rose, "Shimmer: When All You Love Is Being Trashed," in *Arts of Living on a Damaged Planet: Ghosts and Monsters of the Anthropocene*, ed. Anna Lowenhaupt Tsing, Heather Anne Swanson, Elaine Gan, and Nils Bubandt (Minneapolis: University of Minnesota Press, 2017), G51–G63. Also, Jane Bennet has written compellingly of "vital materialities," drawing on multiple Western philosophical traditions to challenge a parsing of the world into a "dull matter" of things versus "vibrant life," or us. She joins Bruno Latour in conceiving of a more distributed notion of agency, or the "effectivity of nonhuman or not-quite-human things," and also advocates for the resistance of those things to any easy representation. Why Bennet embarks on this effort resonates with the concerns of Plumwood and Neidjie: "Because my hunch is that the image of dead or thoroughly instrumentalized matter feeds human hubris and our earth-destroying fantasies of conquest and consumption." Jane

Bennet, *Vibrant Matter: A Political Ecology of Things* (Durham, NC: Duke University Press, 2010), ix.

7. John Agnew, "Space and Place," in *The Sage Handbook of Geographical Knowledge* (London: Sage, 2011), 316; Peter J. Taylor, "Places, Spaces and Macy's: Place–Space Tensions in the Political Geography of Modernities," *Progress in Human Geography* 23, no. 1 (1999), 9, 15.

8. Michel De Certeau, "Walking in the City (1980)," in *Cultural Theory: An Anthology*, ed. Imre Szeman and Timothy Kaposy (West Sussex, U.K.: John Wiley & Sons, 2010), 271.

9. Henri Lefebvre, *The Production of Space*, trans. Donald Nicholson-Smith (Oxford, U.K.: Blackwell, 1991), 49–53.

10. Lefebvre, *The Production of Space*, 52.

11. Lejano, Ingram, and Ingram, *The Power of Narrative*. I appreciate Isabelle Stengers, Bruno Latour, and many other science and technology studies scholars who have written appreciatively of the painstakingly careful work of scientists and those working to build relations and communicate with "others" that are hard to know. Jane Bennett captures this nicely in her writing about Charles Darwin: "Darwin watched English worms: many, many of them for many, many hours." Jane Bennett, *Vibrant Matter: A Political Ecology of Things* (Durham, NC: Duke University Press, 2010), ix.

12. Bennett, *Vibrant Matter*, 95.

13. Deborah Stone, "Caring Communities: What Would It Take," *Long-Term Care and Medicare Policy: Can We Improve Continuity of Care*, ed. David Blumenthal, Marilyn Moon, Mark Warshawsky, and Christina Boccuti (Washington, DC: Brookings Institution Press, 2003), 223.

14. Madeline Bunting, "Crisis of Care," presented on *The Essay*, produced by the BBC, March 18, 2016, available at https://www.bbc.co.uk/programmes /b0739tq7.

15. For an interesting discussion of care in the global transformation literature, see Angela Moriggi, Katriina Soini, Alex Franklin, and Dirk Roep, "A Care-Based Approach to Transformative Change: Ethically-Informed Practices, Relational Responsibility and Emotional Awareness," *Ethics, Policy & Environment* 23, no. 3 (2020): 281–298.

16. Cindi Katz, "Vagabond Capitalism and the Necessity of Social Reproduction," *Antipode* 33, no. 4 (2001): 709–728; Nancy Fraser, "Contradictions of Capital and Care"; Altha Cravey, "Toque una Ranchera, Por Favor," *Antipode* 35, no. 3 (2003): 603–621; María Puig de La Bellacasa, *Matters of Care: Speculative Ethics in More than Human Worlds* (Minneapolis: University of Minnesota Press, 2017); see also Joan C. Tronto, *Moral Boundaries: A Political Argument for an Ethic of Care* (New York: Routledge, 1993).

17. There's no consensus on terms for urban voids, which include "liminal," "loose," "dead," "vague," "superfluous," "ambivalent," and "somewhere between" space. "Stalled Spaces Glasgow" was a city council program engaging local groups to develop temporary projects like pop-up gardens, wildlife areas, and outdoor

play spaces. Vacant spaces are analyzed according to excessive planning of large landscaped open areas, outmigration, deindustrialization, bankruptcy, and environmental disasters. Analyses have also looked at the intersection of overtly favored new construction, sanctioned redlining, well-funded highway programs, and inequitable tax policies, all of which can favor sprawling development on so-called cheap land. Some references include: John Accordino and Gary T. Johnson, "Addressing the Vacant and Abandoned Property Problem," *Journal of Urban Affairs* 22, no. 3 (2000): 301–315; Anna Jorgensen and Marian Tylecote, "Ambivalent Landscapes—Wilderness in the Urban Interstices," *Landscape Research* 32, no. 4 (2007): 443–462; Seog Jeong Lee, Soewon Hwang, and Dongha Lee, "Urban Voids: As a Chance for Sustainable Urban Design," 8th Conference of the International Forum on Urbanism, 2015, Incheon, Korea; and Masayuki Sasaki, "Urban Regeneration through Cultural Creativity and Social Inclusion: Rethinking Creative City Theory through a Japanese Case Study," *Cities* 27 (2010): S3–S9.

18. Anne Whiston Spirn, "Restoring Mill Creek: Landscape Literacy, Environmental Justice and City Planning and Design," *Landscape Research* 30, no. 3 (July 2005): 395–413.

19. Barriers to local participation abound. For meetings alone, consider language, childcare, time, location, and length and structure of meetings, not to mention the very real growth-oriented biases of many town and city planning boards to facilitate new real estate development regardless of local impact. In partial response to the public participation problem, artist Amanda Lovelee's Pop Up Meeting truck literally brought the content of city meetings to the people as they assembled in parks. Amanda Lovelee, "Pop Up Meeting," available at http://amandalovelee.com/filter/Popsicles/Pop-Up-Meeting.

20. Jane Jacobs, *The Death and Life of Great American Cities* (New York: Vintage, 2016), 14; Frederick R. Steiner, *The Living Landscape: An Ecological Approach to Landscape Planning* (Washington, DC: Island Press, 2012). James Howard Kunstler, Geography of Nowhere: The Rise and Decline of America's Man-Made Landscape (New York: Simon and Schuster, 1994), 10; Eran Ben-Joseph, *ReThinking a Lot: The Design and Culture of Parking* (Cambridge, MA: MIT Press, 2012).

21. As I explore more in Chapter 5, conventional ways of behaving as well as systems of laws all create "foreigners": humans and others who are present but always defined as outsiders. As Derrida has written, "[A foreigner] is not only the man or woman who keeps abroad, on the outside of society, the family, the city. It is not the other, the completely other who is relegated to an absolute outside, savage, barbaric, precultural, and prejuridical, outside . . . the relationship to the foreigner is regulated by law, by the becoming-law of justice." Derrida and Dufourmantelle, 2000 (Stanford, CA: Stanford University Press, 73).

22. Panagiota Kotsila, Kathrin Hörschelmann, Isabelle Anguelovski, Filka Sekulova, and Yuliana Lazova, "Clashing Temporalities of Care and Support as

Key Determinants of Transformatory and Justice Potentials in Urban Gardens," *Cities* 106 (2020).

23. Stephen Graham and Simon Marvin, *Splintering Urbanism: Networked Infrastructures, Technological Mobilities and the Urban Condition* (New York: Routledge, 2001). David Harvey describes capitalism's inherent and necessary processes of urban speculation and abandonment as "creative destruction." David Harvey, "The Right to the City," *The City Reader* 6, *New Left* Review no. 1 (2008): 23–40.

24. Alex Loftus and Fiona Lumsden, "Reworking Hegemony in the Urban Waterscape," *Transactions of the Institute of British Geographers* 33, no. 1 (2008): 109–126. Yaffa Truelove, "(Re-)Conceptualizing Water Inequality in Delhi, India through a Feminist Political Ecology Framework," *Geoforum* 42, no. 2 (2011): 143–152. Filip De Boeck, "Spectral Kinshasa: Building the City through an Architecture of Words," in *Urban Theory Beyond the West*, ed. Tim Edensor and Mark Jayne (New York: Routledge, 2012), 318.

25. Mark Purcell, "Possible Worlds: Henri Lefebvre and the Right to the City," *Journal of Urban Affairs* 36, no. 1 (2014): 149. Henri Lefebvre has described the contemporary street: "Although the street may have once had the meaning of a meeting place, it has since lost it, and could only have lost it, by reducing itself . . . to nothing more than a passageway, by splitting itself into a place for the passage of pedestrians (hunted) and automobiles (privileged). The street became a network organized for and by consumption." Henri Lefebvre, *The Urban Revolution* (Minneapolis: University of Minnesota Press, 2003), 20.

26. Mark Purcell, "Possible Worlds: Henri Lefebvre and the Right to the City," *Journal of Urban Affairs* 36, no. 1 (2014): 150.

27. Janina Kowalski and Tenley Conway, "Branching Out: The Inclusion of Urban Food Trees in Canadian Urban Forest Management Plans," *Urban Forestry & Urban Greening* 45 (June 2018), available at https://www.researchgate.net/publication/325535486_Branching_out_The_Inclusion_of_Urban_Food_Trees_in_Canadian_Urban_Forest_Management_Plans.

28. Andrew Karvonen and Ken Yocom, "The Civics of Urban Nature: Enacting Hybrid Landscapes," *Environment and Planning A* 43, no. 6 (2011): 1305–1322. On democracy as conflict, see John S. Dryzek, *Deliberative Democracy and Beyond: Liberals, Critics, Contestations* (New York: Oxford University Press, 2002).

29. Nicole Crutchfield, "Towards Creative Government: Models for Municipal-Artist Partnerships," Common Field Conference online, April 23, 2020, available at https://www.commonfield.org/convenings/3248/program/4021/towards-creative-government-models-for-municipal-artist-partnerships.

30. See endnote 9 in Chapter 1 for readings on the politics of urban greening.

31. Erik Swyngedouw and Maria Kaika, "Urban Political Ecology: Great Promises, Deadlock . . . and New Beginnings?" *Documents d'anàlisi geogràfica* 60, no. 3 (2014), 467; Timothy W. Luke, "Sustainability and the City," in *Handbook of Cities and the Environment*, ed. Kevin Archer, Kris Bezdecny (Chelten-

ham: Edward Elgar, 2016), 433–453; Bruce P. Braun, "A New Urban Dispositif? Governing Life in an Age of Climate Change," *Environment and Planning D: Society and Space* 32, no. 1 (2014), 60; see also Panagiota Kotsila, Isabelle Anguelovski, Francesc Baró, Johannes Langemeyer, Filka Sekulova, and James JT Connolly, "Nature-Based Solutions as Discursive Tools and Contested Practices in Urban Nature's Neoliberalisation Processes," *Environment and Planning E: Nature and Space* 4, no. 2 (2021), 252–274.

32. Kathryn Furlong described a widespread tendency in geography and science and technology studies (STS) to take for granted the holistic nature of systems of infrastructure. She challenges this orientation by writing about the influence of small changes in large infrastructure systems, arguing that small "mediating" technologies, like end-user meters, provide a mechanism through which users not only participate in the economic and environmental performance of a system but also become more aware of it in general, thus countering the tendency of infrastructure to become "invisible." Kathryn Furlong, "Small Technologies, Big Change: Rethinking Infrastructure through STS and Geography," *Progress in Human Geography* 35, no. 4 (2011): 460–482; see also Stephen Graham, ed., *Disrupted Cities: When Infrastructure Fails* (London: Routledge, 2010).

33. A pejorative term, plop-art (a play on pop-art) refers to sculpture or installation in public space, often government or corporate plazas, with no connection to the surroundings.

34. In her *Cosmopolitical Proposal*, Isabelle Stengers distinguishes the figure of the diplomat as one who is there to provide a voice for those who are threatened, to remove the anesthesia that disappears the vulnerable. Diplomatic creativity is not about being neutral, establishing common ground, or forcing alignment, however. It involves creating occasions in which those assembled accomplish what they did not previously imagine possible. I write more extensively about this in Chapter 4. See Isabelle Stengers, "The Cosmopolitical Proposal," in *Making Things Public: Atmospheres of Democracy*, ed. Peter Weibel and Bruno Latour (Cambridge, MA: MIT Press, 2005), 994–1003.

35. Bruce Braun and Sarah Whatmore have written about a "more fully materialist theory of politics," without which we are "unable to make sense of the collectivities in which we live and to respond adequately to the technological ensembles that are folded through social and political life." The authors go on to say that "the profusion of complex materials with and through which we live too often leaves us oscillating between fearful repudiation and glib celebration. Such swings get in the way of creatively exploring new corporeal capacities or reflecting seriously on how we might have been, or could be, different than we currently are." Bruce Braun and Sarah J. Whatmore, *Political Matter* (Minneapolis: University of Minnesota Press, 2010), x.

36. Anna Tsing writes usefully about the ecological concept of assemblage: "Ecologists turned to assemblages to get around the sometimes fixed

and bounded connotations of ecological 'community.' The question of how the varied species in a species assemblage influence each other—if at all—is never settled. . . . Assemblages are open-ended gatherings. They allow us to ask about communal effects without assuming them. They show potential histories in the making." Anna Lowenhaupt Tsing et al., eds., *Arts of Living on a Damaged Planet: Ghosts and Monsters of the Anthropocene* (Minneapolis: University of Minnesota Press, 2017).

Chapter 3

1. JD Pluecker speaking at the Common Field conference, "All Together Session: Notas al Calce/Footnotes to the City," streamed live on April 23, 2020, YouTube video, 28:12, available at https://www.youtube.com/watch?v=LGm X4LmhDx0. Learn more about JD's "The Unsettlements" project at https://jd pluecker.com/the-unsettlements. Quote used by permission of JD Pluecker.

2. Kevin R. Duncan and B. Todd Bailey, "Innocence amid 'LUST': The Innocent Buyer and Leaking Underground Storage Tanks Containing Petroleum," *Brigham Young University Journal of Public Law* 7, no. 2 (1993): 245–279, available at https://digitalcommons.law.byu.edu/jpl/vol7/iss2/3; Mark D. Oshinskie, "Tanks for Nothing: Oil Company Liability for Discharges of Gasoline from Underground Storage Tanks Divested to Station Owners," *Virginia Environmental Law Journal* 18, no. 1 (1999): 1–39, available at http://www.jstor.org/stable/24 785941.

3. According to a 2019 investigation of the nation's fourth-largest environmental agency (TCEQ, or Texas Commission on Environmental Quality) by the *Texas Observer*, hundreds of Texas gas station owners, often first-generation immigrants, have been fined for missing or incorrect paperwork even as big corporations receive lesser punishment for releasing dangerous pollutants. The *Observer* analyzed more than 300,000 rows of data related to TCEQ's enforcement activity from 2009 to 2017, finding that TCEQ collected $24 million from tank operators, the vast majority of whom were gas station owners. That's only slightly lower than the $30 million it collected from the thousands of industrial facilities—refineries, petrochemical plants, and cement batch plants—across the state that violated their air permits. Naveena Sadasivam, "Too Big to Fine, Too Small to Fight Back," *Texas Observer*, February 21, 2018, available at https:// www.texasobserver.org/too-big-to-fine-too-small-to-fight-back/.

4. To learn more about the role of the petroleum industry in the exclusion of gas and gas-related pollution from EPA oversight, see Roger Armstrong, "CERCLA's Petroleum Exclusion: Bad Policy in a Problematic Statute," *Loyola of Los Angeles Law Review* (1993): 1157–1193. The limitations of the regulation essentially placed the responsibility for cleanup on the shoulders of small gas station owners and taxpayers and the burden of the pollution on the bodies of millions of Americans who suffered illness as a result. Sylvia Adipah, "Intro-

duction of Petroleum Hydrocarbons Contaminants and Its Human Effects," *Journal of Environmental Science and Public Health* 3 (2019): 1–9.

5. Sources include: Industrial Economics Incorporated, "Assessment of the Potential Costs, Benefits, and Other Impacts of the Final Revisions to EPA's Underground Storage Tank Regulations," Cambridge, MA (April, 2015), available at https://www.epa.gov/sites/default/files/2015-07/documents/regs2015-ria.pdf; also, Leah Benedict Yasenchak, "What We Know About the Ubiquitous Brownfield: A Case Study of Two New Jersey Cities and Their Gas Stations," *Environmental Practice* 11, no. 3 (2009): 144–152.

6. United States Environmental Protection Agency, *Semiannual Report of UST Performance Measures End of Fiscal Year 2019 (October 1, 2018–September 30, 2019)*, Washington DC: USEPA Office of Underground Storage Tanks (2019). Report available at https://www.epa.gov/sites/production/files/2019-11/documents/ca-19-34.pdf.

7. As just one snapshot of the magnitude of this burden, the state of Michigan reported in 2010 that since 1986 they'd catalogued over 21,800 releases from underground storage tanks, with the potential pollution triggering required regulation at state and federal levels. Over 25 years, the state's environmental agency has cleaned up some 12,750 releases, leaving about 9,100 unaddressed, half of which are orphaned, meaning the state is the only entity likely to take any remedial action on them. At a cost of $400,000 per site, on average, Michigan's environmental agency estimated that this backlog could cost upward of $1.8 billion. The bulk (60 percent) of these documented releases are more than 10 years old. These older release sites represent a catch-22 situation, as older sites tend to require more extensive cleanups since released products have had more time to seep further into the ground and spread. This makes these cleanups more expensive, and consequently the department is unable to perform as many cleanups, which, in turn, allows existing releases to age and become more extensive.

8. In her 2014 New York University Press book, *Toxic Communities*, Dorceta Taylor describes how blighted sites, from landfills to industrial buildings to gas stations, still disproportionately affect communities of color. While the reasons for this are complex and widely varied (the notion that cheap land attracts both economically fragile and disenfranchised communities as well as undesirable uses is one explanation put forth by Taylor), the fact remains that race and not income remains the best predictor of whether or not a person lives close to an unhealthy site. In her research, Leah Beth Benedict Yasenchak found that economically disadvantaged communities host the majority of former gas station sites and that many still pose a threat to those living nearby. Leah Beth Benedict Yasenchak, "The Ubiquitous Brownfield: Abandoned Gas Stations and Their Social, Economic, and Environmental Implications," Ph.D. diss., Rutgers University Graduate School, New Brunswick, New Jersey (2013).

9. A visit to Chicago's Department of Public Health's Tank Asset Database reveals a total of some 45,000 underground storage tank entries.

10. Jessica Higgins, "Evaluating the Chicago Brownfields Initiative: The Effects of City-Initiated Brownfield Redevelopment on Surrounding Communities," *Northwestern Journal of Law and Social Policy* 3, no. 2 (2008): 240, available at https://scholarlycommons.law.northwestern.edu/njlsp/vol3/iss2/5/.

11. Chloe Stephenson and Colin R. Black, "One Step Forward, Two Steps Back: The Evolution of Phytoremediation into Commercial Technologies," *Bioscience Horizons: The International Journal of Student Research* 7 (2014): 1–15.

12. Don Krug, "Ecological Restoration: Mel Chin, Revival Field," greenmuseum.org, 2006, available at http://greenmuseum.org/c/aen/Issues/chin.php.

13. Frances Whitehead and Christine Atha, "Complexity and Engagement: Art and Design in the Post Industrial," *MADE* 6 (2010): 43–52, available at http://www.cardiff.ac.uk/archi/made.php.

14. The Remediation Arboretum, which investigates how fruiting trees and shrubs can reboot urban soils; the Climate Corridor, a linear planting of ornamental flowering trees that beautifies the streetscape, transforming it into a seasonal, place-based, climate-visualization experience; and the Community Lab Orchard, where citizen scientists explore and demonstrate the culture of favorite and forgotten small fruits for a resilient foodshed.

15. Mrill Ingram, "Material Transformations: Urban Ecological Art and Environmental Justice," in *Restoring Layered Landscapes: History, Ecology, and Culture*, ed. Marion Hourdequin and David G. Havlick (Oxford: Oxford University Press, 2012), 222–238.

16. Denis E. Cosgrove, *Social Formation and Symbolic Landscape* (Madison: University of Wisconsin Press, 1984), 15; Grant Kester, "Theories and Methods of Collaborative Art Practice," lead exhibition catalog essay for *Groundworks: Environmental Collaboration in Contemporary Art*, Regina Gouger Miller Gallery (Philadelphia: Carnegie Mellon University, 2005), 18–35; Stephen Daniels, "Marxism, Culture and the Duplicity of Landscape," in *New Models in Geography*, vol. 2, *The Political-Economy Perspective*, ed. Richard Peet and Nigel Thrift (London: Routledge, 1989), 218; Elizabeth Spelman, "Embracing and Resisting the Restorative Impulse," in *Healing Natures, Repairing Relationships: New Perspectives on Restoring Ecological Spaces and Consciousness*, ed. Robert L. France (Winnipeg, Manitoba: Green Frigate Books, 2010), 127–140; see also M. L. Quinn, "Should All Degraded Landscapes Be Restored?" *Land Degradation & Development* 3, no. 2 (1992): 115–134; Laura A. Watt, "Conflicting Restoration Goals in the San Francisco Bay," in *Restoration and History: The Search for a Usable Environmental Past*, ed. Marcus Hall (New York: Routledge, 2010), 218–219; Ingram, "Material Transformations."

17. Andrew Barry, Georgina Born, and Gisa Weszkalnys, "Logics of Interdisciplinarity," *Economy and Society* 37, no 1 (2008): 20–49, available at https://doi.org/10.1080/03085140701760841; also Harriet Hawkins, Sallie A. Marston, Mrill Ingram, and Elizabeth Straughan, "The Art of Socioecological Transformation," *Annals of the Association of American Geographers* 105, no. 2 (2015): 331–341; Keith Woodward, John Paul Jones III, Linda Vigdor, Sallie A. Marston,

Harriet Hawkins, and Deborah P. Dixon, "One Sinister Hurricane: Simondon and Collaborative Visualization," *Annals of the Association of American Geographers* 105, no. 3 (2015): 496–511.

18. Zachary M. Kron, "Memory through Re-Use: Food, Fuel, Fossils, Filth and a Few Filling Stations" (Ph.D. diss., Massachusetts Institute of Technology, 2001): 8; Jamie Marie DeAngelo, "Preservation Probabilities: A Quantitative Analysis of Austin's Historic Gas Station Stock" (Ph.D. diss., Austin: University of Texas, 2016); Matt Hisle and Frank Sleegers, "Utilizing Phytotechnologies: Redesigning Abandoned Gas Stations," in *Proceedings of the Fábos Conference on Landscape and Greenway Planning* 5, no. 1 (2016): 34.

19. Andrew Nikiforuk, "Crazy Days in Alberta: The Poison Wells File," *The Tyee*, December 16, 2019, available at https://thetyee.ca/Analysis/2019/12/16/Alberta-Poison-Wells-File/.

Chapter 4

1. Mrill Ingram, "Washing Urban Water: Diplomacy in Environmental Art in the Bronx, New York City," *Gender, Place & Culture* 21, no. 1 (2014): 105–122. Also, in the catalog essay cited above in footnote 16 Grant Kester (2005, 23) writes constructively about the need for new analytical frameworks to understand collaborative art practice and to "acknowledge the possibility that the process of intersubjective exchange itself, rather than merely transmitting existing knowledge, could be generative and ontologically transformative. It is the promise of collaborative aesthetic experience to prefigure another set of possibilities, to enact change and not simply represent a priori positions."

2. Stengers, "The Cosmopolitical Proposal," 996. Also, Bruno Latour, *We Have Never Been Modern* (Cambridge, MA: Harvard University Press, 2012).

3. Stengers, "Introducing Nonhumans in Political Theory," 6.

4. New York City Department of Parks and Recreation, "Estuary Section," available at https://www.nycgovparks.org/greening/natural-resources-group/bronx-river-wetlands/estuary-section.

5. For example, one Army Corps of Engineers proposed response to the threat of hurricanes and sea level rise in New York City was a $118 billion, five-mile seawall to protect against a storm surge. New York could see as much as a four-foot sea level rise by 2030. In 2014, work started on London's Thames Tideway, a giant "super sewer" dug through the city center to capture and move vast quantities of raw sewage and rainwater. The tunnel will run for some 15 miles, connecting CSOs to a waste treatment facility and requiring almost 926,000 tons of concrete and costing over $4.8 billion. Big cities complement such major projects with green infrastructure approaches, but the investments remain uneven. In 2010, New York City's then mayor, Mike Bloomberg, announced the city would invest up to $1.5 billion to build green infrastructure, including thousands of rain gardens, green roofs, street trees, and more. But since then, and no doubt Hurricane Sandy was an enormous influence, the city has

continued to invest heavily in traditional gray infrastructure, including propos-
ing the giant seawall. For more on the science of coastal green infrastructure,
see Jacqueline Livingston et al., "Natural Infrastructure to Mitigate Inundation
and Coastal Degradation," in *Tomorrow's Coasts: Complex and Impermanent*,
ed. Lynn Donelson Wright and C. Reid Nichols (Cham, Switzerland: Spring-
er, 2019); also Sonia C. Linton, "A Case Study Comparative of Challenges and
Opportunities for Green Infrastructure Implementation in Coastal Regions"
(Ph.D. diss., University of Georgia, 2018).

6. Siddharth Narayan, Michael W. Beck, Paul Wilson, Christopher J. Thom-
as, Alexandra Guerrero, Christine C. Shepard, Borja G. Reguero, Guillermo
Franco, Jane Carter Ingram, and Dania Trespalacios, "The Value of Coastal
Wetlands for Flood Damage Reduction in the Northeastern USA," *Scientific
Reports* 7, no. 1 (2017): 1–12.

7. "Nonnative" *Phragmites australis* may have originated in the Middle
East and not Australia. The plant creates dense networks of roots and rhizomes
that can reach almost 6 feet deep and also spread horizontally via underground
rhizomes and overground runners, which can grow 10 or more feet in a single
growing season and reach 70 feet in total. The plant does not mix well with oth-
ers, forming dense monocultures. It is fond of ditches and disturbed, saline sites
and is a common occupier of roadsides up and down the Eastern Seaboard and
across the northern sections of North America. The reed's "phenotypic plastic-
ity" has allowed it to acclimate to a range of climates.

8. Lillian Ball, Tim Collins, Rieko Goto, and Betsy Damon, "Environmental
Art as Eco-Cultural Restoration," in *Human Dimensions of Ecological Restora-
tion Integrating Science, Nature, and Culture*, ed. Dave Eagan, Evan E. Hjerpe, and
Jesse Abrams (Washington, DC: Island Press, 2011), 308.

9. Ball et al., "Environmental Art as Eco-Cultural Restoration," 309.

10. Ball et al., "Environmental Art as Eco-Cultural Restoration," 311.

11. Stephenson and Black, "One Step Forward, Two Steps Back."

12. Michael Kimmelman, "River of Hope in the Bronx," *New York Times*, July
22, 2012.

13. Watch *Decade of Fire*, a 2014 PBS Film, directed by Vivian Vázquez
Irizarry, Gretchen Hildebran, and Julie S. Allen.

14. The community study, *Clearing the Air: How Reforming the Commercial
Waste Sector Can Address Air Quality Issues in Environmental Justice Commu-
nities*, was released in 2016 by the Transform Don't Trash NYC coalition and
is available at http://transformdonttrashnyc.org/wp-content/uploads/2016/09
/Final-draft-v3_TDT-Air-Qual-Report_Clearing-the-Air-1.pdf. A 2019 study
found that Black Americans are exposed to about 56 percent more pollution
than is caused by their consumption and Hispanics 63 percent more: Chris-
topher W. Tessum, Joshua S. Apte, Andrew L. Goodkind, Nicholas Z. Muller,
Kimberley A. Mullins, David A. Paolella, Stephen Polasky, Nathaniel P. Spring-
er, Sumil K. Thakrar, Julian D. Marshall, and Jason D. Hill, "Inequity in Con-
sumption of Goods and Services Adds to Racial–Ethnic Disparities in Air

Pollution Exposure," *Proceedings of the National Academy of Sciences* 116, no. 13 (March 2019), 6001–6006, available at https://doi.org/10.1073/pnas.1818859116; see also Hazar Kilani, "'Asthma Alley': Why Minorities Bear Burden of Pollution Inequity Caused by White People," *The Guardian*, April 4, 2019, available at https://www.theguardian.com/us-news/2019/apr/04/new-york-south-bronx -minorities-pollution-inequity.

15. Matthew Gandy, "Between Borinquen and the Barrio: Environmental Justice and New York City's Puerto Rican Community, 1969–1972," *Antipode* 34, no. 4 (September 2002), 737.

16. To view Morgan Powell's archives, visit Fordham University Libraries archive and manuscript collections (https://fordham.libguides.com/BronxAfri canAmHistory) as well as Powell's blog, *Bronx River Sankofa, Eco-cultural History in New York City!* (https://bronxriversankofa.wordpress.com/). Also, see Julie Sze, *Noxious New York: The Racial Politics of Urban Health and Environmental Justice* (Cambridge, MA: MIT Press, 2006); and Carolyn McLaughlin, *South Bronx Battles: Stories of Resistance, Resilience, and Renewal* (Berkeley: University of California Press, 2019).

17. Website for the bill: New York City Council, "Reducing Permitted Capacity at Putrescible and Non-Putrescible Solid Waste Transfer Stations in Overburdened Districts," 2018, available at https://legistar.council.nyc.gov/Le gislationDetail.aspx?ID=3331918&GUID=B730F207-D5EF-45B3-9F9E-9F3 56EFC58C0&Options=&Search=.

Source for the issues around waste in the Bronx: Rebecca Solnit and Joshua Jelly-Schapiro, "Trash in the City: Dumping on Staten Island and Beyond," in *Nonstop Metropolis: A New York City Atlas* (Oakland: University of California Press, 2016). Other sources for this chapter include: Joe Riley and Audrey Snyder, "Wastestreaming," *Urban Omnibus*, October 2, 2019, available at https:// urbanomnibus.net/2019/10/wastestream/; Joan Byron, "Transforming the Southern Bronx River Watershed," Pratt Institute Center for Community and Environmental Development, (May, 2004), available at https://mail.prattcenter .net/sites/default/files/transforming_the_southern_bronx_river_watershed .pdf; New York City Department of Parks and Recreation, "Estuary Section"; and Eastern Roads, "Cross Bronx Expressway," available at http://www.nycroads .com/roads/cross-bronx/.

18. Stengers, "The Cosmopolitical Proposal," (994). Diplomacy, according to Stengers, "catalyzes a regime of thought and feeling that bestows the power on that around which there is a gathering to become a cause for thinking. . . . A presence that transforms each protagonist's relations with his or her own knowledge . . . and allows the whole to generate what each one would have been unable to produce separately." Diplomacy represents a "practical and artificial" arrangement and is not defined by a mission to arrive at some deeper or transcendent truth but instead a symbiosis between heterogeneous beings with very different motivations (1002).

Chapter 5

1. D. P. Schwert, "A Geologist's Perspective on the Red River of the North: History, Geography, and Planning/Management Issues," *Proceedings of the First International Water Conference* (Moorhead, MN: Red River Basin Institute, 2003), available at https://www.ndsu.edu/fargo_geology/documents/geologists_perspective_2003.pdf; also Ross F. Collins, "Red River on a Rampage," North Dakota State University, 2004, available at https://www.ndsu.edu/pubweb/~rcollins/scholarship/Redriver.html.

2. According to Lutheran Social Services, 90 percent of the refugees resettled in North Dakota in 2015 joined family members who were already living there. In his last year in office, President Obama's administration allowed 110,000 refugees into the United States, the most since the current iteration of a U.S. refugee resettlement program began in 1980. Those numbers plummeted under the xenophobic administration of Donald J. Trump to 18,000 in 2020, but under President Biden, that trend was reversed.

3. Hands and feet were featured in a number of Jackie Brookner's works. For her 1994–1998 project *Of Earth and Cotton*, the artist visited seven locations from the Carolinas to Texas, following the westward migration of the cotton belt. "I spoke with people who farmed and picked cotton by hand in the 1930s and '40s," she wrote of the work. "As they spoke about their memories, I sat on the ground sculpting portraits of their feet out of nearby soil." The clay foot "portraits" were later displayed in installations where they rested on piles of native soil or ginned cotton. Source: http://jackiebrookner.com/project/

4. *ART/SCIENCE: Collaborations, Bodies, and Environments* was funded by an Arts and Humanities Research Council/National Science Foundation grant (AHRC Grant No. AH/I500022/1; NSF Grant No. 86908) and AHRC Grant No. AH/L005034/1.

5. Crutchfield, "Towards Creative Government."

6. Joan Ellison, "The Reshaping of Pelican Rapids: How One Small Town Met the Challenge of Transformation," *Rural Minnesota Journal* 7 (2012): 1–9, available at https://www.slideshare.net/crpdmn/rural-mn-journal-reshaping-pelican-rapids; also Sharon Schmickle, "From Ethnic Turmoil to Vibrant Diversity, Trio Helped Pelican Rapids Transform Its Culture," *Minnpost*, August 17, 2011.

7. In brief, art critics have raised concerns about work that uncritically glorifies the democratic potential of concepts such as "local" and "community" but facilitates the cultural consumption of place (Miwon Kwon, *One Place after Another: Site-Specific Art and Locational Identity* [Cambridge, MA: MIT Press, 2004], 166); reinforces notions of the autonomous expert artist as ethnographer (Hal Foster, "The Artist as Ethnographer?" in *The Traffic in Culture: Refiguring Art and Anthropology*, ed. George E. Marcus and Fred R. Myers [Berkeley: University of California Press, 1995], 302–309); misrepresents democratic pro-

cess as convivial instead of antagonistic (Claire Bishop, "Antagonism and Relational Aesthetics," *October* [2004]: 51–79); and presents apolitical distractions from problems, converting places into sites for capitalist development instead of meaningful engagement (Rosalyn Deutsche, *Evictions: Art and Spatial Politics* [Cambridge, MA: MIT Press, 1996]). As Shannon Jackson argued: "Systemic support for the arts paradoxically can use the arts as a vehicle for training citizens to seek 'individual solutions to system problems,' to recall Ulrich Beck. Such artistic palliatives offer therapeutic rehabilitation, temporary pride, or imaginative escape in once-a-week artist visits that are not reciprocally empowered to re-imagine the political economic landscape of participants." Jackson, *Social Works, 27.* In contrast, Jan Cohen-Cruz of Americans for the Arts, writing in an online tool kit for municipal-artist "partnerships," describes potential leverage points for artists to exert influence, emphasizing them as different types of labor involved in making municipal-art projects "successful." (See A Blade of Grass, "Municipal Artist Partnerships," available at https://municipal -artist.org.) These criticisms underline the importance of seeking and welcoming trouble and the unanticipated, and the willingness to take risks and upset structures of power. They gesture to why "diplomacy," with its dedication to attending to what is not typically heard, is critical. The willingness to share power, especially give it up, and to break rules almost by definition thwarts conventional notions of "partnership."

8. Vian Dakhil, "One Yazidi against ISIS," June 1, 2017, YouTube video, 16:41, available at https://www.youtube.com/watch?v=nGDhcDCLY9U.

9. Mark Anthony Rolo, *My Mother Is Now Earth* (Minneapolis: Minnesota Historical Society Press, 2012).

10. One 2016 local North Dakota "survey" carried out by a Breitbart-backed news media station stated that 57 percent of respondents don't want refugees to settle in the area and reported a much-contested story (subsequently removed from their website) about rising cases of immigrant-borne TB with the tagline: "Could kindness be bad for your health?" In September 2016 Fargo city commissioner Dave Piepkorn stated his "concern" that refugee resettlement efforts were costing Fargo millions of dollars and claimed falsely that refugees break the law more than other citizens (available at https://www.usnews.com/news /best-states/north-dakota/articles/2017-04-29/north-dakota-official-faces-re call-threat-for-refugee-claims). A rash of hate crimes followed Piepkorn's statements. A Somali man was beaten by two men yelling racial slurs. A shared video of another incident showed a woman, gold cross dangling, leaning toward a car to threaten three Muslim women in a Walmart parking lot, telling them, "We're going to kill every single one of you fucking Muslims," (available at https:// www.youtube.com/watch?v=ceBIpxrO1JY). Fargoans stood up to the racism in multiple ways. A city task force gathered data showing how quickly immigrants to Fargo contribute to the economy (available at https://download.fargond .gov/0/refugee_resettlement_in_fargo.pdf). At a Center for American Progress panel on refugee resettlement, the city's mayor shared that he'd responded to

a reporter's concern that Fargo has one of the highest per capita number of refugees by telling him he should feel proud and saying, "Great! We ought to tell everybody!" (available at https://www.youtube.com/watch?v=lKifTAEcSGc, [59:50]). As I reported in a 2018 story for *The Progressive* (available at https://progressive.org/magazine/the-refugees-of-north-dakota/), Shirley Dykshoorn, vice president for senior and humanitarian services with Lutheran Social Services, related to me that she doesn't have to look far in Fargo to find people delighted to be living with and working with refugees. "Fargo businesses are facing worker shortages," she said. "And we have eager employees."

11. Marion Ernwein and Laurent Matthey, "Events in the Affective City: Affect, Attention and Alignment in Two Ordinary Urban events," *Environment and Planning A: Economy and Space* 51, no. 2 (2019): 283–301.

Chapter 6

1. See, for example, the Co-Cities Project at http://commoning.city/ and the related article, "The City as a Commons," in which the authors state, "City space is highly contested space. As rapid urbanization takes hold around much of the world, contestations over city space—how that space is used and for whose benefit—are at the heart of many urban movements and policy debates." Sheila Foster and Christian Iaione, "The City as a Commons," *Yale Law & Policy Review* 34, no. 2 (2016): 282, available at https://papers.ssrn.com/sol3/papers.cfm?abstract_id=2653084.

2. For readers interested in how those in the policy and planning field have written about collaboration within and across institutional contexts, two good sources include Edward Weber and Anne M. Khademian, "Wicked problems, knowledge challenges, and collaborative capacity builders in network settings." *Public Administration Review* 68, no. 2 (2008): 334–349; and Rebecca Nearera Abers and Margaret Keck, *Practical Authority: Agency and Institutional Change in Brazilian Water Politics* (Oxford: Oxford University Press, 2013).

3. Jackson, *Social Works*, 29; Malcolm Miles, *Art, Space and the City: Public Art and Urban Futures* (London: Routledge, 1997), 148–149.

4. Nicola Dempsey, Harry Smith, and Mel Burton, eds., *Place-Keeping: Open Space Management in Practice* (New York: Routledge, 2014).

5. Isabelle Stengers, *In Catastrophic Times: Resisting the Coming Barbarism* (Open Humanities Press, 2015): 93, available at https://library.oapen.org/bitstream/handle/20.500.12657/32931/588461.pdf?sequence=1.

6. This book builds on ideas in my coauthored volume, *The Power of Narrative in Environmental Networks*, in which we examined the role of storytelling in developing and maintaining social networks. We were particularly interested in how narrative provided a kind of glue, binding together people, animals, resources, and other "things" and providing insight into how humans were making sense of these relationships. Lejano, Ingram, and Ingram, *The Power of Narrative in Environmental Networks*.

7. Noting how the UN Climate Action Summit called for greater invest-ment and financial tools for "nature-based solutions," or NBS, Panogiata Kotsi-la and her colleagues warn of issues with this general term as it can support a prescriptive and top-down provision of "solutions" even before problems are de-fined, import definitions of nature without paying attention to the politics and nuance of our relationships with what might be defined as nature, and harness particular definitions in order to promote discriminatory economic agendas. Kotsila et al., "Nature-Based Solutions as Discursive Tools."

8. Looking at how anarchic and Indigenous groups have shifted tactics in the face of massive disenfranchisement, Richard Day writes about a "politics of affinity," in which there is a stepping away from a focus on "the ask"—that is, demanding from authorities for what is desired. Day describes a "move away from a politics of demand, in which apparatuses of power as domination are asked for 'gifts' of 'freedom,' 'equality' and 'rights,' towards a politics of the act, in which individuals and communities give themselves what they need, with-out waiting for the help or approval of state and corporate structures." Richard J. F. Day, "Setting up Shop in Nullity: Protest Aesthetics and the New 'Situ-ationism,'" *The Review of Education, Pedagogy, and Cultural Studies* 29 no. 2–3 (2007): 241.

9. Andrew S. Matthews describes "an alert practice of natural history" as a matter of exploring the partial and historical relations between multiple actors and changing relations. G147 Andrew S. Matthews, "Ghostly Forms and Forest Histories," in Tsing et al., *Arts of Living on a Damaged Planet.*

Selected Bibliography

Angel, Shlomo, Alejandro M. Blei, Daniel L. Civco, and Jason Parent. *Atlas of Urban Expansion*. Cambridge, MA: Lincoln Institute of Land Policy, 2012. Online database available at http://www.atlasofurbanexpansion.org/.

Augé, Marc. *Non-Places: Introduction to an Anthropology of Supermodernity*. London: Verso, 1995.

Balayannis, Angeliki, and Emma Garnett. "Chemical Kinship: Interdisciplinary Experiments with Pollution." *Catalyst: Feminism, Theory, Technoscience* 6 no. 1 (2020): 1–10.

Ball, Lillian. "Called to Action: Environmental Restoration by Artists." *Ecological Restoration* 26, no. 1 (2008): 27–32.

Ball, Lillian, Tim Collins, Rieko Goto, and Betsy Damon. "Environmental Art as Eco-Cultural Restoration." In *Human Dimensions of Ecological Restoration: Integrating Science, Nature, and Culture*, edited by Dave Eagan, Evan E. Hjerpe, and Jesse Abrams, 299–312. Washington, DC: Island Press, 2011.

Barad, Karen. "No Small Matter: Mushroom Clouds, Ecologies of Nothingness, and Strange Topologies of Spacetimemattering." In *Arts of Living on a Damaged Planet: Ghosts and Monsters of the Anthropocene*, edited by Anna L. Tsing, Nils Bubandt, Elaine Gan, and Heather A. Swanson, 103–120. Minneapolis: University of Minnesota Press, 2017.

Barry, Andrew, Georgina Born, and Gisa Weszkalnys. "Logics of Interdisciplinarity." *Economy and Society* 37, no. 1 (2008): 20–49.

Bennet, Jane. *Vibrant Matter: A Political Ecology of Things*. Durham, NC: Duke University Press, 2010.

Berry, Wendell. *The Hidden Wound*. Boston, MA: Houghton Mifflin, 1970.

Boetzkes, Amanda. *The Ethics of Earth Art*. Minneapolis: University of Minnesota Press, 2010.

Bourriaud, Nicolas. *Relational Aesthetics*. Paris: Les Presses du Reel, 2002.

Braun, Bruce P. "A New Urban Dispositif? Governing Life in an Age of Climate Change." *Environment and Planning D: Society and Space* 32, no. 1 (2014): 49–64.

Braun, Bruce, and Sarah J. Whatmore. *Political Matter*. Minneapolis: University of Minnesota Press, 2010.

Bunting, Deborah. "Crisis of Care." In *The Essay*, produced by the BBC, March 18, 2016. Available at https://www.bbc.co.uk/sounds/play/b073b0y1.

Cain, Colleen. *Fighting Blight in the Northeast-Midwest Region: Assessing the Federal Response to Vacant and Abandoned Properties*. Northeast Midwest Institute, May 2016. Available at https://www.nemw.org/wp-content/uploads/2016/05/2016-Fighting-Blight-in-NEMW.pdf.

Collins, Ross F. "Red River on a Rampage." North Dakota State University, 2004. Available at https://www.ndsu.edu/pubweb/~rcollins/scholarship/Redriver.html.

Cosgrove, Denis E. *Social Formation and Symbolic Landscape*. Madison: University of Wisconsin Press, 1984.

Cravey, Altha. "Toque una Ranchera, Por Favor." *Antipode* 35, no. 3 (2003): 603–621.

Daniels, Stephen. "Marxism, Culture and the Duplicity of Landscape." In *New Models in Geography*. Vol. 2, *The Political-Economy Perspective*, edited by Richard Peet and Nigel Thrift, 196–220. London: Routledge, 1989.

De Boeck, Filip. "Spectral Kinshasa: Building the City through an Architecture of Words." In *Urban Theory Beyond the West*, edited by Tim Edensor and Mark Jayne, 320–337. New York: Routledge, 2012.

De Certeau, Michel. "Walking in the City (1980)." In *Cultural Theory: An Anthology*, edited by Imre Szeman and Timothy Kaposy, 264–273. West Sussex, U.K.: John Wiley & Sons, 2010.

de La Bellacasa, María Puig. *Matters of Care: Speculative Ethics in More than Human Worlds*. Minneapolis: University of Minnesota Press, 2017.

De Leon, Jason. *The Land of Open Graves: Living and Dying on the Migrant Trail*. Berkeley: University of California Press, 2015.

Deutsche, Rosalyn. *Evictions: Art and Spatial Politics*. Cambridge, MA: MIT Press, 1996.

Dryzek, John S. *Deliberative Democracy and Beyond: Liberals, Critics, Contestations*. New York: Oxford University Press, 2002.

D'Souza, Aruna. "The Art of Citizenship: Mierle Laderman Ukeles at the Queens Museum." *Art Practical*, November 10, 2016. Available at https://www.art

practical.com/feature/the-art-of-citizenship-mierle-laderman-ukeles-at
-the-queens-museum.

Duncan, Kevin T., and B. Todd Bailey. "Innocence amid 'LUST': The Innocent
Buyer and Leaking Underground Storage Tanks Containing Petroleum."
Brigham Young University Journal of Public Law 7, no. 2 (1993): 245.

Ellison, Joan. "The Reshaping of Pelican Rapids: How One Small Town Met the
Challenge of Transformation." *Rural Minnesota Journal* 7 (2012): 1–9. Available at https://www.slideshare.net/crpdmn/rural-mn-journal-reshaping
-pelican-rapids.

Erdrich, Louise. *The Night Watchman.* New York: HarperCollins Publishers,
2020.

Ernwein, Marion, and Laurent Matthey. "Events in the Affective City: Affect,
Attention and Alignment in Two Ordinary Urban Events." *Environment and
Planning A: Economy and Space* 51, no. 2 (2019): 283–301.

Flyn, Cal. *Islands of Abandonment: Life in the Post-Human Landscape.* London:
HarperCollins, 2021.

Foster, Jennifer, and L. Anders Sandberg. "Friends or Foe? Invasive Species and
Public Green Space in Toronto." *Geographical Review* 94, no. 2 (2004): 178–
198.

Foster, Sheila, and Christian Iaione. "Ostrom in the City: Design Principles and
Practices for the Urban Commons." *Routledge Handbook of the Study of the
Commons*, edited by Dan Cole, Blake Hudson, and Jonathan Rosenbloom,
235–255. New York: Routledge, 2019.

Fraser, Nancy. "Contradictions of Capital and Care." *New Left Review* 100, no.
99 (2016): 117.

Gandy, Matthew. "Between Borinquen and the Barrio: Environmental Justice
and New York City's Puerto Rican Community, 1969–1972." *Antipode* 34,
no. 4 (September 2002): 730–776. Available at https://doi.org/10.1111/1467
-8330.00267.

———. "Unintentional Landscapes." *Landscape Research* 41, no. 4 (2016): 433–
440.

Gilmore, Ruth Wilson. "Forgotten Places and the Seeds of Grassroots Planning." In *Engaging Contradictions: Theory, Politics, and Methods of Activist
Scholarship*, edited by Charles R. Hale, 31–61. Oakland: University of California Press, 2008.

Gould, Kenneth A., and Tammy L. Lewis. *Green Gentrification: Urban Sustainability and the Struggle for Environmental Justice.* New York: Routledge,
2016.

Graham, Stephen, and Simon Marvin. *Splintering Urbanism: Networked Infrastructures, Technological Mobilities and the Urban Condition.* New York:
Routledge, 2001.

Graham, Stephen, and Nigel Thrift. "Out of Order: Understanding Repair and
Maintenance." *Theory, Culture & Society* 24, no. 3 (2007): 1–25.

Güneralp, Burak, Meredith Reba, Billy U. Hales, Elizabeth A. Wentz, and Karen C. Seto. "Trends in Urban Land Expansion, Density, and Land Transitions from 1970 to 2010: A Global Synthesis." *Environmental Research Letters* 15, no. 4 (2020).

Gwynn, Wendy Laird-Benner, and Helen Ingram. "Sonoran Desert Network Weavers: Surprising Environmental Successes on the US/Mexico Border." *Environment* 53, no. 1 (2010): 6–17.

Harvey, David. "The Crisis of Planetary Urbanisms." In *Uneven Growth: Tactical Urbanisms for Expanding Megacities.* New York: Museum of Modern Art, 2014. Exhibition catalog. Available at https://www.artbook.com/9780 870709142.html.

———. "The Right to the City." *New Left Review* 58 (2008): 23–40.

Haskell, David George. *The Forest Unseen: A Year's Watch in Nature.* New York: Penguin, 2013.

Havlick, David G., and Marion Hourdequin, eds. *Restoring Layered Landscapes: History, Ecology, and Culture.* New York: Oxford University Press, 2016.

Hawkins, Harriet, Sallie A. Marston, Mrill Ingram, and Elizabeth Straughan. "The Art of Socioecological Transformation." *Annals of the Association of American Geographers* 105, no. 2 (2015): 331–341.

Heneghan, Liam. "What Restoration Ecology Could Learn from Art Conservation." *Aeon*, December 15, 2020. Available at https://aeon.co/essays/what -restoration-ecology-could-learn-from-art-conservation.

Higgins, Jessica. "Evaluating the Chicago Brownfields Initiative: The Effects of City-Initiated Brownfield Redevelopment on Surrounding Communities." *Northwestern Journal of Law and Social Policy* 3, no. 2 (2008): 240. Available at https://scholarlycommons.law.northwestern.edu/njlsp/vol3/iss2/5/.

Ingram, Mrill. "Ecopolitics and Aesthetics: The Art of Helen Mayer Harrison and Newton Harrison." *Geographical Review* 103, no. 2 (2013): 260–274.

———. "Material Transformations: Urban Ecological Art and Environmental Justice." In *Restoring Layered Landscapes: History, Ecology, and Culture*, edited by Marion Hourdequin and David G. Havlick, 222–238. Oxford: Oxford University Press, 2012.

———. "Washing Urban Water: Diplomacy in Environmental Art in the Bronx, New York City." *Gender, Place & Culture* 21, no. 1 (2014): 105–122.

Jackson, Shannon. *Social Works: Performing Art, Supporting Publics.* New York: Routledge, 2011.

Jacobs, Jane. *The Death and Life of Great American Cities.* New York: Vintage, 2016.

Kaika, Maria, and Erik Swyngedouw. "Fetishizing the Modern City: The Phantasmagoria of Urban Technological Networks." *International Journal of Urban and Regional Research* 24, no. 1 (2000): 120–138. Available at https:// doi-org.ezproxy.library.wisc.edu/10.1111/1468-2427.00239.

Kastner, Jeffrey, and Brian Wallis. *Land and Environmental Art.* London: Phaidon, 1988.

Katz, Cindi. "Vagabond Capitalism and the Necessity of Social Reproduction." *Antipode* 33, no. 4 (2001): 709–728.

Kester, Grant H. *Conversation Pieces: Community Communication in Modern Art.* Berkeley: University of California Press, 2004.

Kotsila, Panagiota, Kathrin Hörschelmann, Isabelle Anguelovski, Filka Sekulova, and Yuliana Lazova. "Clashing Temporalities of Care and Support as Key Determinants of Transformatory and Justice Potentials in Urban Gardens." *Cities* 106 (2020).

Kowalski, Janina, and Tenley Conway. "Branching Out: The Inclusion of Urban Food Trees in Canadian Urban Forest Management Plans." *Urban Forestry & Urban Greening* 45 (June 2018). Available at https://www.researchgate.net/publication/325535486_Branching_out_The_Inclusion_of_Urban_Food_Trees_in_Canadian_Urban_Forest_Management_Plans.

Krug, Don. "Ecological Restoration: Mel Chin, Revival Field." Greenmuseum.org, 2006. Accessed at http://greenmuseum.org/c/aen/Issues/chin.php; site archived in 2019.

Kunstler, James Howard. *Geography of Nowhere: The Rise and Decline of America's Man-Made Landscape.* New York: Simon and Schuster, 1994.

Kwon, Miwon. *One Place after Another: Site-Specific Art and Locational Identity.* Cambridge, MA: MIT Press, 2004.

Lacy, Suzanne. *Leaving Art: Writings on Performance, Politics, and Publics, 1974–2007.* Durham, NC: Duke University Press, 2010.

Latour, Bruno. *We Have Never Been Modern.* Cambridge, MA: Harvard University Press, 2012.

Lee, Robert, and Tristan Ahtone. "Land-Grab Universities," *High Country News*, March 30, 2020, https://www.hcn.org/issues/52.4/indigenous-affairs-education-land-grab-universities.

Lefebvre, Henri. *The Production of Space.* Translated by Donald Nicholson-Smith. Oxford, U.K.: Blackwell, 1991.

Lejano, Raul, Mrill Ingram, and Helen Ingram. *The Power of Narrative in Environmental Networks.* Cambridge, MA: MIT Press, 2013.

Loftus, Alex, and Fiona Lumsden. "Reworking Hegemony in the Urban Waterscape." *Transactions of the Institute of British Geographers* 33, no. 1 (2008): 109–126.

Marres, Noortje, Michael Guggenheim, and Alex Wilkie. "Introduction: From Performance to Inventing the Social." In *Inventing the Social*, edited by Noortje Marres, Michael Guggenheim, and Alex Wilkie, 19–39. Manchester, U.K.: Mattering Press, 2018.

Mazur, Laurie Ann. *Resilience Matters 2017: Transformative Thinking in a Year of Crisis.* Washington, DC: Island Press, 2018.

Meerow, Sara, Joshua P. Newell, and Melissa Stults. "Defining Urban Resilience: A Review." *Landscape and Urban Planning* 147 (2016): 38–49.

Miles, Malcolm. *Art, Space and the City: Public Art and Urban Futures.* London: Routledge, 1997.

Nearera Abers, Rebecca, and Margaret Keck. *Practical Authority: Agency and Institutional Change in Brazilian Water Politics.* Oxford: Oxford University Press, 2013.

Newman, Galen D., Ann O'M. Bowman, Ryun Jung Lee, and Boah Kim. "A Current Inventory of Vacant Urban Land in America." *Journal of Urban Design* 21, no. 3 (2016): 302–319.

Oshinskie, Mark D. "Tanks for Nothing: Oil Company Liability for Discharges of Gasoline from Underground Storage Tanks Divested to Station Owners." *Virginia Environmental Law Journal* 18, no. 1 (1999): 1–39. Available at http://www.jstor.org/stable/24785941.

Plumwood, Val. "Shadow Places and the Politics of Dwelling." *Australian Humanities Review*, no. 44 (2008): 134–150.

Purcell, Mark. "Possible Worlds: Henri Lefebvre and the Right to the City." *Journal of Urban Affairs* 36, no. 1 (2014): 141–154.

Quinn, M. L. "Should All Degraded Landscapes Be Restored?" *Land Degradation & Development* 3, no. 2 (1992): 115–134.

Rose, Deborah Bird. "Shimmer: When All You Love Is Being Trashed." In *Arts of Living on a Damaged Planet: Ghosts and Monsters of the Anthropocene*, edited by Anna Lowenhaupt Tsing, Heather Anne Swanson, Elaine Gan, and Nils Bubandt, G51–G63. Minneapolis: University of Minnesota Press, 2017.

Schyler, Krista. "Embattled Borderlands." 2017. Available at http://storymaps.esri.com/stories/2017/embattled-borderlands/index.html.

Smiley, Kevin T., and Christopher R. Hakkenberg. "Race and Affluence Shape Spatio-Temporal Urbanization Trends in Greater Houston, 1997 to 2016." *Land Use Policy* 99 (2020).

Solnit, Rebecca, and Joshua Jelly-Schapiro. "Trash in the City: Dumping on Staten Island and Beyond." In *Nonstop Metropolis: A New York City Atlas*. Oakland: University of California Press, 2016.

Spelman, Elizabeth. "Embracing and Resisting the Restorative Impulse." In *Healing Natures, Repairing Relationships: New Perspectives on Restoring Ecological Spaces and Consciousness*, edited by Robert L. France, 127–140. Winnipeg, Manitoba: Green Frigate Books.

Spirn, Anne Whiston. "Restoring Mill Creek: Landscape Literacy, Environmental Justice and City Planning and Design." *Landscape Research* 30, no. 3 (July 2005): 395–413.

Star, Susan Leigh. "The Ethnography of Infrastructure." *American Behavioral Scientist* 43, no. 3 (1999): 377–391.

Steiner, Frederick R. *The Living Landscape: An Ecological Approach to Landscape Planning.* Washington, DC: Island Press, 2012.

Stengers, Isabelle. "The Cosmopolitical Proposal." In *Making Things Public: Atmospheres of Democracy*, edited by Peter Weibel and Bruno Latour, 994–1003. Cambridge, MA: MIT Press, 2005.

———. "Introducing Nonhumans in Political Theory." In *Political Matter*, edited by Bruce Braun and Sarah J. Whatmore, 1–33. Minneapolis: University of Minnesota Press, 2010.

Stone, Deborah. "Caring Communities: What Would It Take." In *Long-Term Care and Medicare Policy: Can We Improve Continuity of Care*, edited by David Blumenthal, Marilyn Moon, Mark Warshawsky, and Christina Boccuti, 214–224. Washington, DC: Brookings Institution Press, 2003.

Swenson, Kirsten J. *Critical Landscapes: Art, Space, Politics*. Berkeley: University of California Press, 2015.

Swyngedouw, Erik, and Maria Kaika. "Urban Political Ecology: Great Promises, Deadlock . . . and New Beginnings?" *Documents d'anàlisi geogràfica* 60, no. 3 (2014): 459–481.

Sze, Julie. *Noxious New York: The Racial Politics of Urban Health and Environmental Justice*. Cambridge, MA: MIT Press, 2006.

Taylor, Dorceta. *Toxic Communities: Environmental Racism, Industrial Pollution, and Residential Mobility*. New York: New York University Press, 2014.

Taylor, Peter J. "Places, Spaces and Macy's: Place–Space Tensions in the Political Geography of Modernities." *Progress in Human Geography* 23, no. 1 (1999): 7–26.

Tornaghi, Chiara, and Chiara Certomà, eds. *Urban Gardening as Politics*. New York: Routledge, 2018.

Truelove, Yaffa. "(Re-)Conceptualizing Water Inequality in Delhi, India through a Feminist Political Ecology Framework." *Geoforum* 42, no. 2 (2011): 143–152.

Tsing, Anna Lowenhaupt, Heather Anne Swanson, Elaine Gan, and Nils Bubandt, eds. *Arts of Living on a Damaged Planet: Ghosts and Monsters of the Anthropocene*. Minneapolis: University of Minnesota Press, 2017.

Ukeles, Mierle Laderman. "MANIFESTO FOR MAINTENANCE ART, 1969! Proposal for an Exhibition: 'CARE', 1969." Available at https://feldmangallery.com/exhibition/manifesto-for-maintenance-art-1969.

Ukeles, Mierle Laderman, Jimmie Durham, Rackstraw Downes, Alfredo Jaar, Peter Fend, Patricia Johanson, Agnes Denes, Billy Curmano, and Regina Vater. "Artists' Pages." *Art Journal* 51, no. 2 (1992): 12.

Van Dooren, Thom, and Deborah Bird Rose. "Storied-Places in a Multispecies City." *Humanimalia* 3, no. 2 (2012): 1–27.

Watt, Laura, A. "Conflicting Restoration Goals in the San Francisco Bay." In *Restoration and History: The Search for a Usable Environmental Past*, edited by Marcus Hall, 218–219. New York: Routledge, 2010.

Whitehead, Frances, and Christine Atha. "Complexity and Engagement: Art and Design in the Post Industrial." *MADE* 6 (2010): 3–52. Available at http://www.cardiff.ac.uk/archi/made.php.

Wolch, Jennifer R., Jason Byrne, and Joshua P. Newell, "Urban Green Space, Public Health, and Environmental Justice: The Challenge of Making Cities 'Just Green Enough,'" *Landscape and Urban Planning* 125 (2014): 234–244.

Index

Note: *Italic page numbers refer to figures.*

Mrill Ingram is a Geographer and Participatory Action Research Scientist at the Center for Integrated Agricultural Systems at the University of Wisconsin–Madison. She is the author of many articles on the environment and past editor of *Ecological Restoration* and at *The Progressive* magazine. She is coauthor of *The Power of Narrative in Environmental Networks*.